IMAGES
of America

ORO VALLEY

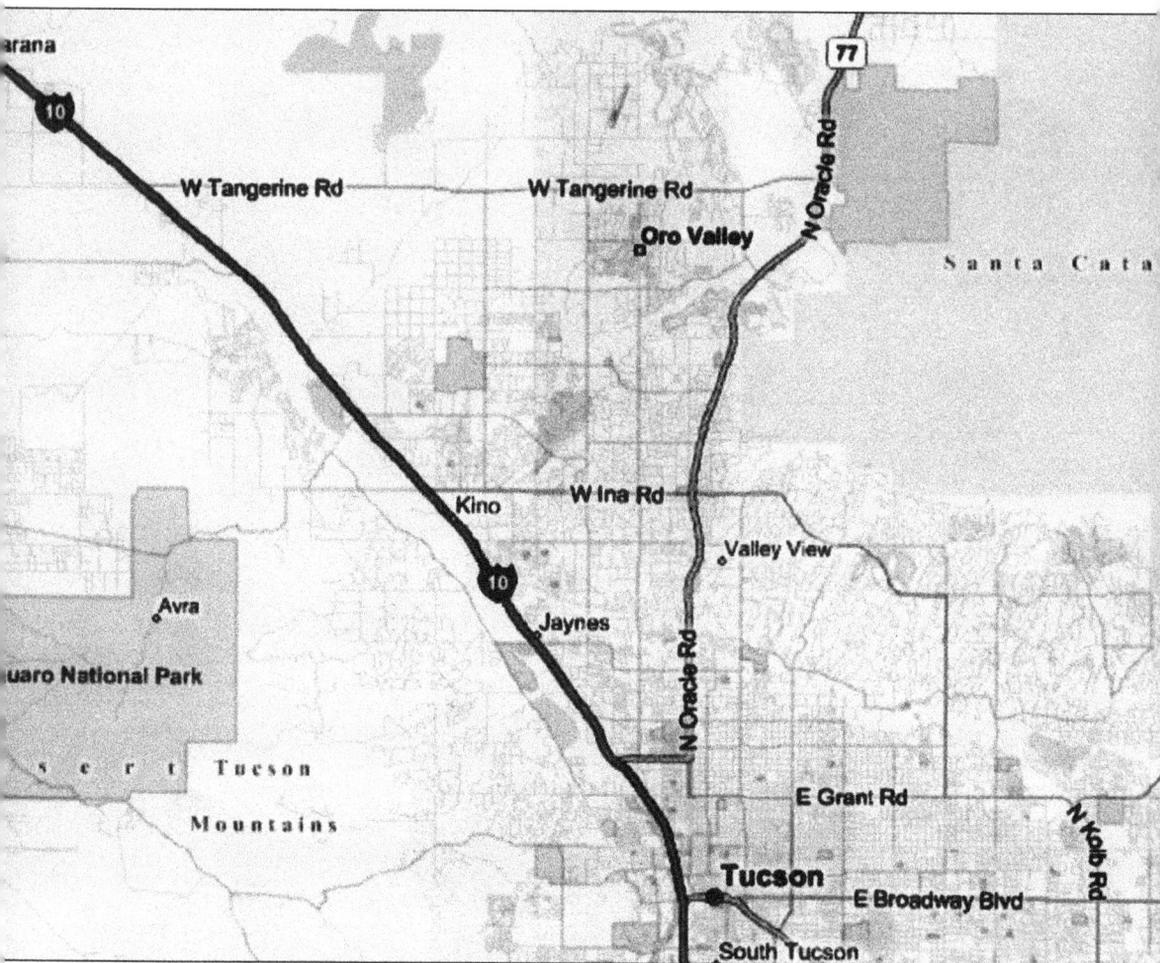

arana

10

W Tangerine Rd W Tangerine Rd

77

N Oracle Rd

Oro Valley

Santa Cata

Kino W Ina Rd

10

Valley View

Avra

Jaynes

uaro National Park

N Oracle Rd

s e r t Tucson

E Grant Rd

Mountains

N Kolb Rd

Tucson

E Broadway Blvd

South Tucson

Oro Valley is a mere 10 miles from the city of Tucson. Plans to make 2.5 miles of this area into a new town started in the late 1960s, but it was not until 1974 that Oro Valley's incorporation was finalized. The original population was about 800. Today the town covers almost 40 square miles and is home to approximately 40,000 residents. Despite its rapid growth, the town has managed to protect its heritage and the ancient history of the land while offering a luxurious and convenient lifestyle to its citizens. The land is dominated by the Santa Catalina Mountains on the east and the Tortolita Mountains on the north, and it is bisected by the dry Cañada del Oro wash, which seasonally changes to a free-flowing river. (Courtesy author.)

ON THE COVER: Prospectors in the 1800s did not need much to seek their fortune—a couple of good pack animals, a dish for panning, good eyesight to spot the tiny flakes of color, and determination. The mountains of Oro Valley beckoned; a few answered and scoured its washes and peaks looking for the evasive color. But the only glitter the area gave up was in its name. (Courtesy Arizona Historical Foundation.)

IMAGES
of America

ORO VALLEY

Barbara Marriott and
the Oro Valley Historical Society

Arizona Historical Foundation

ARCADIA
PUBLISHING

Copyright © 2008 by Barbara Marriott and the Oro Valley Historical Society
ISBN 978-1-5316-2982-3

Published by Arcadia Publishing
Charleston, South Carolina

Library of Congress Catalog Card Number: 2007934177

For all general information contact Arcadia Publishing at:
Telephone 843-853-2070
Fax 843-853-0044
E-mail sales@arcadiapublishing.com
For customer service and orders:
Toll-Free 1-888-313-2665

Visit us on the Internet at www.arcadiapublishing.com

For Jim Kriegh, the father of Oro Valley, a man who walked softly and accomplished extraordinary deeds.

CONTENTS

ACKNOWLEDGMENTS

This book came into existence from the generosity of the people of Oro Valley, who opened up their photo albums, searched through storage, and discovered their family's pioneer photographs. It also is possible because of others outside the community who donated their professional and personal photographs for the book. Special thanks to Robin Coulter, Kathryn Cuvelier, Dennis De Vault, William H. Doelle, Dick Eggerding, Alpha Evans, Georgia Hollinger, R. Brooks Jeffery, Roxy Johnson, Kurt Keller, Eva Kramer, Jim Kriegh, Mayor Paul Loomis, Michael Marriott, Dorothy L. Myrick, Sybil Needham, Jeanette O'Donald, Dan Reidy, Nadine Rentschler, Pat Spoerl, Mary Shields, Pat Sokolowski, Evonne Springer, Phil Usberne, Sister Vivian of Immaculate Heart, Christina Wicker, Henry Zipf, and all the others mentioned in the credit lines.

INTRODUCTION

Stretching out in the valley between the Tortolita Mountains and the Santa Catalina Mountains is a gem of a town called Oro Valley. The town spreads out in a land that is arid, cacti covered, and beautifully wild. Cutting across this challenging landscape is the Cañada del Oro, which sometimes is a raging river and at other times a wide, sandy wash. It was the Cañada del Oro that brought the First Families to settle in the area around 700 AD, and here they established their pit-house villages. The accessibility of water encouraged the growing of crops such as corn and squash to sustain these early inhabitants. There is archeological proof that ancient people followed the Cañada del Oro through the valley on their trade migrations. Shells, beads, and pottery from other ancient societies have been found along its banks and in the surrounding hills. The finicky waters were a lure for many generations, and they managed to supply life-giving waters to man and beast for thousands of years.

The Cañada del Oro has played an important role in the history of this area, as have the Santa Catalina Mountains. Flowing down the western side of the mountains from its headwaters in the Santa Catalina Mountains, the Cañada del Oro breaks out and heads west, crossing over what is now Highway 77. While it no longer is a major source of water, it is very much a major feature of the area, especially when snow melts and monsoons turn its wide sandy bed into a ranging river that can tear up trees and destroy cars.

In the surrounding mountains of the Tortolitas and the Santa Catalinas are hidden pockets of pools and lush plateaus that sustained the deer, rabbit, quail, long-horned sheep, mountain lions, and bears that once inhibited these mountains. They too followed the Cañada del Oro in their migrations. The game animals are mostly gone, but the beauty remains. On this stage the history of southern Arizona played and left its mark in Hohokam ruins, artifacts of Apache and Tohono O'odham life, and in foundations of old adobes and abandoned ranches.

In Honey Bee Canyon, archaeologists have uncovered significant evidence of a thriving Hohokam village. In Catalina State Park, the Romero Ruin site offers further proof of the occupation of ancient Americans in what is now the modern Oro Valley area. Scattered throughout the valley, a hiker can find evidence left by ancient Native Americans in the petroglyphs and broken artifacts.

The waters of the Cañada del Oro were also a major draw for the early pioneers. When immigrant George Pusch decided to seek his fortune in the mid-1800s, he headed west. California proved to be a disappointment for both his fortune-seeking and his goal of becoming a cattle baron. A disillusioned Pusch redirected his hopes and made his way to Tucson, Arizona Territory. The old pueblo was a thriving Mexican/Anglo town of dusty streets and merchant shops. However, north of the town and near the western edge of the Santa Catalina Mountain chain, Pusch discovered the Cañada del Oro, its abundant waters running at least nine months of the year. Here he established his Steam Pump Ranch on the land that became Oro Valley.

Then, around the beginning of the 20th century, another group discovered this area: the health seekers. Men and women suffering from what was termed "consumption" were advised by doctors around the world to move to the southern Arizona Territory. They were the early

settlers. These health seekers homesteaded the land, worked to improve their lives, and rooted Oro Valley in strong values.

This valley has been a major north-south thoroughfare since the earliest of times. Apaches used this route when traveling to and from their lands in the White Mountains. Prospectors and pioneers heading west to find fortune and fame in California made their way along this path, some of them stopping to probe the Tortolita and Santa Catalina Mountains for gold and silver. A few found what they were looking for. The ease of travel and the accessibility of water lured stagecoaches, cattle drives, and army patrols. When the Tucson railhead opened in 1880, cattle drives from the north stopped at the Cañada del Oro to fatten and water the animals. Stagecoaches and travelers heading to the cities of Phoenix, Florence, and other northern points filled their water jugs from the Cañada del Oro wells. Even today, this route serves as a major north-south highway cutting through Arizona, winding its way between mountain ranges and crossing washes and rivers.

When the army established western outposts such as Camp Grant and Fort Lowell in the 1800s, supply wagons and patrols followed this track north and south. When more people settled in the territory, stagecoaches plied their trade along the valley delivering people and goods in each direction. A stop for all travelers then was the Steam Pump Ranch, which offered abundant water from the Cañada del Oro to men and cattle.

Pioneers such as George Pusch and Francisco Romaro recognized the Cañada del Oro's value. In later years, when these first pioneers disappeared, their lands were divided among the settlers whose names still identify the area. Rooney Ranch, Suffolk Estates, Pusch Ridge, and Buster Mountain stand as testimonies to the rugged men and women who conquered this desert area and carved out a way of life.

In the late 1960s, seeking a life independent of the city of Tucson, which loomed over them in the south, the residents of the area decided to forge their own path. In 1974, after a difficult legal battle, the area became the incorporated town of Oro Valley.

While the early marks of history are honored and many preserved, Oro Valley has moved forward, taking its residents into an age of modern conveniences and necessities. Now luxury resorts, two significant hospitals, verdant golf courses, high-tech manufacturers, and upscale homes stand where cattle grazed and Native Americans lived.

In addition to having a respect for its glorious historical past, Oro Valley understands the finer things in life. The town is spotted with delightful parks that display art as part of life. These parks encourage children to play and regularly host community events, such as farmers' markets, art shows, and musical offerings. Oro Valley's many parks are very much a part of life in this community.

Oro Valley's transition from the wilderness of the Native Americans to a modern city is a story of planning, foresight, and courage. Its success owes much to its ability to take the past along as the town travels into the 21st century and beyond and to its realization that the footprints of Arizona's past are in the soil of Oro Valley.

The historical images of Oro Valley are not of big business or government projects but of people—strong, courageous, and innovative—who braved difficult circumstances thrown at them by nature and man; they did more than survive, they achieved tremendous success.

Through pictures and text, the reader can travel from the early Hohokam days to the modern city. Along the way, readers will meet the people and places that are the history of Oro Valley, Arizona.

One

FIRST FAMILIES

The utilization, fascination, and appreciation of Oro Valley land started well over 1,000 years ago. The mystic Santa Catalina Mountains, teeming with wildlife and combined with the rushing waters of the Cañada del Oro, lured the ancient Hohokam. Here they established their pit-house villages.

Evidence of these settlements and the Hohokam way of life can be found in the ruins of two major sites, the Romero Ruin and Honey Bee Village, and in the petroglyphs and broken pottery scattered around the area.

Pat Spoerl, archeologist and Oro Valley resident, gives insight into these First Families: "These villages consisted of several hundred houses, generally dug into the ground, with a plastered floor and a brush superstructure. The Hohokam relied heavily on the growing of corn, beans and squash. They managed their desert environment by slowing runoffs of water with rock piles and rock terraces."

Spoerl identifies the Romero Ruin as one of the largest Hohokam sites of these ancient people in the greater Tucson Basin. The village was established by 500 AD and is located on a ridge above the Sutherland Wash.

The Hohokam built ball courts for games and social gatherings, and the remains of these ball courts can be seen in two oval depressions at the Romero Ruin.

Not more than three miles away is Honey Bee Village, another large Hohokam ball court settlement. Honey Bee Village had over 500 pit-houses. This village was situated above Honey Bee Wash and Big Wash, both of which flow into the Cañada del Oro. Honey Bee Village was established around 450 AD and was continually occupied until about 1250 AD.

The Hohokam left their history in more than pit-houses and ball courts. As Spoerl explains, "Along Sutherland Wash and on the rocky ridges of the Santa Catalina and Tortolita mountains are hundreds of petroglyph figures pecked into large boulders. These figures include animals, humans and abstract symbols whose meanings are unknown but probably depict important aspects of life among the First Families of Oro Valley."

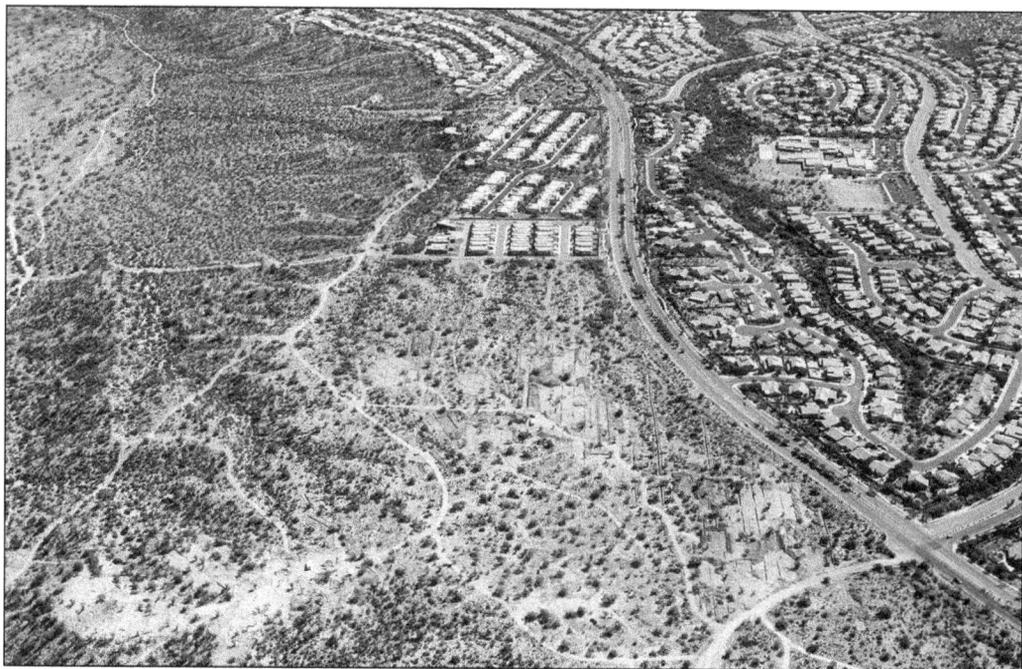

The word *Hohokam* has been defined as "those who came before," or "all used up." From 450 AD until about 1100 AD, the Hohokam occupied land that is now part of the town of Oro Valley. Their village sat next to the mountains and a small waterway. This 1980 aerial view shows little sign that this blank land once contained over 400 pit-houses in what archeologists today call Honey Bee Village. (Courtesy Henry D. Wallace, Desert Archeology.)

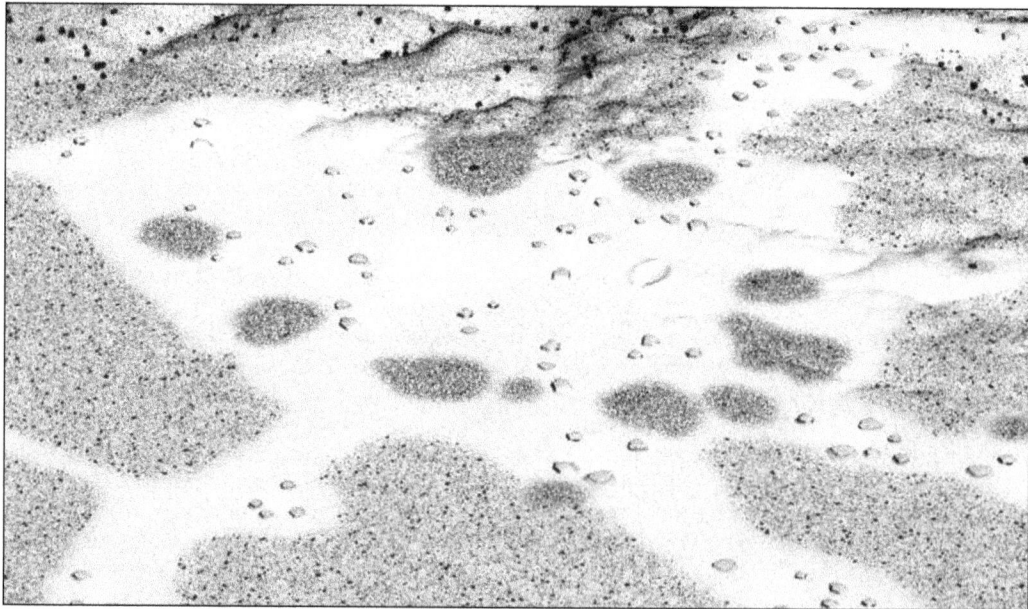

The Hohokam built their pit-houses around a central plaza that served as a site for community functions. Pit-houses were built in family groupings. In central right is the oval shape of a ball court. The exact use of the ball courts is unknown, although some believe the games had religious purposes. (Courtesy Douglas W. Gann, Desert Archeology.)

The pit-houses were built partially underground, resulting in cooler houses. The house was entered through an elongated entryway with a step down into the pit-house's single room. A fire pit was centrally located in the room, but most of the cooking took place outside the pit-house. (Courtesy Henry D. Wallace, Desert Archeology.)

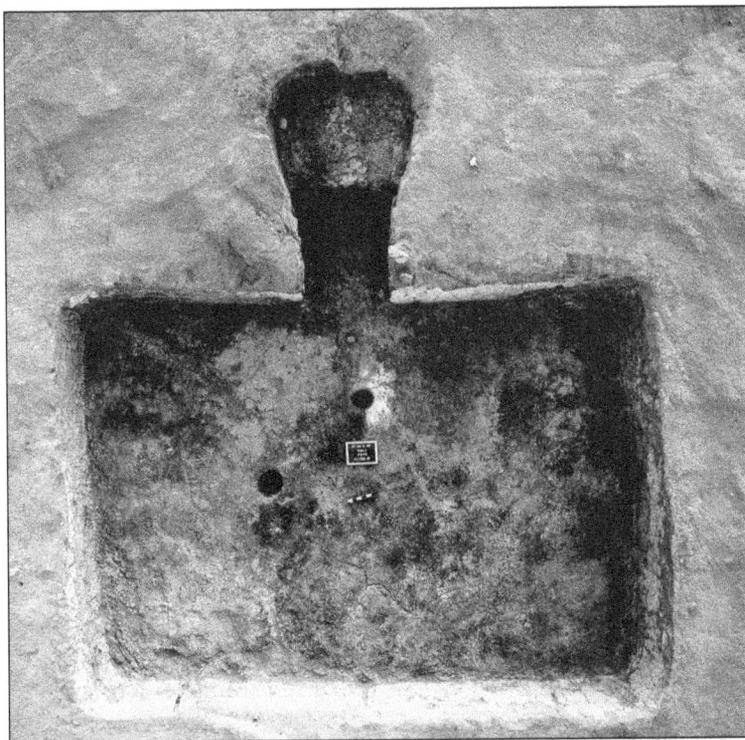

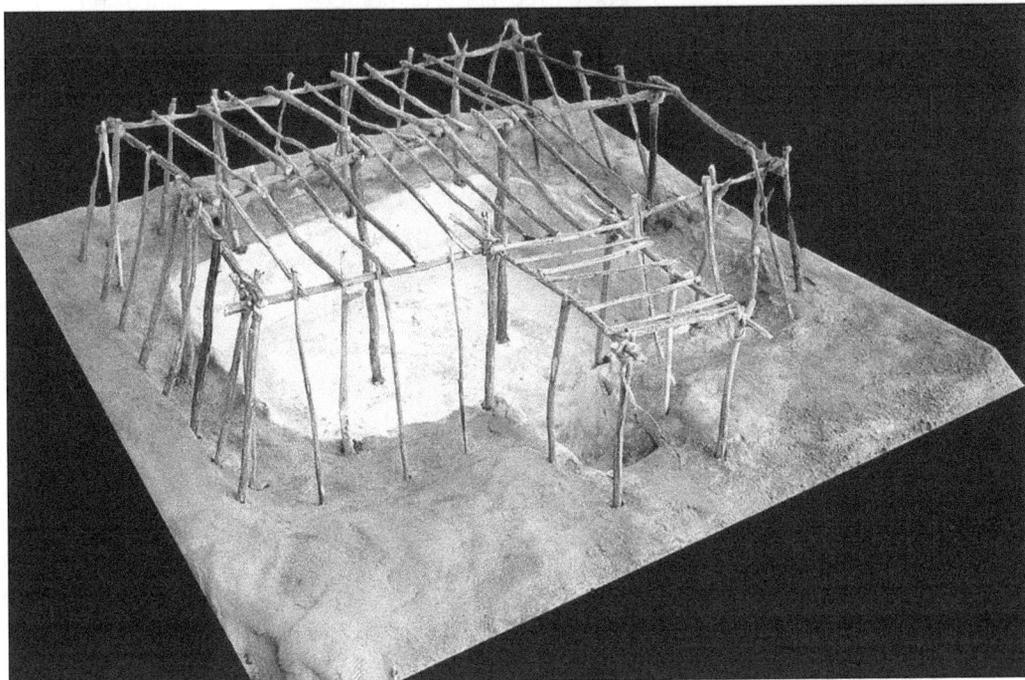

Hohokam pit-houses start with a 1.5-foot-deep pit. Mesquite or cottonwood beams woven with sticks, saguaro ribs, cholla branches, and grasses form the structure, which is covered with mud and adobe. Oro Valley's Honey Bee Village pit-houses are oval or semi-rectangular, with a small covered entrance. (Courtesy Douglas W. Gann, Desert Archeology.)

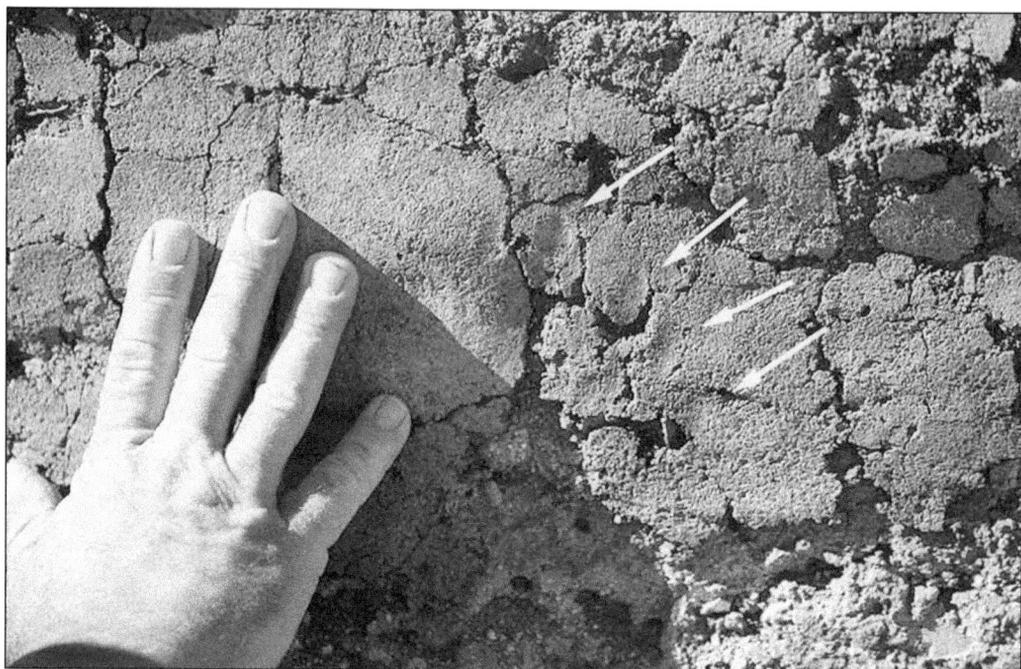

Fingerprints of a time past are captured in the ruins of Honey Bee Village. The arrows point to the prints of a Hohokam child and are compared with the hand of an archeologist's. The prints were probably made when the child worked to cover the pit-house structure with mud and adobe. (Courtesy Henry D. Wallace, Desert Archeology.)

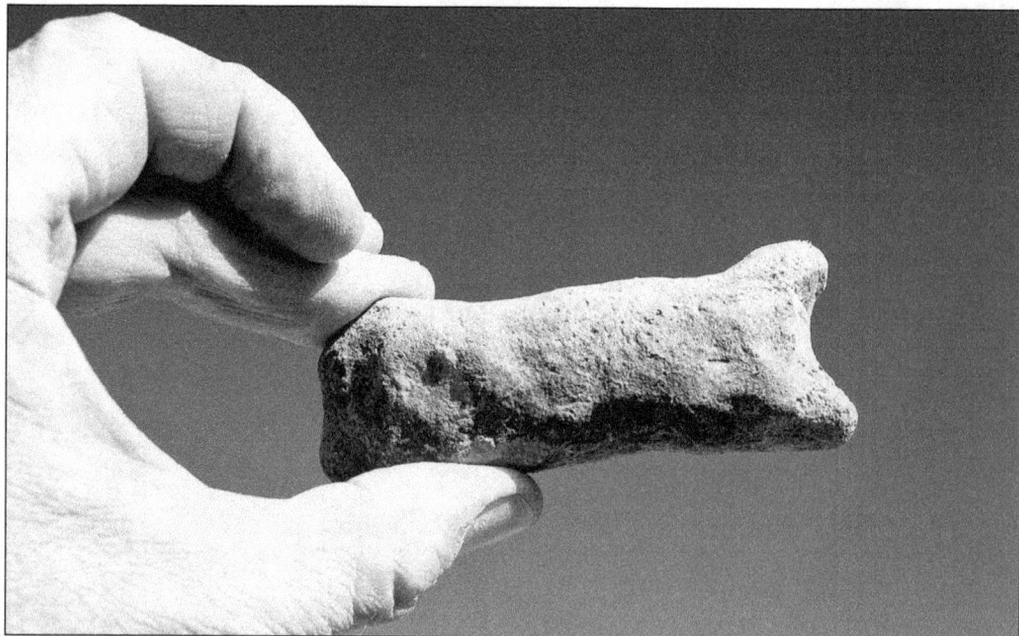

The Hohokam domesticated dogs and probably treated them as pets. Several dogs' graves were uncovered at Honey Bee. This small dog's pottery play bone was found at the site. The Hohokam were skilled potters, using some of their wares as trade items in exchange for items not available in the Oro Valley area. (Courtesy Henry D. Wallace, Desert Archeology.)

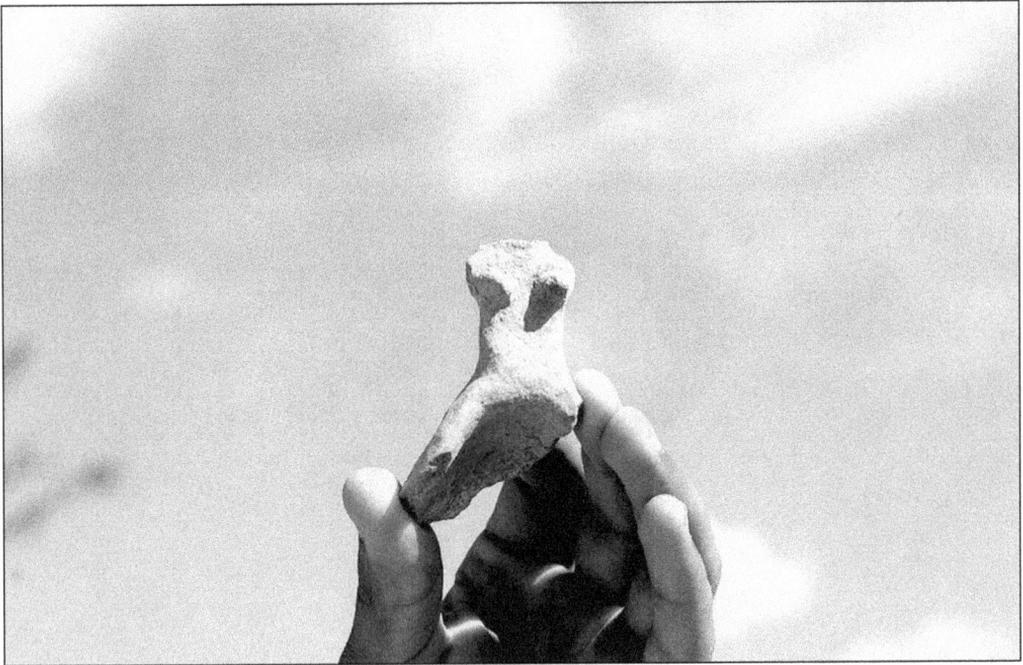

The pottery skill of the Honey Bee Hohokam reached its peak between 800 AD and 1100 AD. This tiny broken figurine found at Honey Bee shows the fine detailing achieved by these ancient potters. Figurines were of animals as well as humans and could be religious items as well as decorative or trade pieces. (Courtesy Henry D. Wallace, Desert Archeology.)

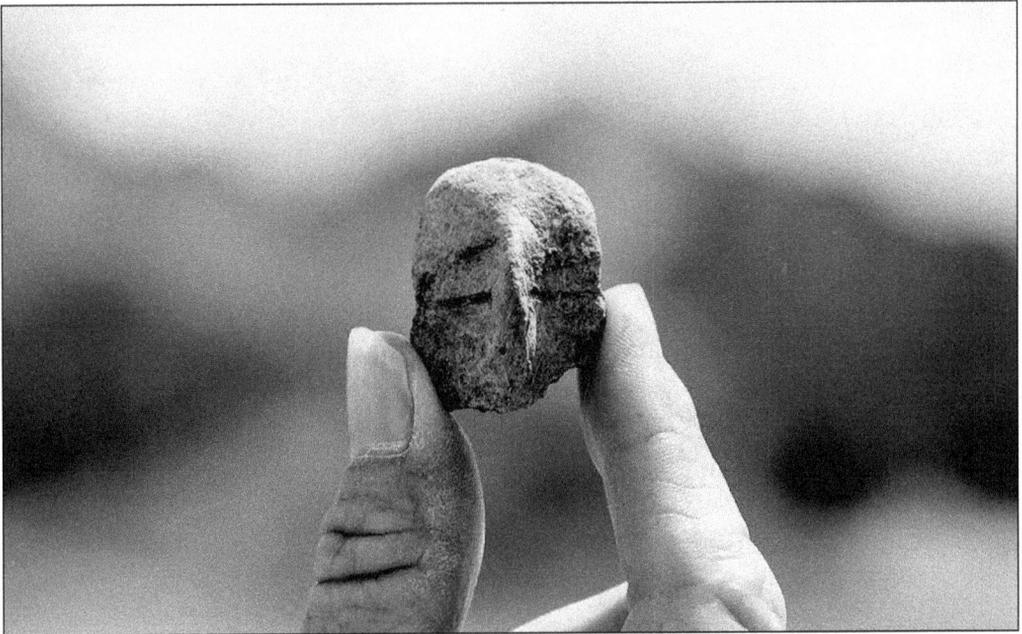

A clay figurine head found at the Oro Valley site of Honey Bee shows faint traces of decoration. The body paint was representative of Hohokam body paint. Figurines were crafted to duplicate the clothing and body decorations of the Hohokam. These effigies may have been art or for religious or ceremonial purposes. (Courtesy Henry D. Wallace, Desert Archeology.)

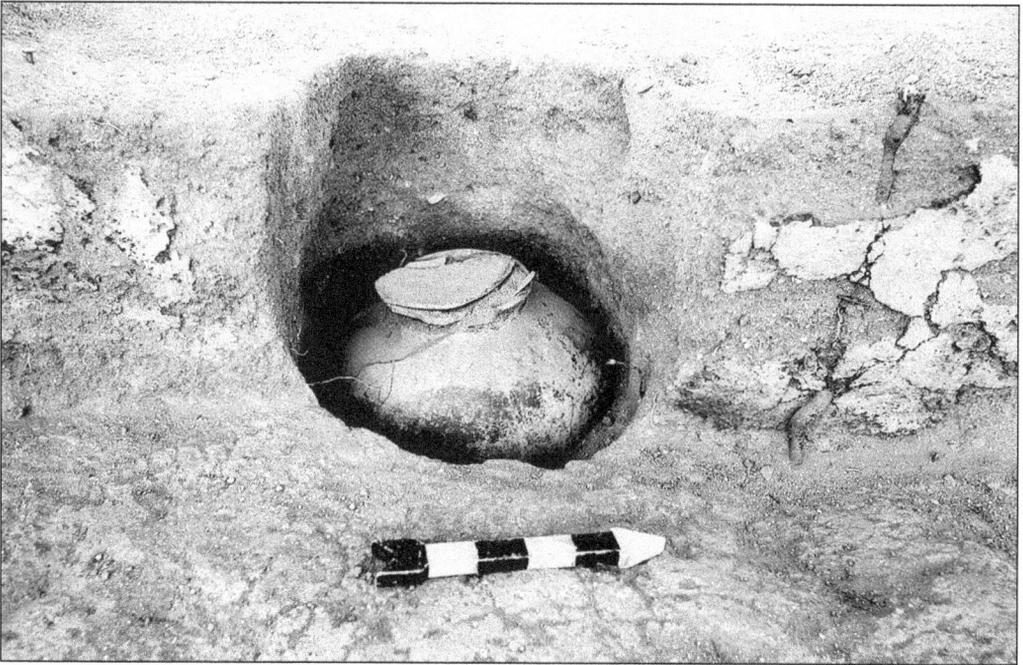

A prized find was this vessel found in the wall of a pit-house. It was made from local clay mixed with sand and crushed rock. These early farmers used pots to store food and water, as cooking pots, and as trade ware. The large pots, called ollas, were used as water jugs that kept the water cool in the desert heat. (Courtesy Henry D. Wallace, Desert Archeology.)

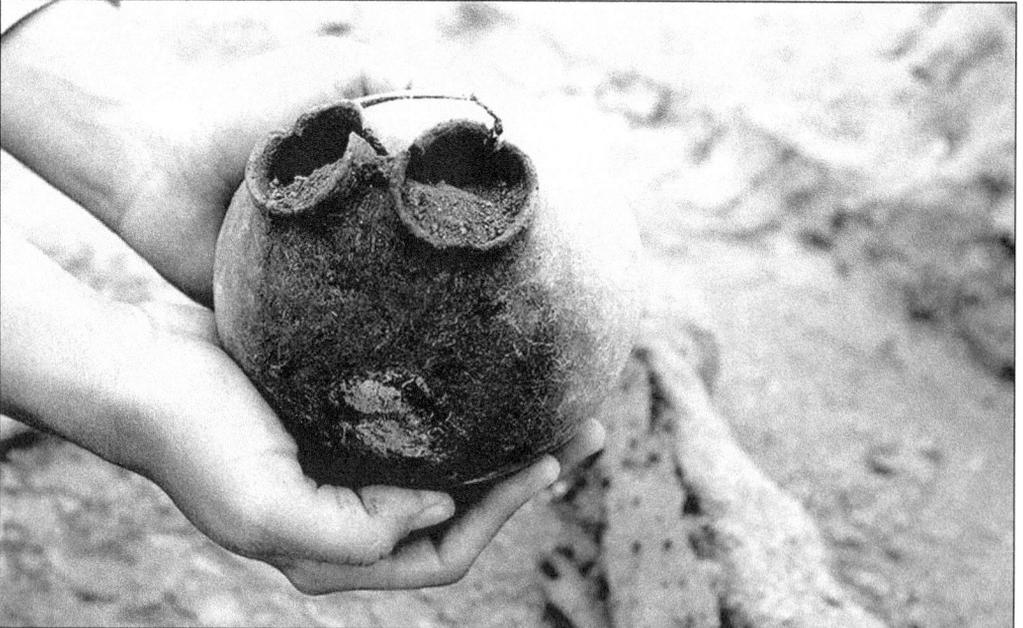

A unique double vessel shows the fine artisanship of these early Oro Valley potters. Some vessels were used as funerary accompaniments, and these were favored for trade. Hohokam pottery included jars, bowls, pitchers, scoops, and plates. Later pottery items were decorated with painted designs of red on gray or red on buff. (Courtesy Henry D. Wallace, Desert Archeology.)

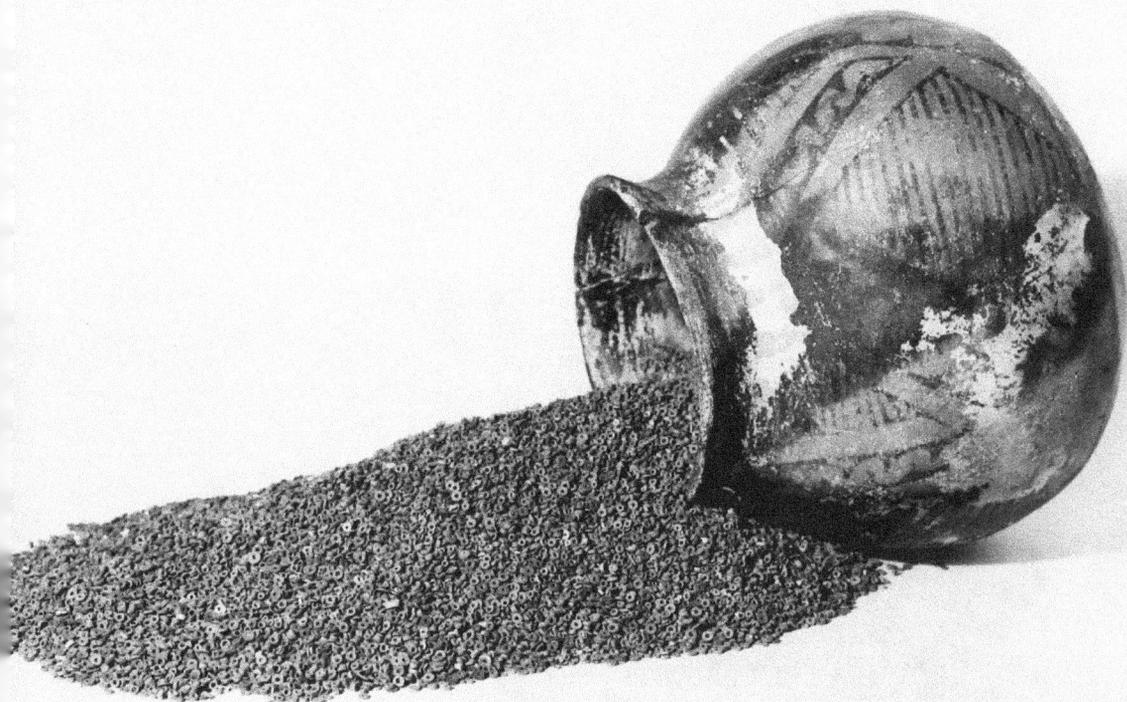

This treasure found hidden in a crevice in the Santa Catalina Mountains contained over 100,000 beads and 30 copper bells. This number of beads would take a single person 2.8 years to craft. The beads were first drilled with simple tools, and then they were strung and shaped. If strung all together string would measure 300 feet. An average necklace measured about 4 feet. These beads would have produced 75 necklaces. The copper bells probably came from Mexico and with the beads were traded to the Hohokam. Never have this many copper bells been found in one place. This cache was probably the wealth of the village. (Courtesy Arizona State Museum, University of Arizona, #5151.)

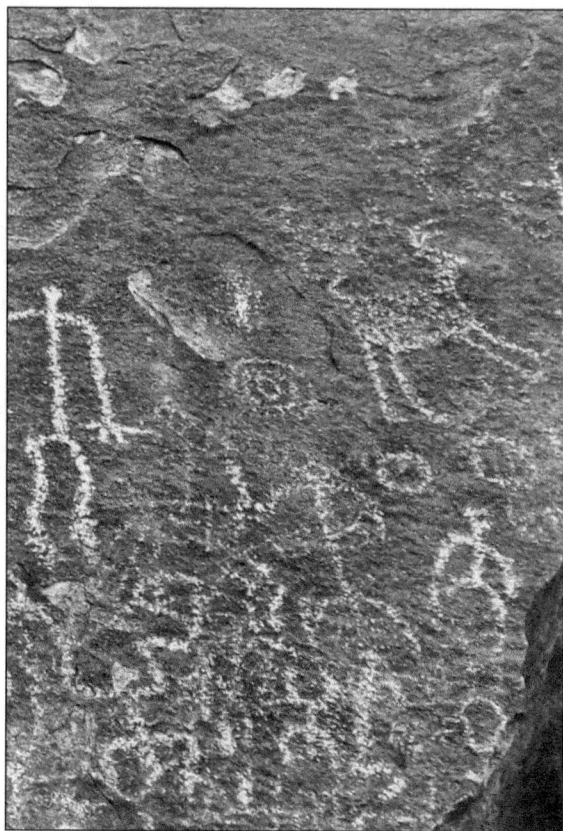

Scattered around Oro Valley land is the rock art of the ancients. Petroglyphs, picked into the rock by hammer stones, are artistic displays of the Hohokam way of life. It is not certain what these pieces signify. Recurring subjects of the local Hohokam were humans and long-horned sheep. (Courtesy Pat Spoerl.)

Forever captured in rock art, a pair of long-horned sheep makes their way up the mountains. This Hohokam sign could be indicating where sheep were. Rock art could also be religious works, directions, stories, or just early art expressions. Rock art was a time-consuming process, so it was not just casual graffiti. (Courtesy Pat Spoerl.)

16

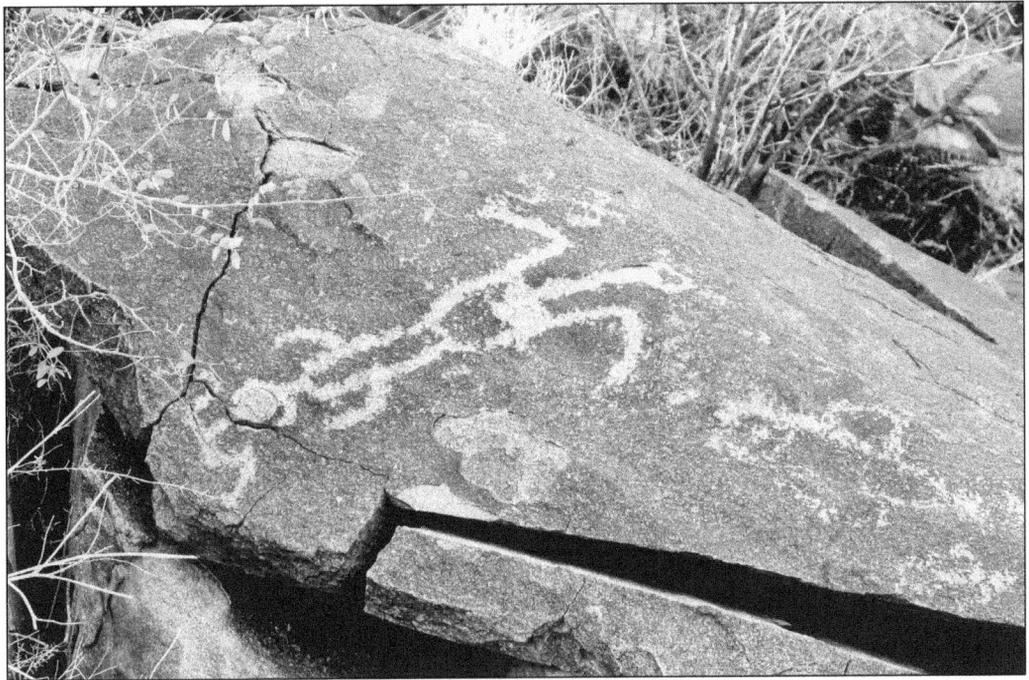

A very important figure was captured for eternity in this rock art. The figure is wearing a headdress and what looks like ceremonial garb. The garb might be that of a ballplayer or a religious figure. This single figure must have been of great importance to be captured in art. (Courtesy Pat Spoerl.)

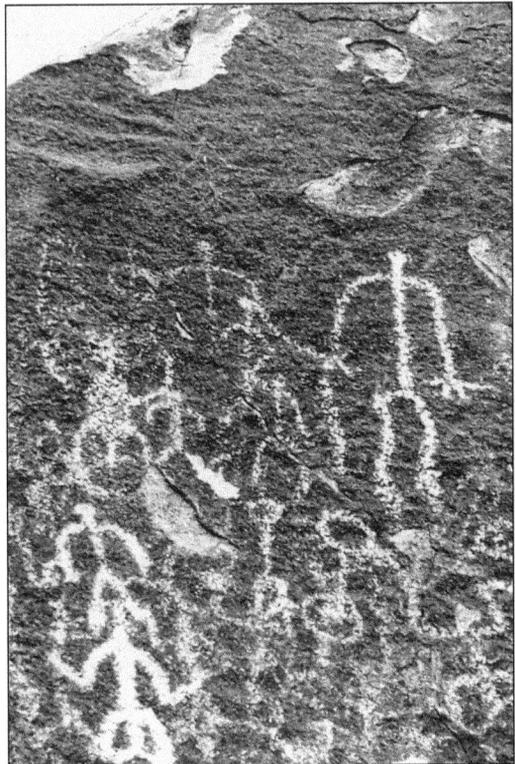

A multitude of figures are captured climbing upward in this rock art. Various sizes indicated people of all ages. Where are they going? Could they be escaping from flood or enemies, or could they be on a religious pilgrimage? Rock art gives us much to speculate about but few answers. (Courtesy Pat Spoerl.)

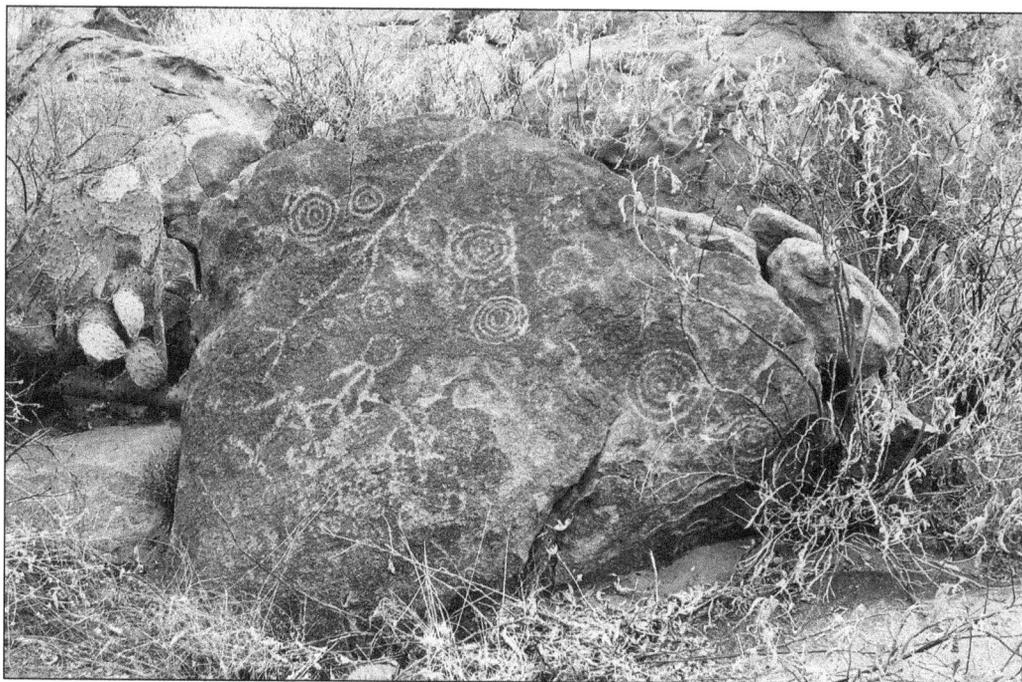

A line of dancers graces this rock. Religious dancing is still part of the Native American culture, and it has been passed down through generations. It is believed that the present-day Tohono O'odham, whose reservation is south of Tucson, are the descendents of the ancient Hohokam. (Courtesy Pat Spoerl.)

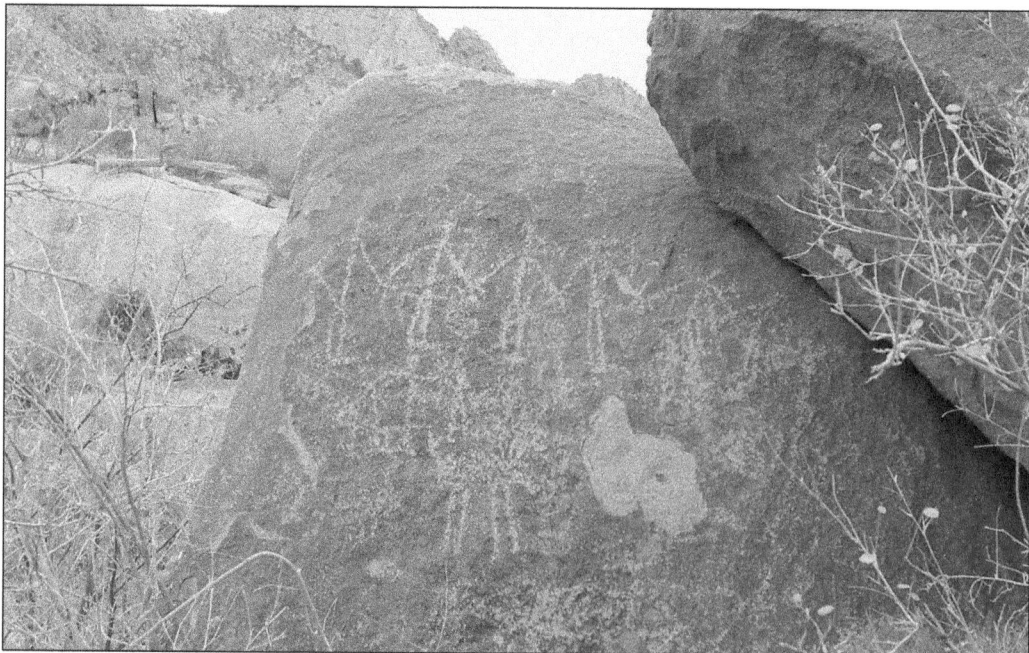

This rock shows the many graphic shapes used by the Hohokam in their petroglyphic artwork. Circles, straight lines, and stick figures cover the rock. Was this a practice work, or did it contain a message? Pale patches on the rock are where time and weather have worn away the surface.

Among the earliest Oro Valley people were the Apaches, such as Chief Nalt'Zilli, or Nut Cilli, who was a Mescalero Apache chief. Apaches roamed free in Oro Valley land as late as the early 1900s. They hunted and raided in the Santa Catalina and Tortolita Mountains, traveling great distances from the north and east to hunt the wildlife and later plague early pioneers. (Courtesy author.)

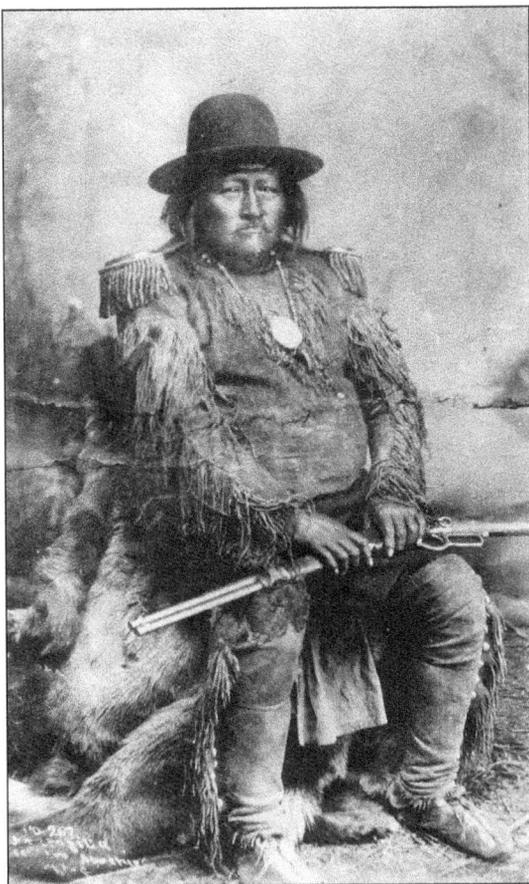

Apache chief Eskiminza is seen posing in the late 1800s beside his wickiup, a traditional Apache dwelling. The western foothills of the Santa Catalina Mountains and the Cañada del Oro were part of the territorial homeland for the Western Apaches, especially the Aravaipa band. (Courtesy Arizona Historical Society, #4155.)

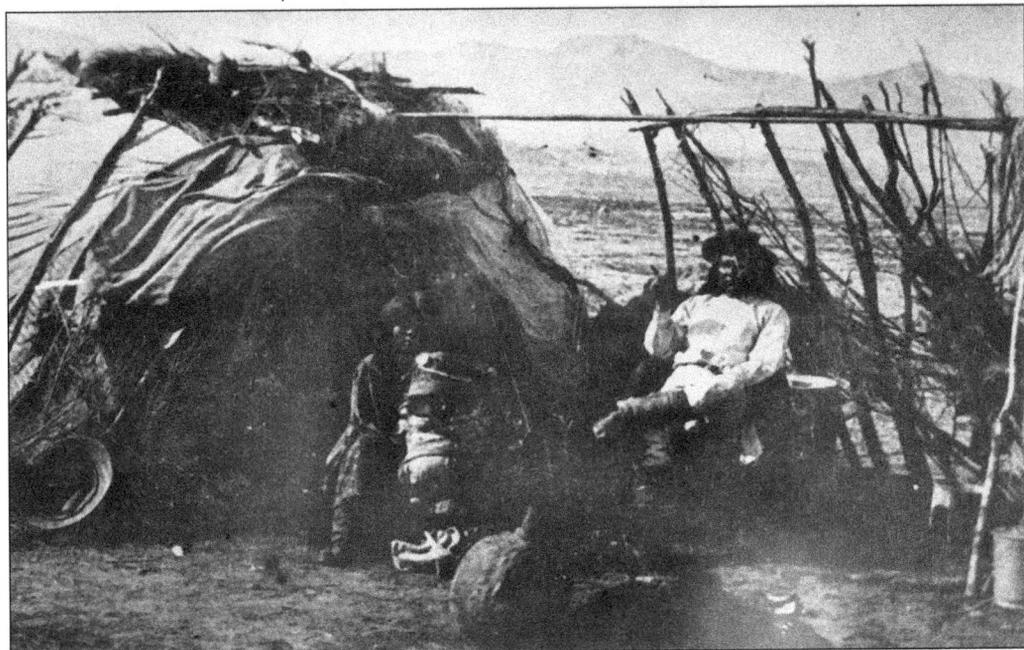

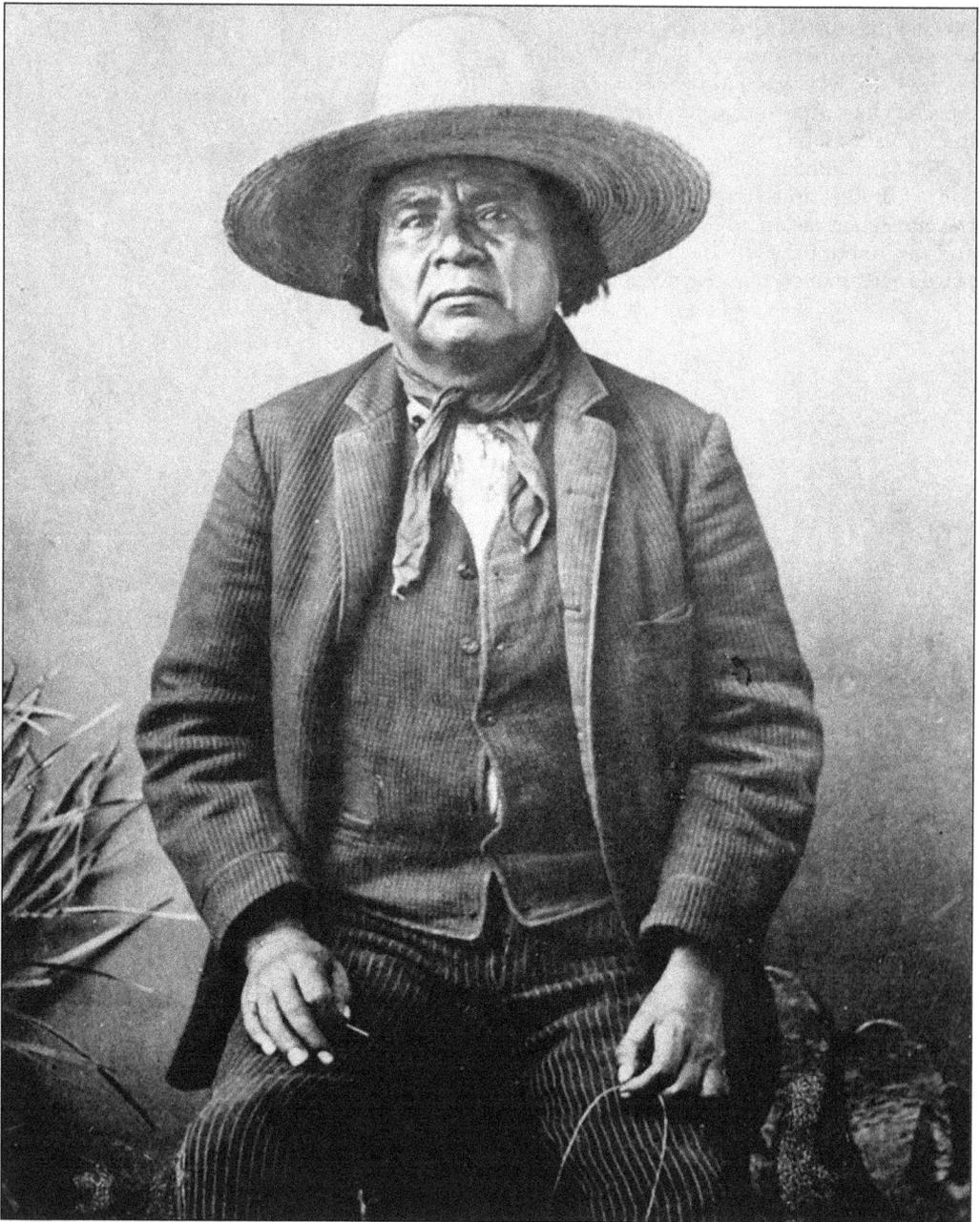

Aravaipa Apache chief Eskiminza and his warriors had the most devastating effect on the Oro Valley pioneers. Frustrated and angry over the multiple attacks of the Apaches on supply trains and homesteads, a group of Tucson vigilantes planned their own raid. To ensure the surprise attack, the vigilantes posted runners on the Oro Valley route to stop any travelers from warning the Apaches. The retaliatory vigilante attack took place at Camp Grant in 1871 and resulted in the slaughter of 100, mainly women and children. Most of the braves were away hunting. The attack horrified the nation and led to an inquiry by the president of the United States. Months later, members of the vigilante group were brought to trial and acquitted. (Courtesy Arizona Historical Society, #30378.)

Two

THE PIONEERS

In 1874, German immigrant George Pusch founded his cattle ranch in the wild, uninhabited area north of the town of Tucson and on the banks of a running wash called the Cañada del Oro. Water for the ranch was supplied by a steam pump, one of only two in the territory. This mechanical wonder earned the ranch its name—the Steam Pump Ranch. George, a butcher by trade, had ambitions of becoming a big cattle baron, but the rugged, mountainous territory proved to be impossible cattle land. George soon found he was making more money selling water to travelers than he was selling beef.

The Pusch family kept the Steam Pump as a convenient stop on their trips from their town home in Tucson to their other ranch in Aravaipa. The Steam Pump also served as a vacation spot for family and friends. The Pusch's oldest child, Gertrude Pusch Zipf, loved the ranch and spent as much time there as she could, often bringing her two sons Frank and Henry "Hank" along to enjoy the freedom of the ranch. Hank Zipf and his dad would go into the Santa Catalina Mountains looking for the legendary mine known as the Mine with the Iron Door.

The ranch house had a cellar where canned goods and apples were stored. Hank remembers it well. "We used to go down and swipe that stuff. My mother told me that they kept a snake down there, a king snake to get the mice. One night they were having a party and the snake came slithering across the floor and somebody reached out with a butcher knife and cut it right in half."

After George Pusch died, the ranch was sold to Jack Proctor, manager of Tucson's Pioneer Hotel. Proctor's daughter and son-in-law, Hank Leiber, lived on the Steam Pump Ranch. Before retiring to Tucson, Hank Leiber had been a well-known baseball player for the New York Giants and the Chicago Cubs, but too many balls to the head forced his early retirement.

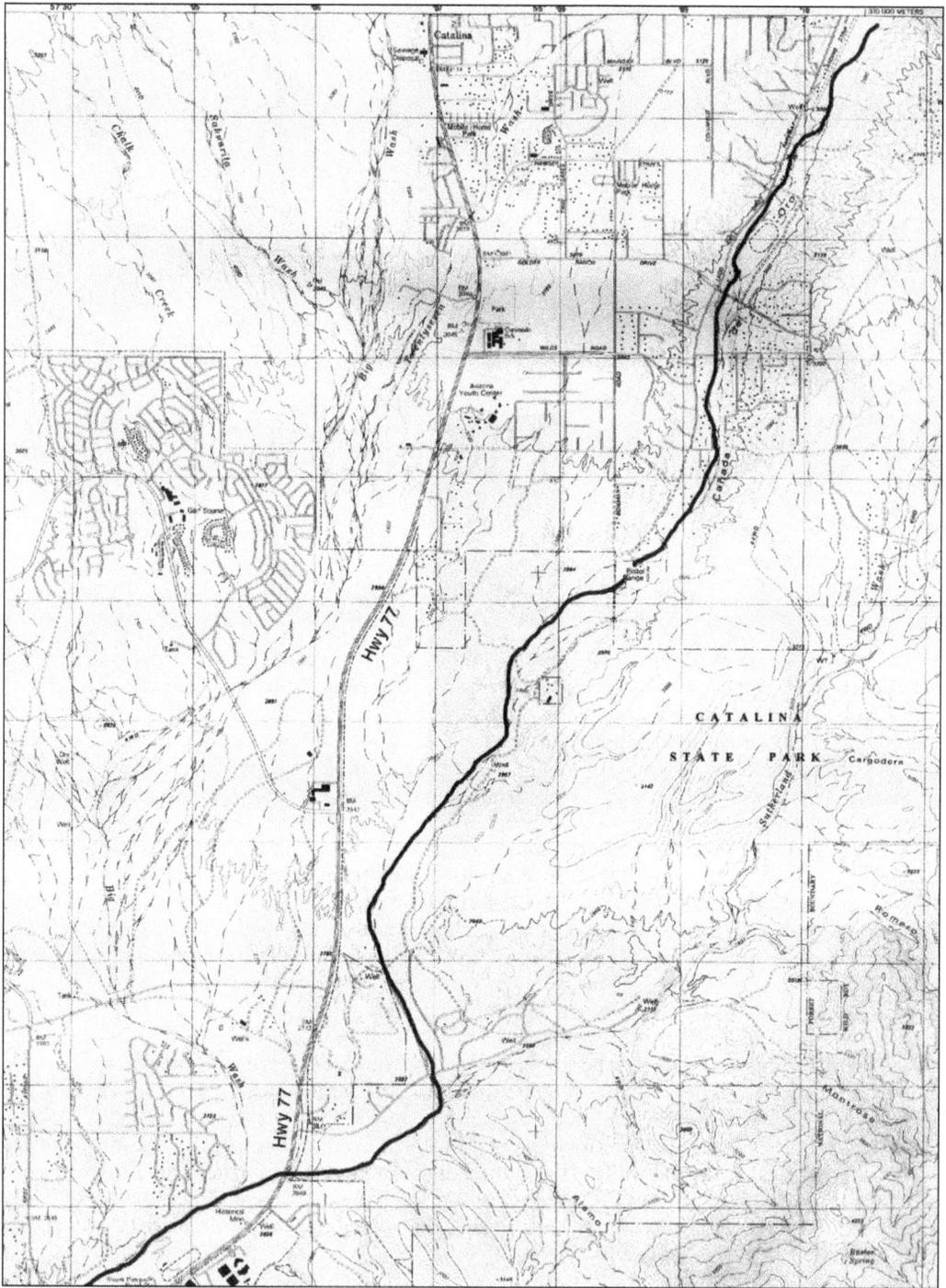

The Cañada del Oro starts its journey at an altitude of 9,000 feet on Santa Catalina's Mount Lemmon. Working its way down the western slope of the mountain, it bisects Oro Valley. The waters once ran 9 to 12 months of the year. Today the Cañada del Oro runs only a few days after a monsoon. This abundant water, plus the lush grazing land and cooler temperatures, lured early pioneers. (Courtesy author.)

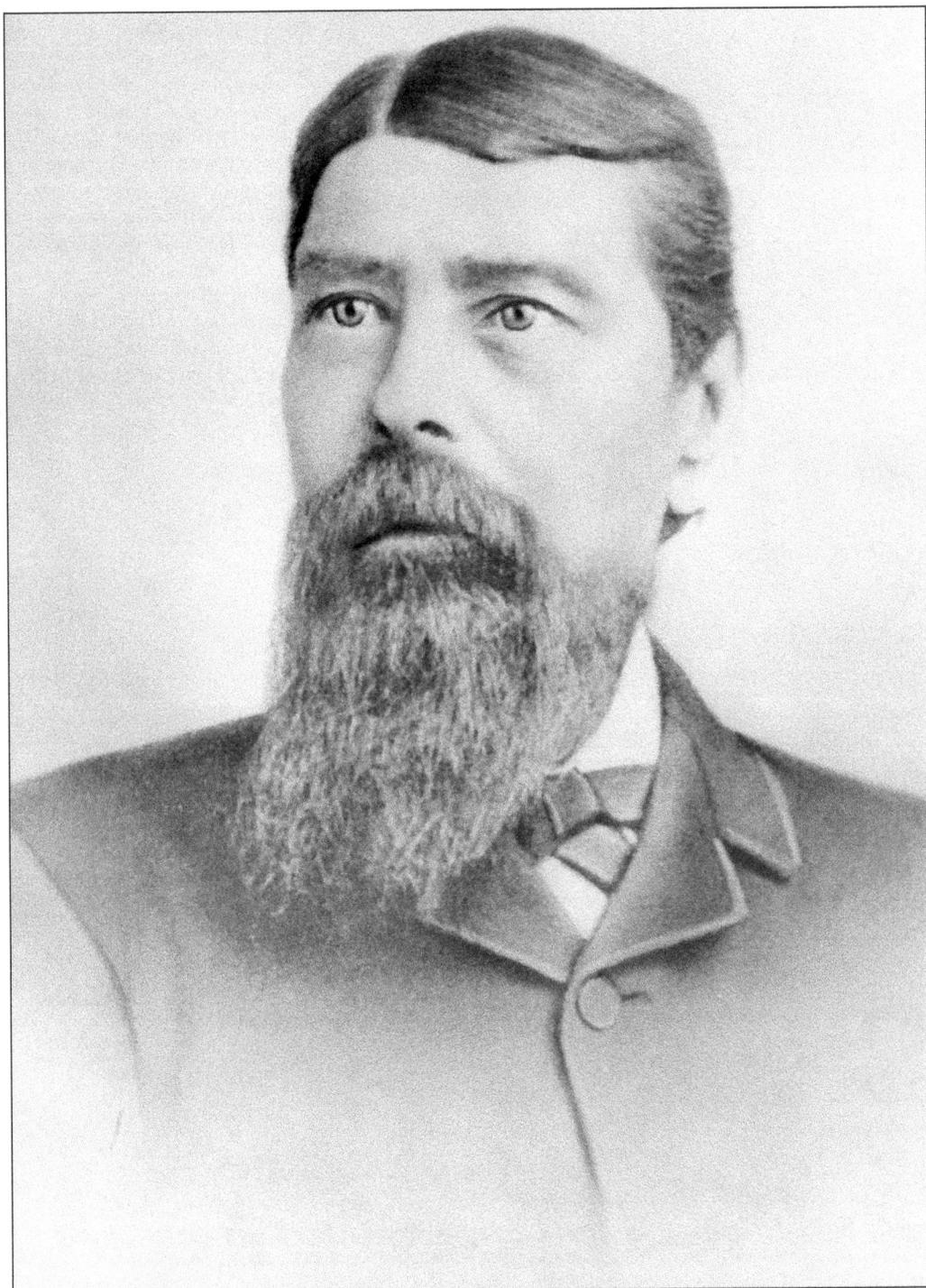

One of the first homesteads of Oro Valley land was at the base of the Santa Catalina Mountains. In the mid-1800s, Francisco Romero located his ranch near the Cañada del Oro. This was Apache land, and constant raids by the Apaches eventually forced him and his wife, Victoriana, to give up their ranch and return to Tucson. (Courtesy Arizona Historical Society #27340.)

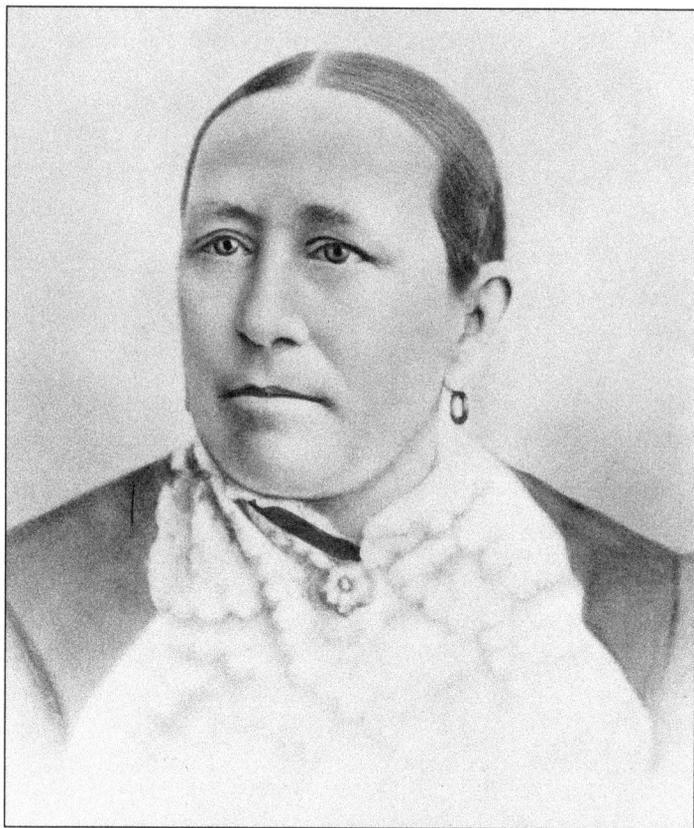

Victoriana Ocoboa Romero was a touch pioneer who fought next to her husband against the Apache raiders, but their herd of 30 head was constantly depleted by the raids. After several years of fighting a losing battle, the arrow-scarred Francisco and his wife gave up the ranch and returned to Tucson to raise a family. (Courtesy Arizona Historical Society #27339.)

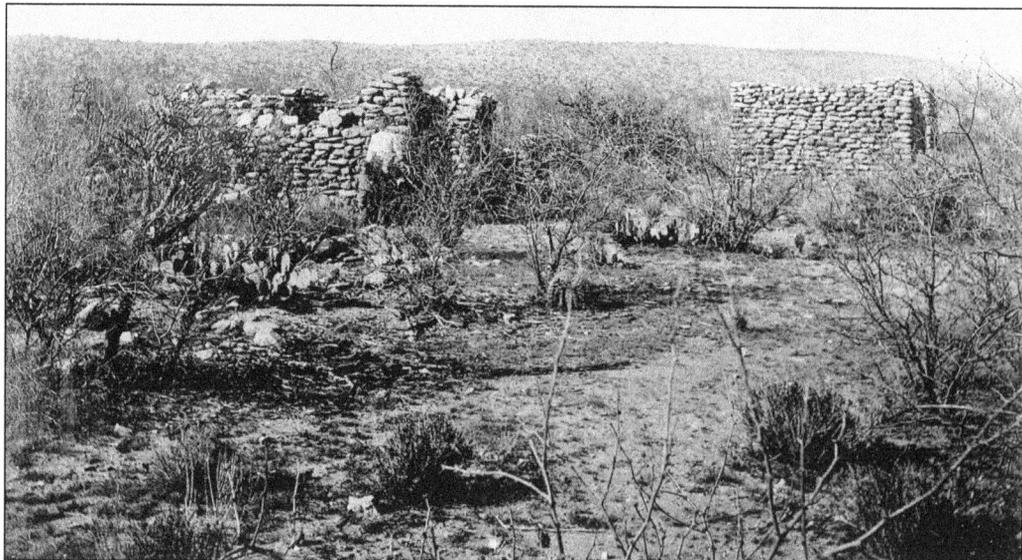

In 1910, all that remained standing of the Romero Ranch were some broken walls. A stone wall originally enclosed several structures. One had two rooms, while the other three had only one room each. Romero, a fourth-generation Tucsonan, found a nice mound for a foundation. The fact that this mound was the ruins of an ancient Hohokam site bothered Francisco not at all. (Courtesy Arizona Historical Society, #5471.)

24

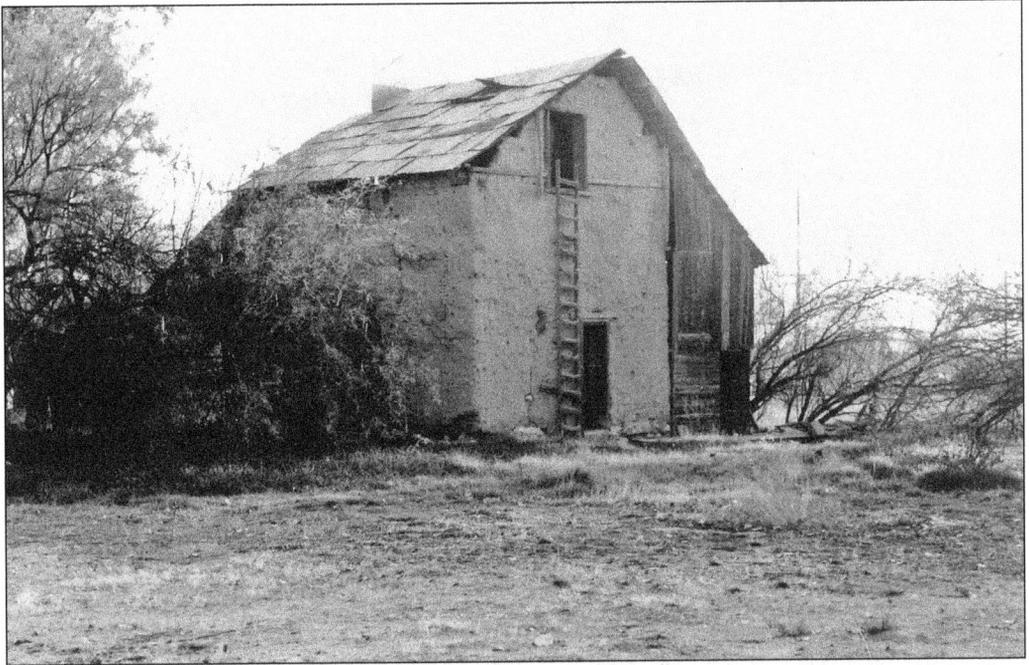

In 1874, the young German immigrant George Pusch established a ranch on the Cañada del Oro. He and his partner, John Zellwager, purchased a steam pump to access the water. The pump was one of only two in the Arizona Territory and was housed in this special adobe building. Its novelty earned the ranch the name the Steam Pump Ranch. (Courtesy Oro Valley Historical Society.)

These portraits of the Puschs were taken in the 1900, years after their marriage in 1879. When they met, Mathilda Feldman was in Arizona Territory visiting her German childhood friend Sophia Spieling, who later became Mrs. John Zellwager. In 1883, George obtained sole ownership of the Steam Pump Ranch. (Courtesy Oro Valley Historical Society.)

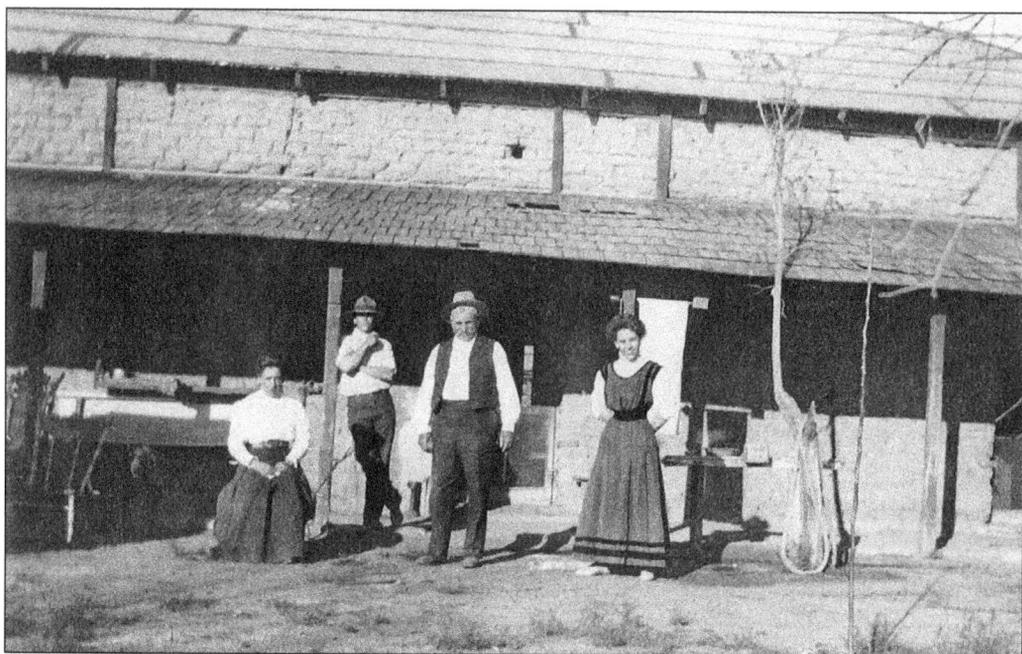

George and Mathilda had eight children; six lived to adulthood. About 1900, part of the family posed in front of their house at Steam Pump Ranch. Mathilda is seated on the left. The suave young man leaning against the post is George Jr. George Sr. is standing next to his oldest child, his daughter Gertrude. (Courtesy Oro Valley Historical Society.)

Always in the background of ranch life were the magnificent Santa Catalina Mountains. In this photograph taken in the early 1900s—before modern roads, shopping centers, and upscale housing—Pusch Ridge looks isolated and imposing. This section of the Santa Catalina Mountains was named after one of the first pioneer families. (Courtesy Simon Herbert, Pima County Culture Resources.)

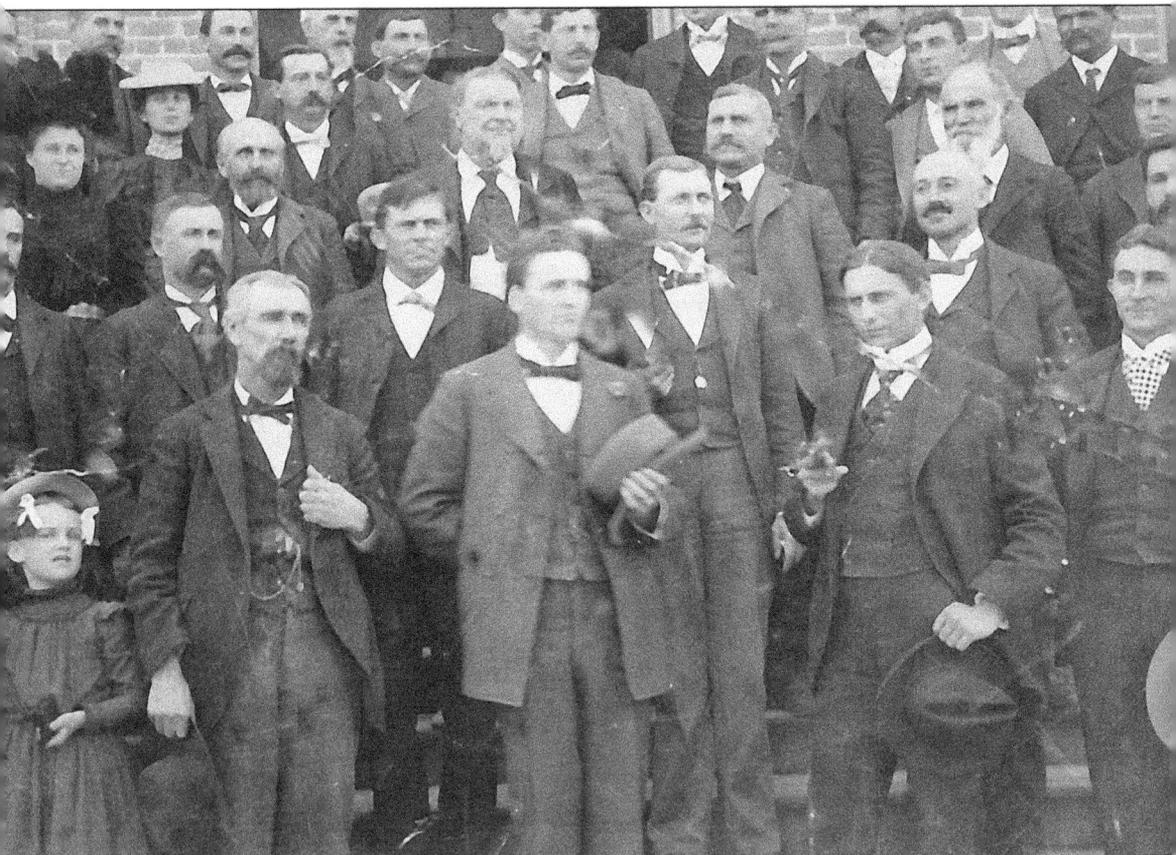

George was a robust man and a brilliant businessman. He was well respected in the Tucson community and was elected to the several Arizona Territory legislatures. Second from right in the third row is a proud George Pusch standing with his fellow legislators and some friends. (Courtesy Oro Valley Historical Society.)

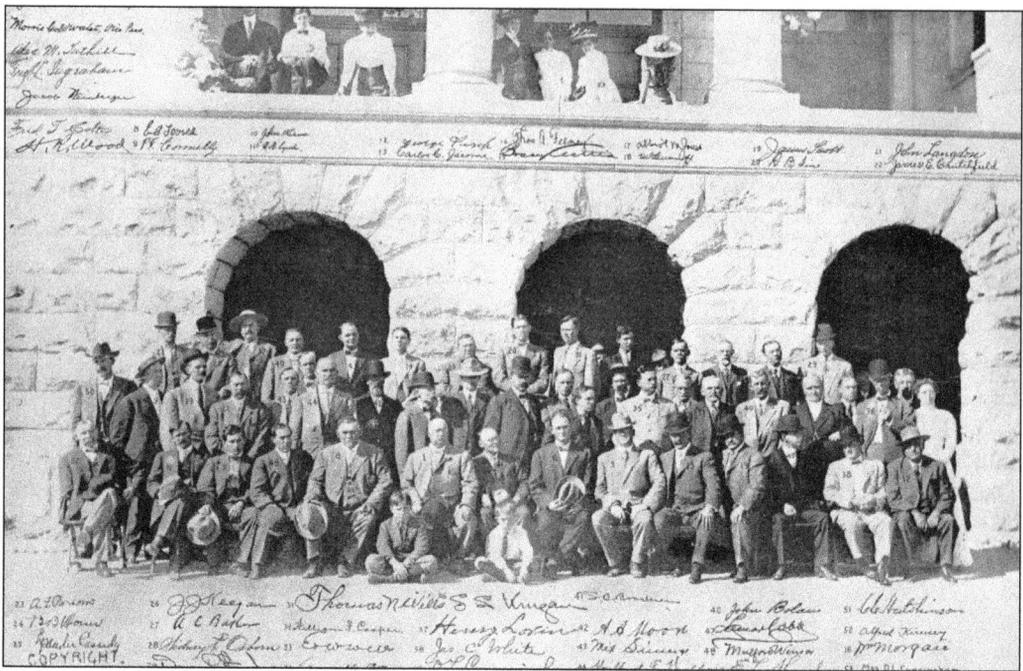

George Push Sr. was one of the representatives from Tucson to the 1910 Constitutional Convention when the Arizona Territory was in the process of acquiring statehood. A staunch Republican, he fought the powerful Democratic block from Phoenix and along with other Tucsonans refused to sign the final document. (Courtesy Oro Valley Historical Society.)

Standing Committees

For Conducting Convention

1. *Rules and Procedure.* Chairman WINSOR, Bolan, Franklin, Goldwater, Doe.
2. *Finance, Accounts and Expense.* Chairman WOOD, Cobb, Jones (Maricopa).
3. *Printing and Clerks.* Chairman SHORT, Jones (Maricopa), Cooper.

For Constitution Making

1. *Preamble and Declaration of Rights.* Chairman CRUTCHFIELD, Connelly, Morgan.
2. *Legislative Department, Distribution of Powers and Apportionment.* Chairman WINSOR, Cassidy, Baker, Cunniff, Coker, Colter, Feeney, Morgan, Roberts, Simms (Graham), Webb, Weinberger, Curtis.
3. *Executive, Impeachment and Removal from Office.* Chairman WEINBERGER, Cassidy, Cunningham, Franklin, Short, Sims (Cochise), Bradner, Wood, Jones (Yavapai).
4. *Judiciary.* Chairman CUNNINGHAM, Baker, Ingraham, Ellinwood, Weinberger, Lynch, Franklin, Parsons, Goldwater, Wood, Doe, Kingan, Crutchfield.
5. *Suffrage and Election.* Chairman JONES (Yavapai), Cobb, Osborn, Kinney, Ingraham, Lovin, Moeur, Tovrea, Scott, Langdon, Orme.
6. *Counties and Municipalities.* Chairman SIMS (Cochise), Colter, Baker, Feeney, Moeur,
7. *Education and Public Institutions.* Chairman MOEUR, Bolan, Kinney, Hutchinson, White.
8. *State and School Lands.* Chairman COKER, Jones (Yavapai), Simms (Graham), Orme, Cunningham.
9. *Public Service Corporations Other than Railroads.* Chairman INGRAHAM, Parsons, Jones (Maricopa), Kinney, Lynch, Moeur, Wills, Langdon, Pusch. X
10. *Private Corporations and Banks.* Chairman ROBERTS, Keegan, Goldwater, Ellinwood, Tuthill, Tovrea, Winsor, Curtis, Wells.
11. *Railroads.* Chairman JONES (Maricopa), Cunniff, Ellinwood, Bradner, Connelly, Short, Jacome.
12. *Agriculture, Irrigation and Water Rights.* Chairman ORME, Colter, Coker, Simms (Graham), Moore.
13. *Mines and Mining.* Chairman COBB, Cunniff, Feeney, Lovin, Short.
14. *Federal Relations.* Chairman PARSONS, Standage, Wells.
15. *Militia and Public Defense.* Chairman TUTHILL, Osborn, Standage.
16. *Public Debt, Revenue and Taxation.* Chairman KEEGAN, Wills, Webb, Wood, Ellinwood, Osborn, Moore, Lovin, Roberts, Standage, Pusch, Scott, White. X
17. *Labor.* Chairman BOLAN, Bradner, Morgan, Feeney, Cooper.
18. *Schedule, Mode of Amending and Miscellaneous.* Chairman COLTER, Connelly, Tuthill, Jacome, Kingan.
19. *Ordinance.* Chairman GOLDWATER, Crutchfield, Hutchinson.
20. *Matters for Separate Submission.* Chairman WILLS, Franklin, Webb, Tovrea, Keegan.
21. *Style, Revision and Compilation.* Chairman CUNNIFF, Ingraham, Cassidy, Lynch, Weinberger.

An announcement of the standing committees in the Constitutional Convention lists such names as Barry Goldwater, William Cooper, and Carlos C. Jacome. George Pusch was a member of the Public Service Corporation Committee and the Public Debt, Revenue, and Taxation Committee. He found his appointment to the Constitutional Convention both frustrating and aggravating. (Courtesy Oro Valley Historical Society.)

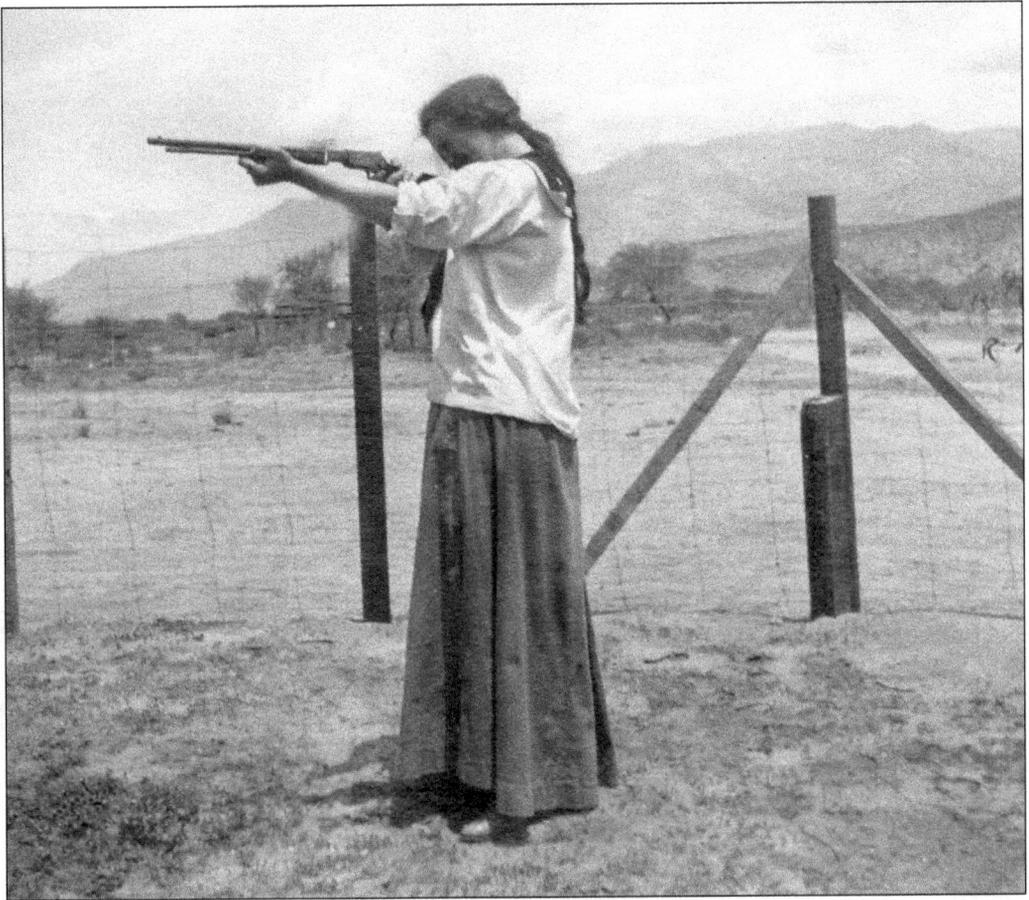

Ranch life on the frontier could be harsh, and anyone who lived on a ranch where wildlife was still hunted needed to know the fine art of shooting. Early in 1900, one of the Pusch girls practices her marksmanship against a background of the Santa Catalina Mountains. (Courtesy Oro Valley Historical Society.)

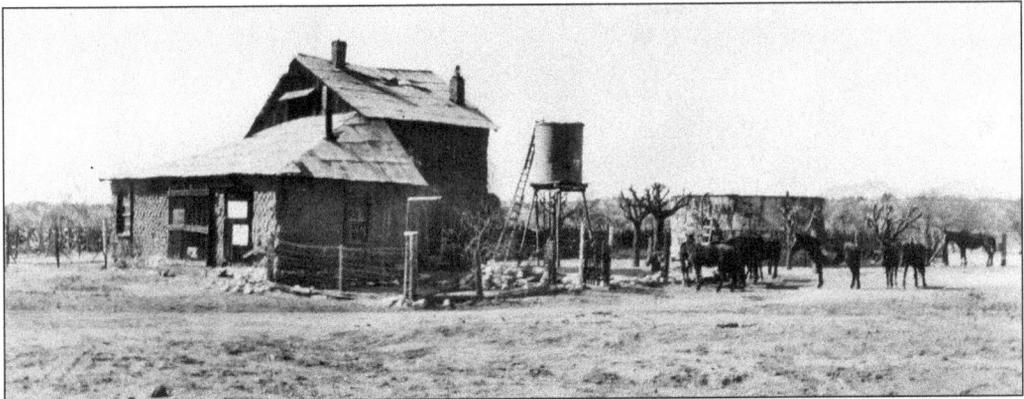

The steam pump building was an icon of old Oro Valley ranching life. The adobe building was once a functional part of the ranch, but in later years it all but disappeared, leaving only a few pieces of metal roof and the stubble of crumbing adobe walls as a reminder of the great ranching days of the Steam Pump Ranch. (Courtesy Oro Valley Historical Society.)

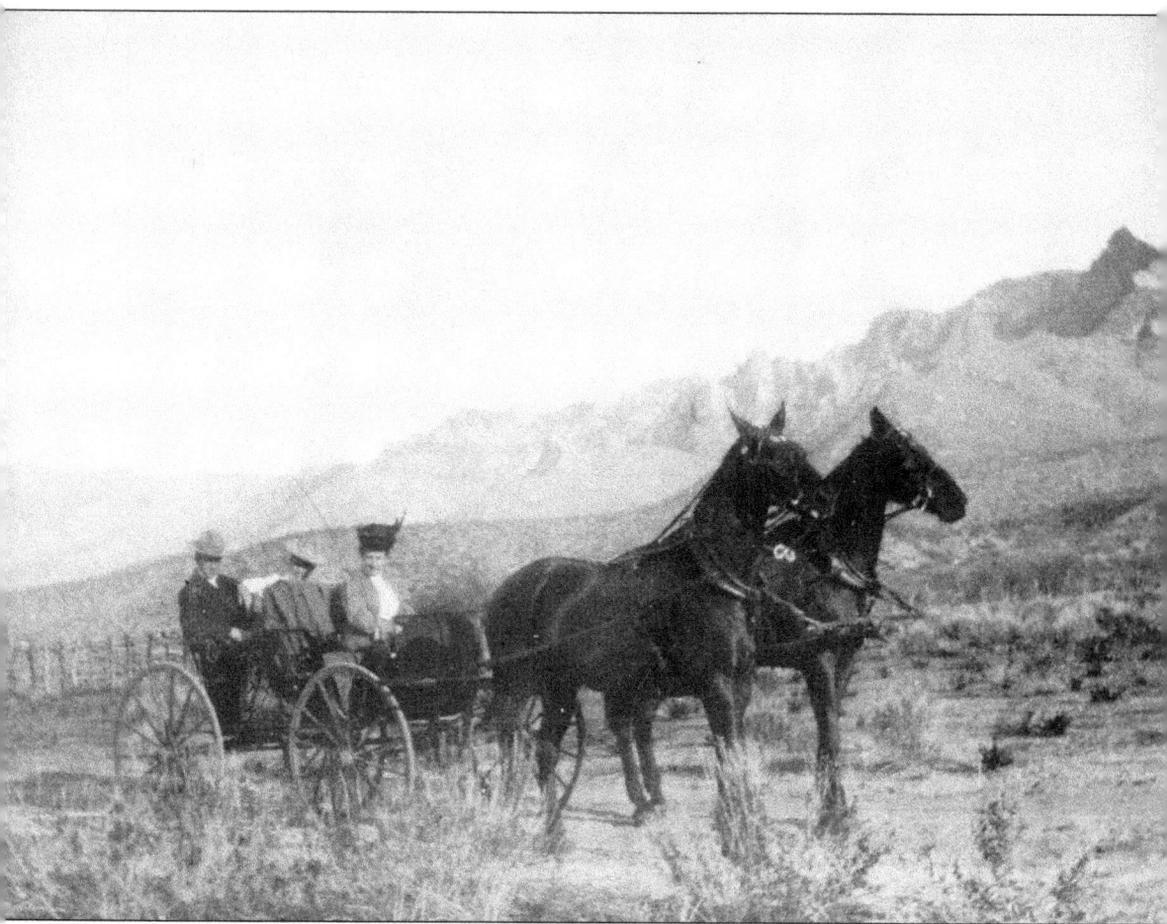

In 1890, a buggy ride along the base of Pusch Ridge was an event. Pusch Ridge and Pusch Peak were northern landmarks for people traveling north from Tucson. Roads south to Tucson and north to Florence were no more than wide dirt paths. This fine equipage was traveling in style and the Pusches were dressed in their best for the occasion. (Courtesy Oro Valley Historical Society.)

Cowboys liked nothing better than showing off their ranch skills. Whenever they could take a break from work, they would put on an exhibition of their skills, better known as a rodeo. Here some Steam Pump cowpunchers show off their talents. Ranch work in the early 1900s was basically the same as it is today—eating dust and working with stubborn cattle. (Courtesy Oro Valley Historical Society.)

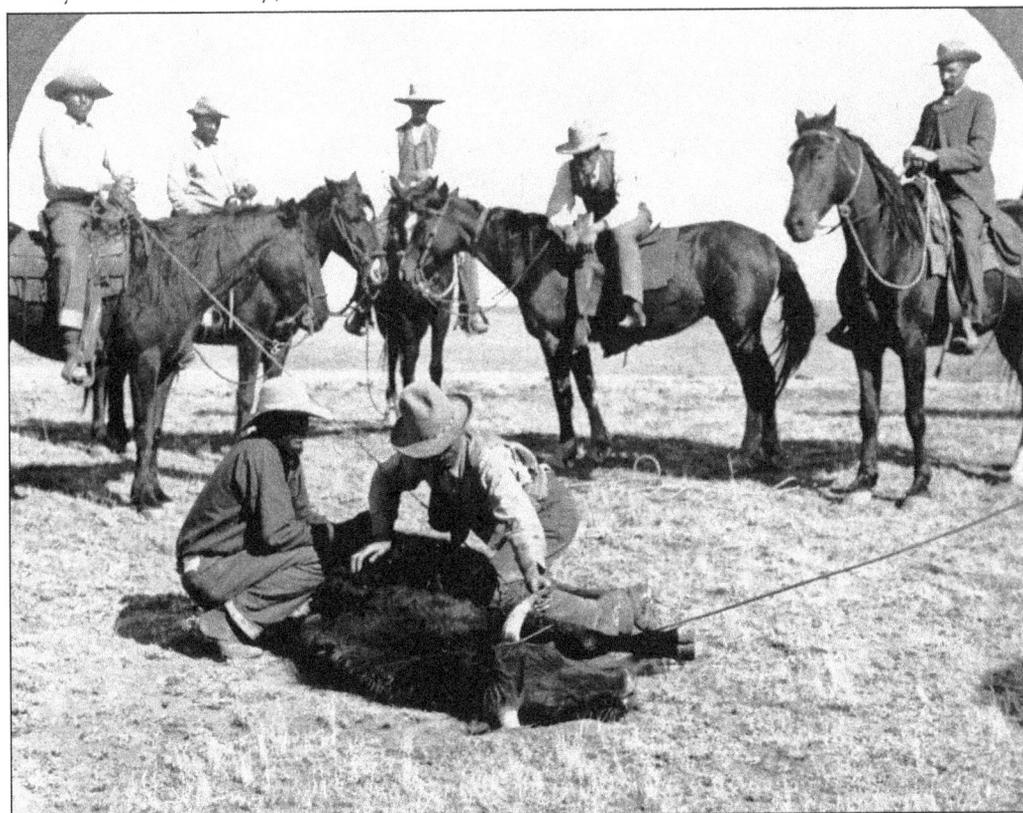

Branding, tagging, and dehorning cattle were all part of ranch life. It took more than one rope to tie down the cattle, and all ranch hands knew their way with the lariats. In this 1900 ranch shot, one can see the ropes on the legs and the head—the practical skill that is known as the team roping event in rodeos. (Courtesy Arizona Historical Society, #52047.)

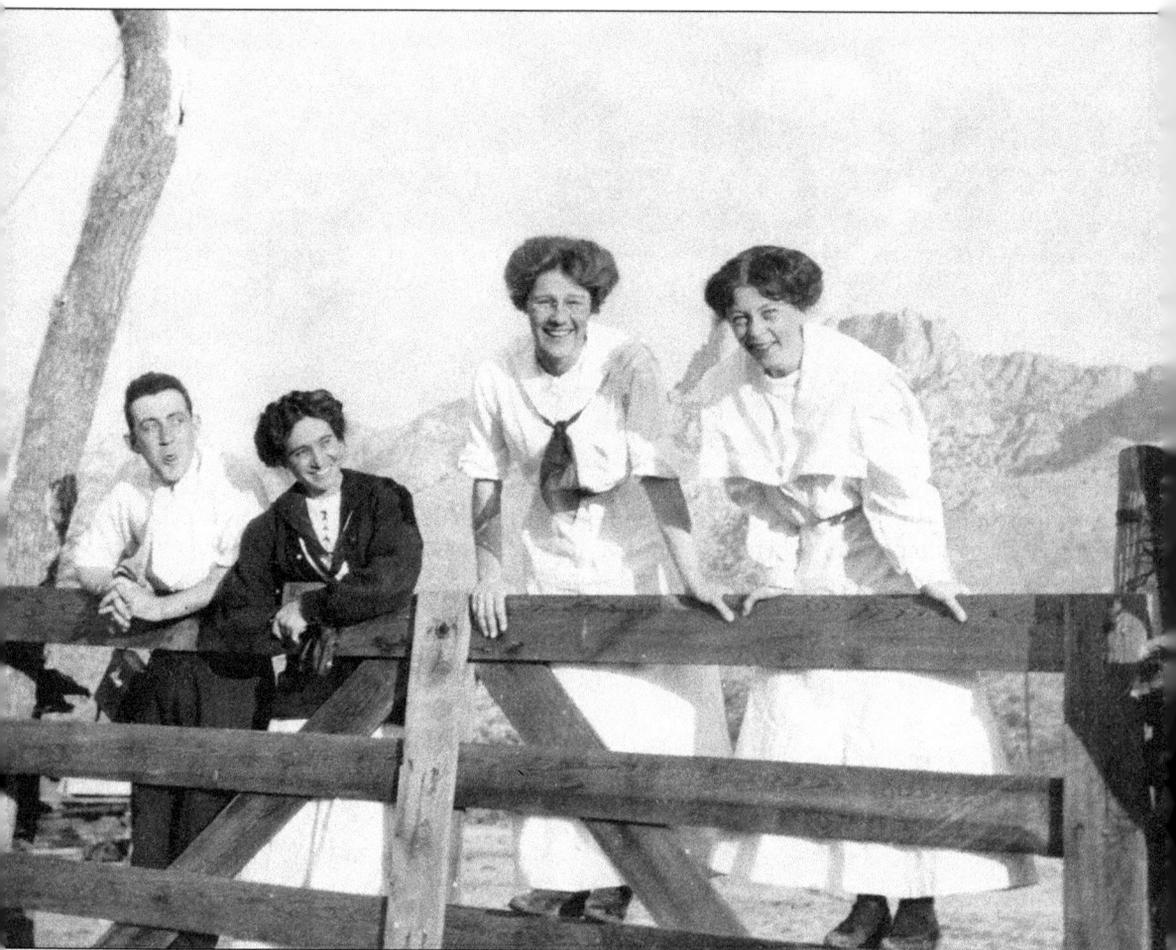

Gertrude Pusch, George's oldest child, loved the Steam Pump Ranch. After her family moved to Tucson, she always found reasons to invite her friends for a visit to the ranch. Her circle of friends who visited the ranch increased when she attended the University of Arizona in 1900. (Courtesy Oro Valley Historical Society.)

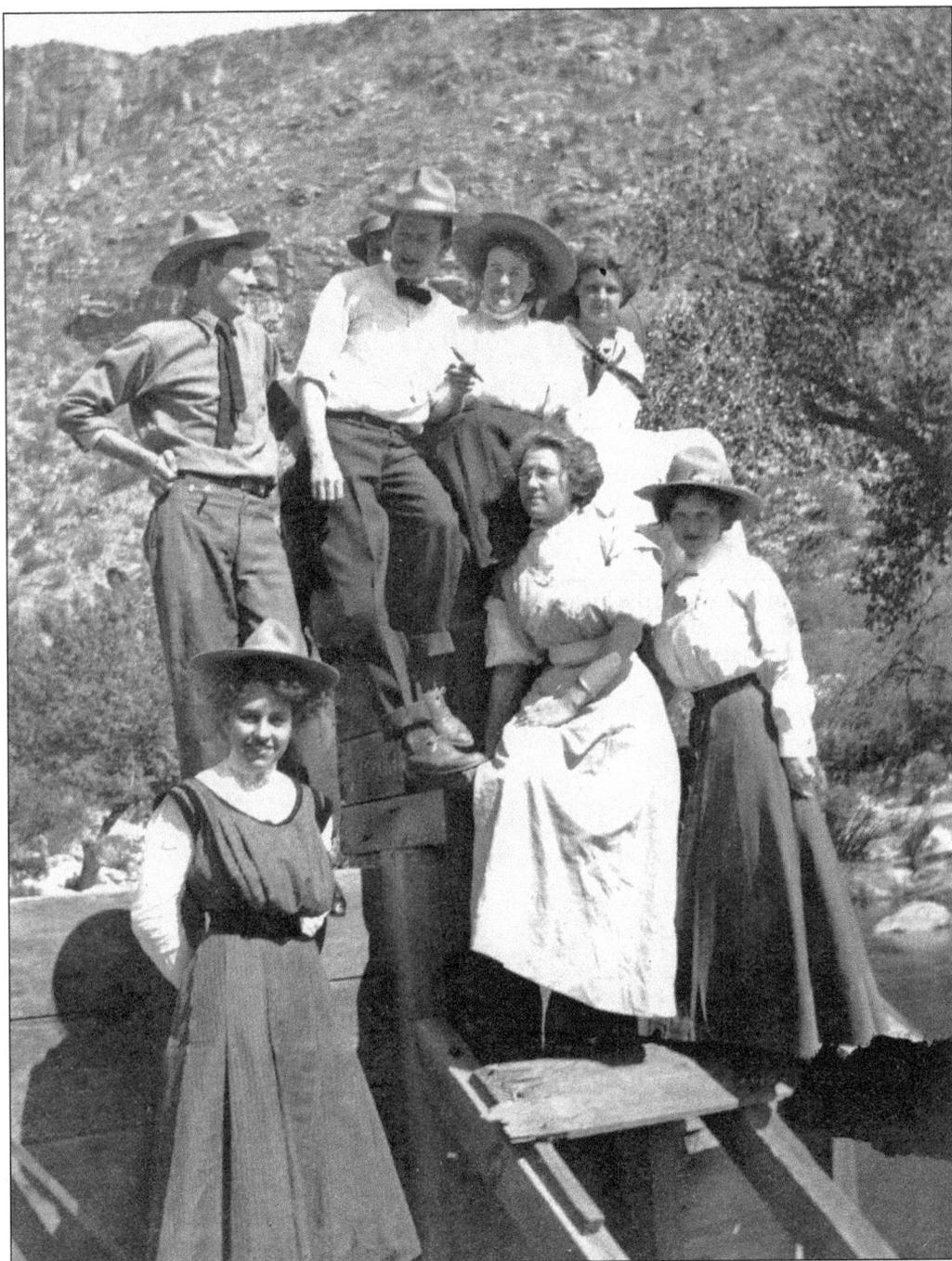

Whether it was swinging on the front gate with Pusch Ridge in the background or piled atop a piece of ranch equipment, Gertrude delighted in snapping her friends at play at her favorite spot. With everyone piled high and precariously above her, Gertrude, on the left, stayed grounded. (Courtesy Oro Valley Historical Society.)

Because of its abundant water, the Steam Pump Ranch was a stopping-off place for cattle drives, stagecoaches, and U.S. Cavalry troops. On September 4, 1888, at 7:15 a.m., a troop on patrol left Fort Lowell and headed north. Their first stop was at 11:15 a.m., when they arrived at the Steam Pump for water. (Courtesy author.)

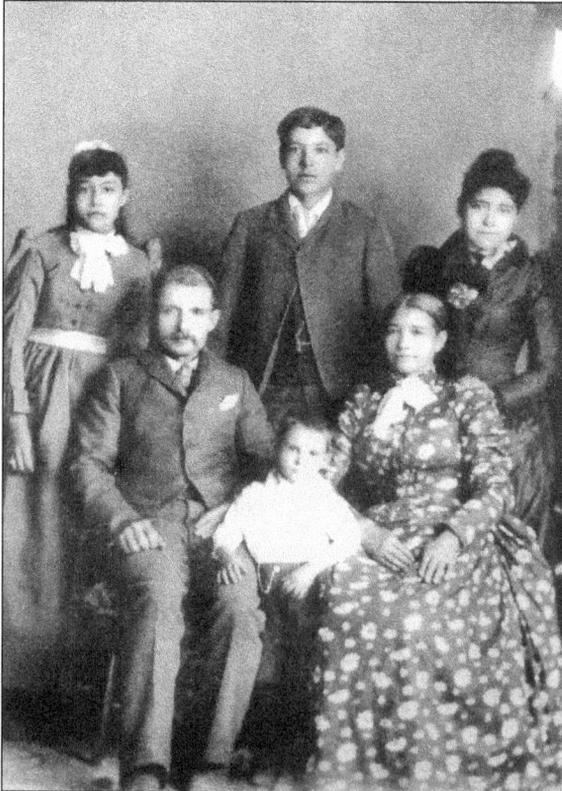

This picture was taken between 1890 and 1892, when Henry Smith was the foreman at the Steam Pump Ranch. He and his family lived on the ranch. Charles Smith is seated between his father, Henry, and his mother, Isabella Gomes Smith. Standing, from left to right, are Mary Victoria, Henry, and Isabella Catharina. (Courtesy Isabella Machado.)

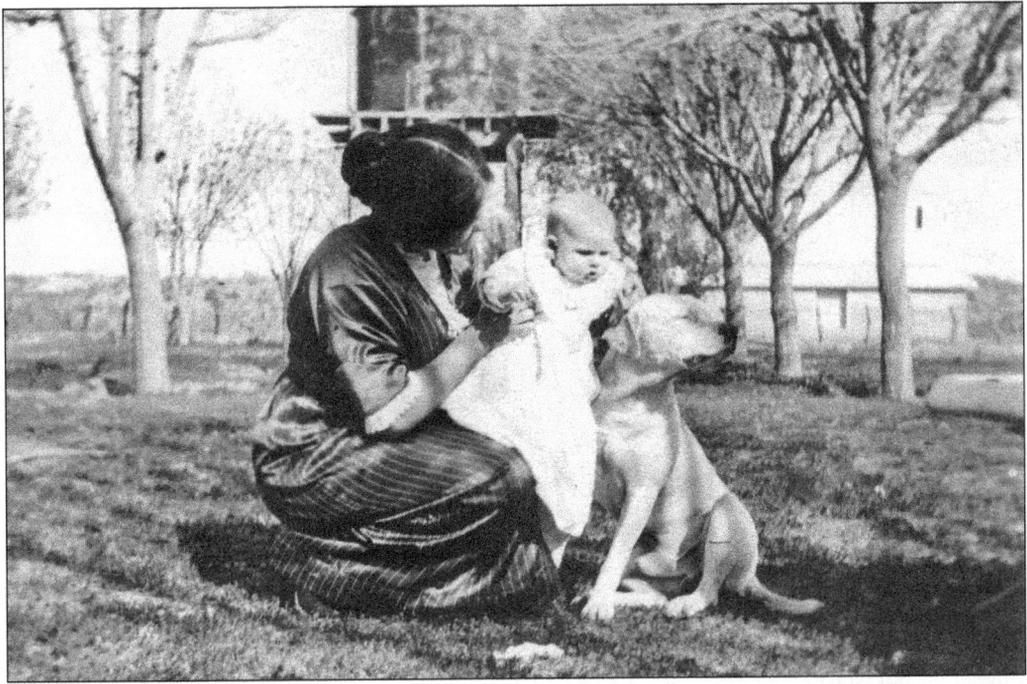

The Steam Pump was a good place to bring up a family in the early 1900s. Mathilda Pusch and one of her children take time to enjoy a grassy patch on the ranch, but the young Pusch was more interested in the ranch dog lying in the dirt. (Courtesy Oro Valley Historical Society.)

The original ranch house that George Pusch built was fashioned from adobes made from soil dug out of the surrounding hills. Mexicans crafted the house with 24-inch walls and a porch front. A hog-wire fence enclosed the yard and the outdoor wooden shower. (Courtesy Oro Valley Historical Society.)

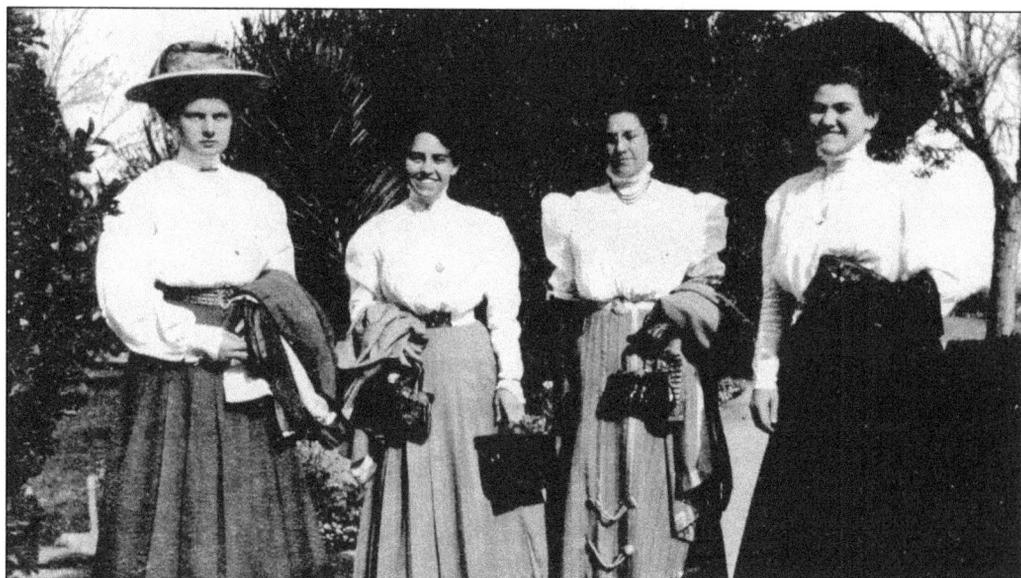

A bevy of Gibson Girls from the University of Arizona, including Gertrude Zipf (second from left), show off their finery on a visit to the ranch. The Gibson Girl style was popular in the early 1900s—the nipped-in waist, billowing shirt tops, and low boots were the fashion rage, even in the wilderness of Oro Valley. (Courtesy Oro Valley Historical Society.)

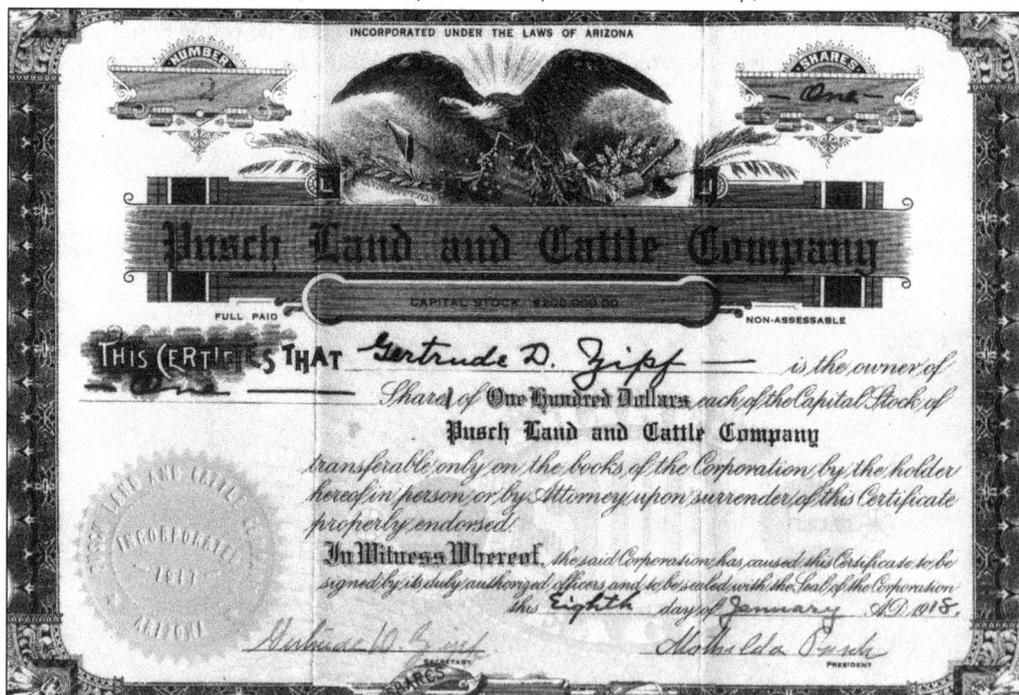

In 1917, the Pusch family gathered to make decisions about the Pusch businesses. In addition to two ranches, the Pusch Company owned a butcher shop, an icehouse, and other investments in Tucson. The family incorporated and issued stock. The board of directors was Mathilda (president), George Jr. (vice president), and Gertrude Pusch Zipf (secretary and treasurer). (Courtesy Oro Valley Historical Society.)

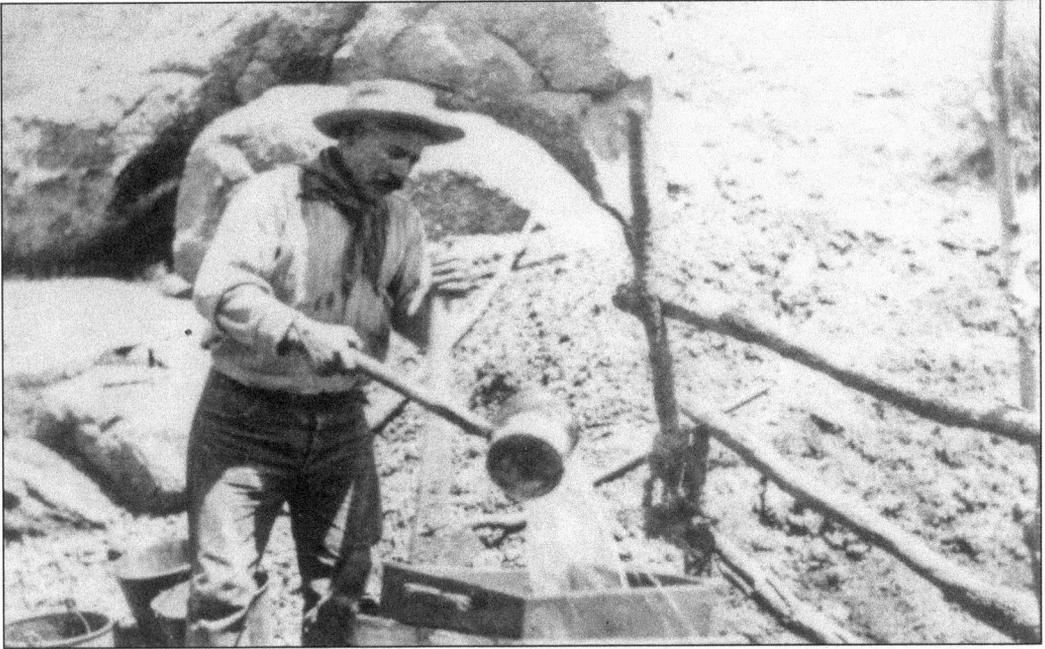

The lure of California gold brought prospectors traveling west. Some tried their luck in the Santa Catalina and Tortolita Mountains. Prospectors who found some color and staked a claim discovered that sluicing proved to be the best way to get the gold. Sluice boxes could be found near their claim sites. (Courtesy author.)

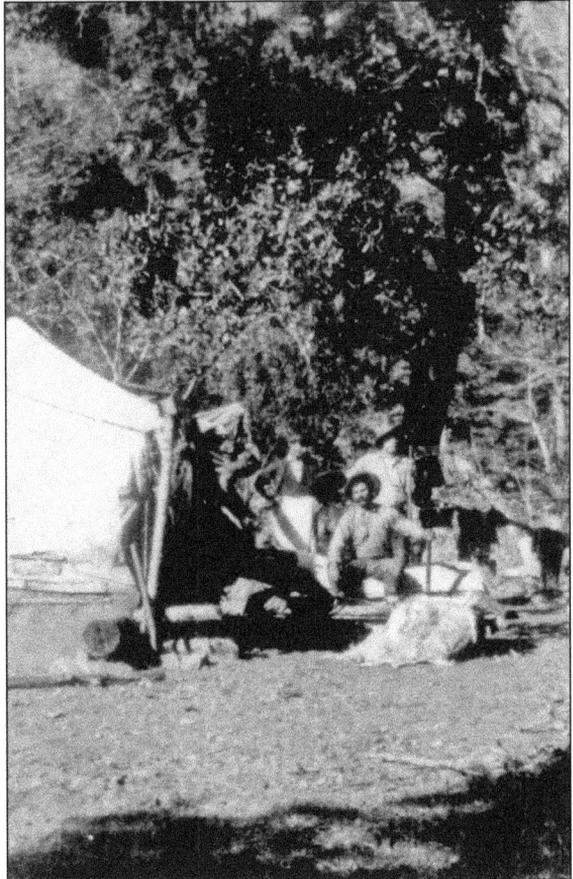

If the claim showed promise, the prospectors made themselves comfortable and lived in luxury in a wooden-floor tent with outdoor cooking facilities. Big tin cans became their stew pots, and the coffee was always on. These prospector tent sites dotted the Oro Valley Mountains. (Courtesy author.)

From its earliest days the valley between the Santa Catalina and the Tortolita Mountains was used as a major traveling route in all directions. Several stagecoach lines had regular runs through Oro Valley land, including the Arizona State Coach line, owned by William Sutherland. (Courtesy Arizona Historical Society, #52039.)

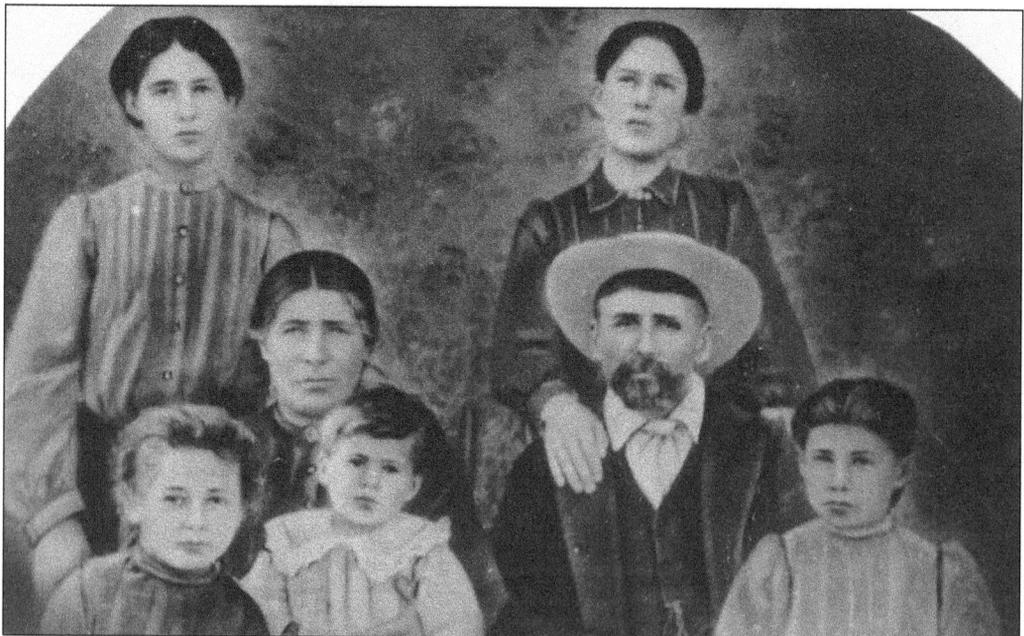

Francisco Marin, with his family in the late 1800s, owned several stage stops. One of the most used was at the base of what is now Marin Hill, in the foothills of the Santa Catalina Mountains. It was a horse-changing stop on the Tucson-to-Oracle run. (Courtesy Edward Montano.)

Three

THE SETTLERS

The 20th century was still in its infancy when the adventuresome and bold began their migration to what would be called the town of Oro Valley. Some came to start a more promising life, such as William and Matilda Sutherland, who came up from Tucson to homestead.

However, most of the new settlers came for their health. Doctors all over the world were recommending the Arizona Territory for its warm, dry climate, which was beneficial to certain physical conditions, including those of heart and lungs.

Francis Hallett Burns, suffering from the effects of mustard gas from his soldier years in World War I, came to Arizona from Sumter, South Carolina. L. H. Rooney, who was diagnosed with polio, arrived from Oklahoma and established his ranch next to the Steam Pump. Catherine Carey Chapman Reidy came because of her heart condition.

While the weather was kind to their physical problems, nature and the government were hard on them. They suffered, fought, and endured droughts, floods, the Depression, Prohibition, and eventually war. They survived because of their determination and innovativeness.

Catherine Reidy used what nature offered in abundance—rattlesnakes. She took wildlife courses at the University of Illinois and the University of Arizona. When times got hard, she started her rattlesnake business. "She did what she had to do to survive the Depression," Roxy Johnson, her daughter, remarked. Dan Reidy, just a small boy at the time, remembers his mother working on the snakes. "She skinned the snakes and made jewelry and clothes. One time the local department store had a whole outfit made by her in its window; skirt, hat, vest, and I think boots. The snakes were brought in from a lot of places, but she got most of them from a family in Oracle. They would bring them in by the truck load. A professor from University of Arizona would come up and milk them, and some she sold to zoos." The snake business helped the Reidys through tough times. That spirit of independence and innovativeness marked the settlers, and it is still alive in Oro Valley.

The man who made the legend of gold in the Santa Catalina Mountains believable was Harold Bell Wright, who wrote about the tale in *The Mine with the Iron Door*. The book, published in 1923, was made into a successful movie. Wright first heard the tale of the lost mine at the Steam Pump Ranch. While sitting in the kitchen, his hostess, Gertrude Pusch Zipf, told him about her visitors the day before. Two prospectors had stopped by the Steam Pump and spun a tale about an old lost gold mine found by the early Jesuit priests and worked by the local Native Americans. When an Apache attack threatened the mine, it was closed with an iron door, and the priests and Native Americans fled, never to return. Over the years, a few prospectors showed up with significant nuggets and even bigger secrets, but the location of their finds was never known, and the legend lived on, given new life by the Hollywood writer Harold Bell Wright. (Courtesy Arizona Historical Society, #24957.)

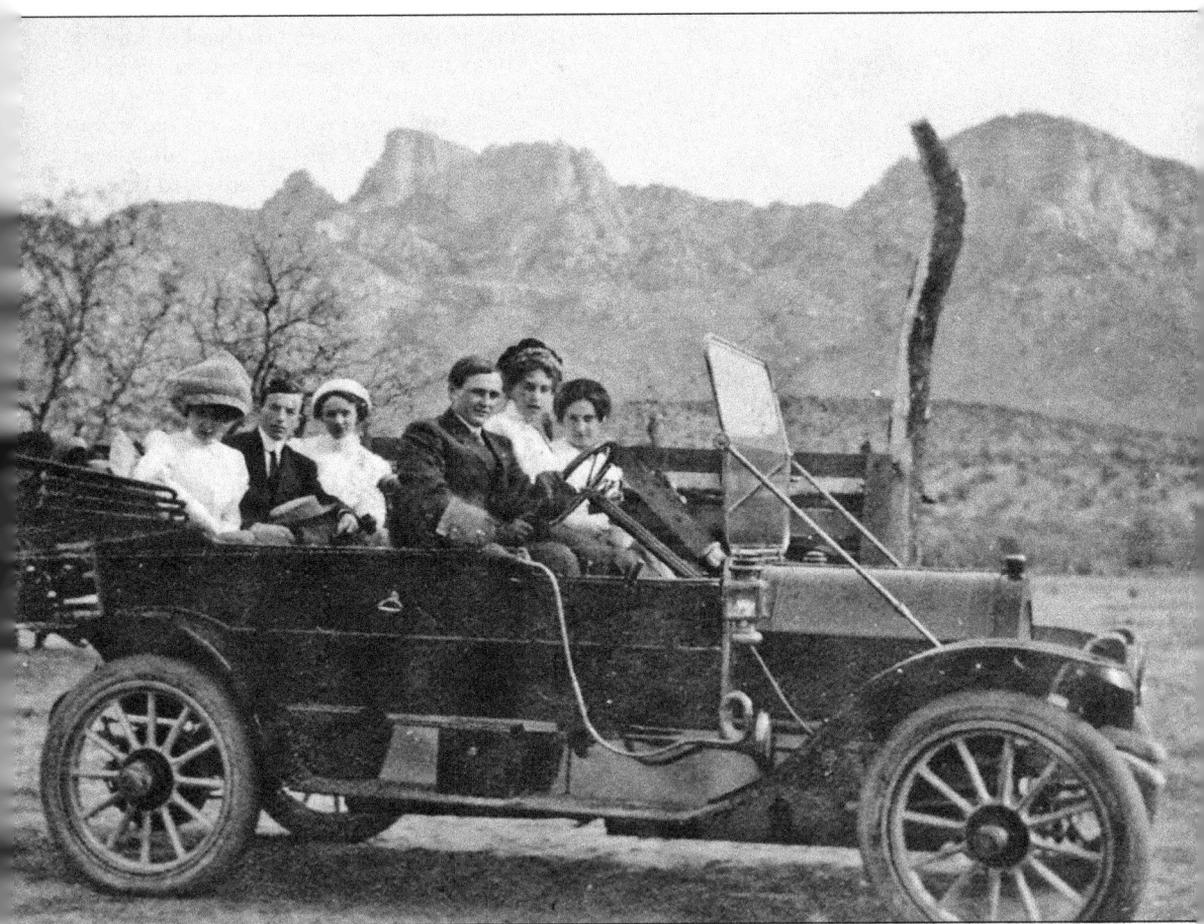

The availability of the automobile made the Santa Catalina area much more accessible. These unidentified visitors to the Steam Pump Ranch ride near Pusch Ridge. Cooler than Tucson, the Oro Valley area was a draw for visitors and for the settlers, who were discovering this undeveloped land. (Courtesy Henry Zipf.)

The mountains were not the only lure for the pioneers and settlers in what would become Oro Valley. Water for cattle, for crops, and for wild animals was a necessity. The Cañada del Oro running full at least nine months of the year provided this necessary commodity. (Courtesy author.)

In 1882, Matilda and William Sutherland filed for homestead sections, which included some of the most beautiful land in the Santa Catalina Mountains. Through their sections ran a small valley for grazing, ancient rocks inscribed with Hohokam petroglyphs, and this wash, which would eventually bear the name of the ranchers, the Sutherland Wash. (Courtesy author.)

William Henry Sutherland was part owner of the Arizona Stage Coach Company. On November 11, 1870, he sold some of his business interests and started a ranch he homesteaded north of Tucson. When he died in 1925, his sons inherited the ranch. (Courtesy William Ray Sutherland family.)

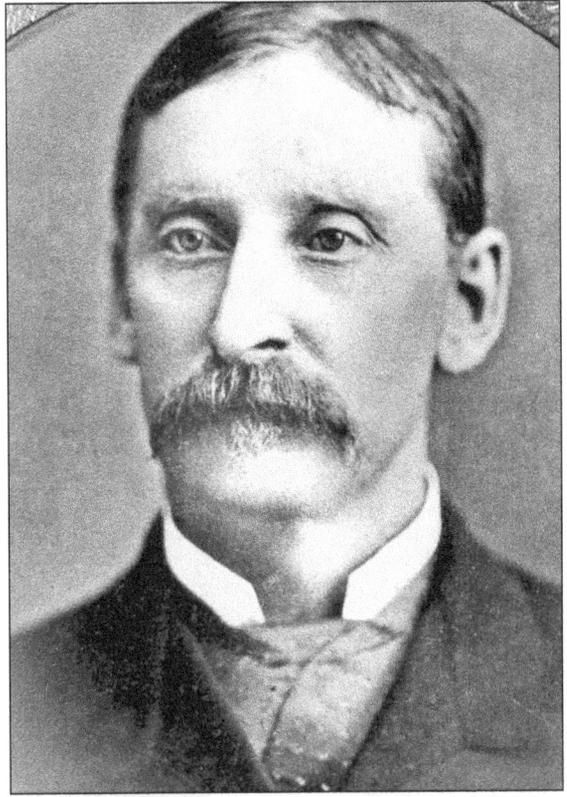

Matilda Sutherland called the ranch the MS. Some time in the early 1900s, this adobe house was built on the ranch. It stood for many years, occupied by the Sutherland men and their families. After John Nelson bought the land, the house eventually became the home of his son, Myron, and his family. (Courtesy William Ray Sutherland family.)

On July 28, 1915, William Ray and his wife, Elsie, entertained a friend at the MS Ranch. Elsie was a true frontier woman. On a trip into Tucson, she interrupted her journey, pulled over to the side of the road, settled in under a mesquite tree, and gave birth to her daughter. (Courtesy William Ray Sutherland family.)

Elsie Sutherland dressed her girls in frilly white outfits. Muriel in her finery is a contrast to the simple adobe building that was typical of ranch houses and their sparse surroundings in the beginning of the 20th century. When the Depression hit, William Ray had to let his ranch go. (Courtesy William Ray Sutherland family.)

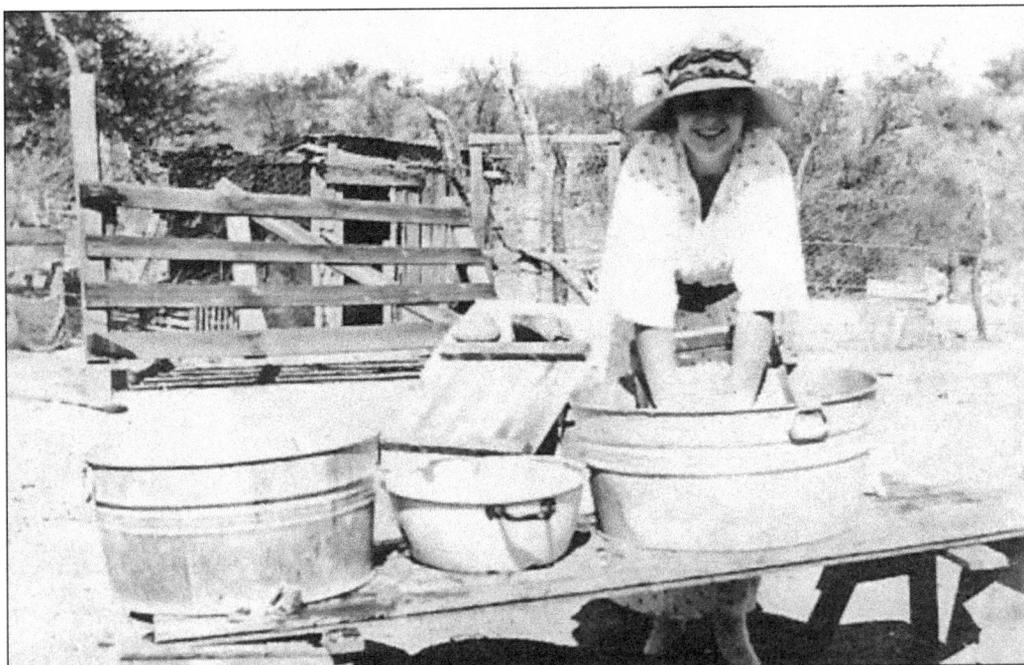

It took a lot of scrubbing in 1915 to keep a little girl in white dresses. Elsie Sutherland put elbow action into her washing tub at the MS Ranch. The right setup included one tub for scrubbing and one for rinsing, as well as the proper attire. (Courtesy William Ray Sutherland family.)

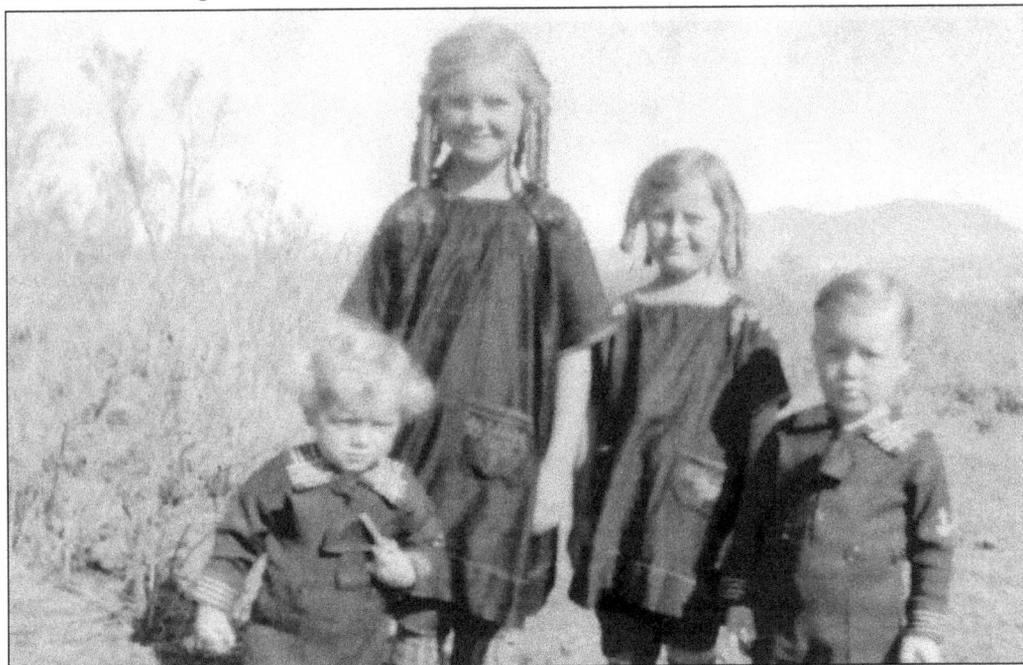

William Ray Sutherland's children stood still for their picture at the MS. Most clothes were homemade, and a bolt of fabric made clothes for several children in the early 1900s. Even store-bought clothes did not have much variety, and little boys in sailor suits were ubiquitous. (Courtesy William Ray Sutherland family.)

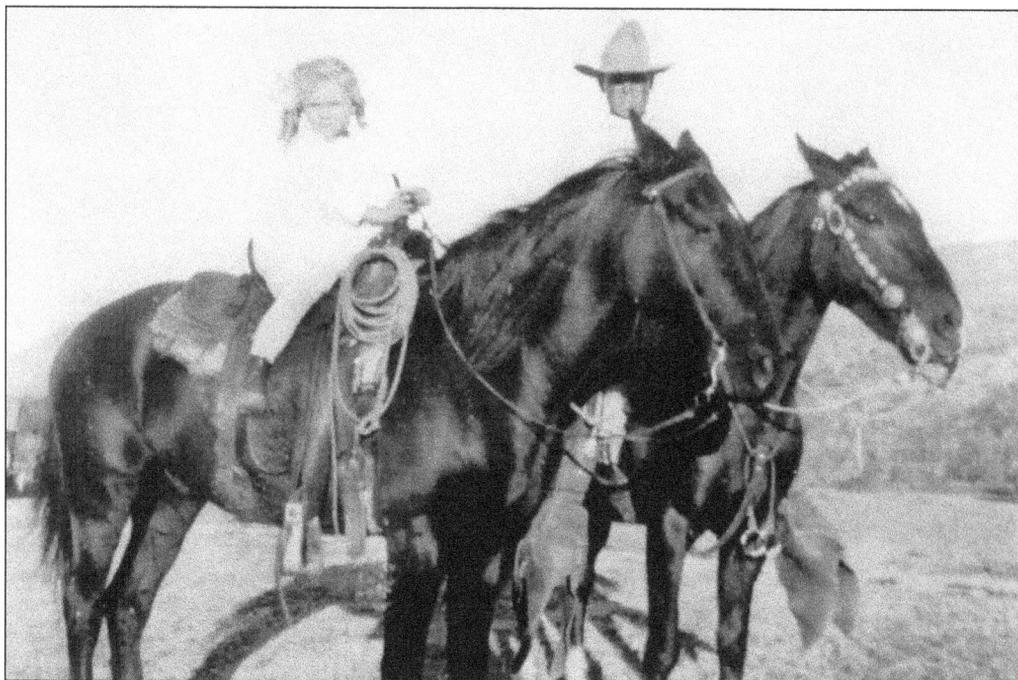

Under the watchful eye of her father, William Ray Sutherland, Muriel is saddled up and ready to ride. On April 30, 1918, Muriel, dressed in white with a bow in her blond curls, may not look like the typical cowboy, but she has her lariat. (Courtesy William Ray Sutherland family.)

About 1916, just before Frank Sutherland's death, his wife, Sophia Elias, and their two children, Isme and Frank D., went to town. Frank was John Nelson's undersheriff, and they were partners in the MS Ranch. After Sutherland's death, John Nelson bought out Sutherland's widow for $50,000. (Courtesy William Ray Sutherland family.)

Frank Otto Sutherland was in California when he fell ill. A doctor advised him to return home and see his doctor. Sutherland returned to his ranch and planned a medical visit for a few days later, but it was too late. On June 20, 1917, he died from a ruptured appendix. (Courtesy John and Myron Nelson family.)

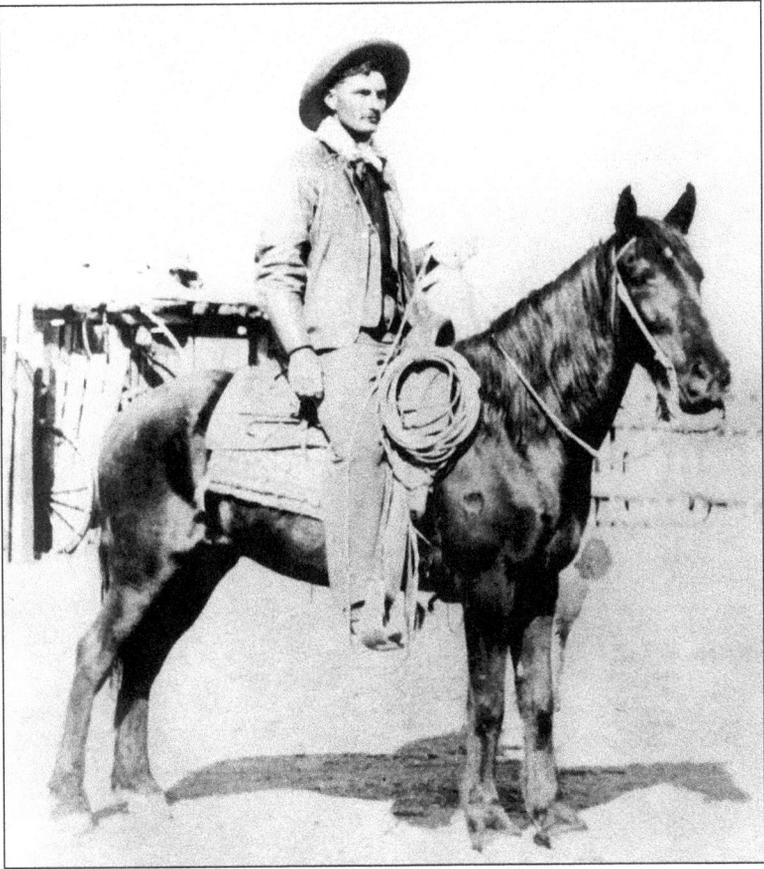

John Nelson was born in Sweden in 1869 and arrived in Arizona in 1889. A few years later, he partnered with Frank Treat of Benson in the cattle business in the Tortolita Mountains. He extended his holdings when he partnered with Frank Sutherland in the MS and Last Chance Ranches. (Courtesy John and Myron Nelson family.)

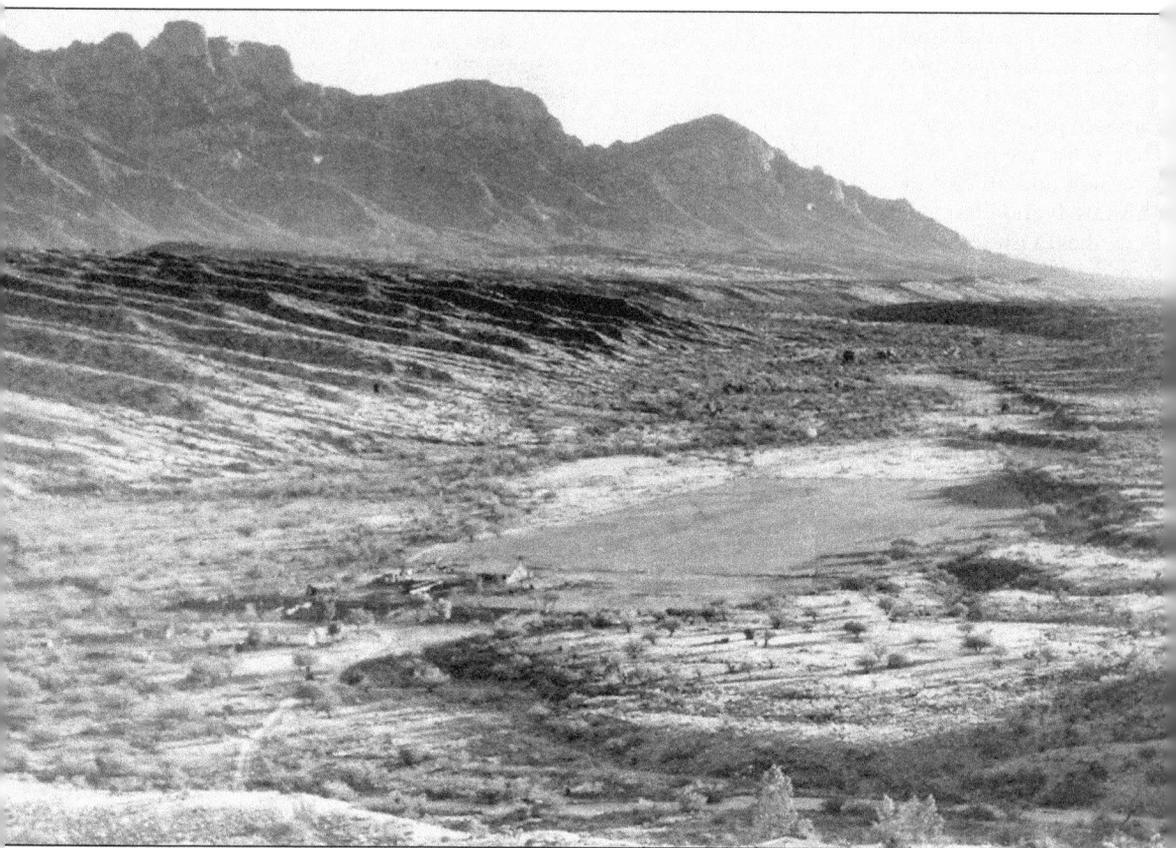

The MS Ranch was ideally situated at the base of a Santa Catalina Mountain ridge. The land was flat enough to support a landing strip for small planes. This late-1930s picture shows the ranch house, outbuildings, and working areas on the ranch. (Courtesy John and Myron Nelson family.)

In 1908, Nelson was elected sheriff of Pima County. That was the year he married Gerda Melgren. The Nelsons had three children—Hanna (left), Ina (center), and Myron—pictured here in 1914. After college, Myron managed both the MS and the Last Chance Ranches, which were on opposite sides of Oracle Road. (Courtesy John and Myron Nelson family.)

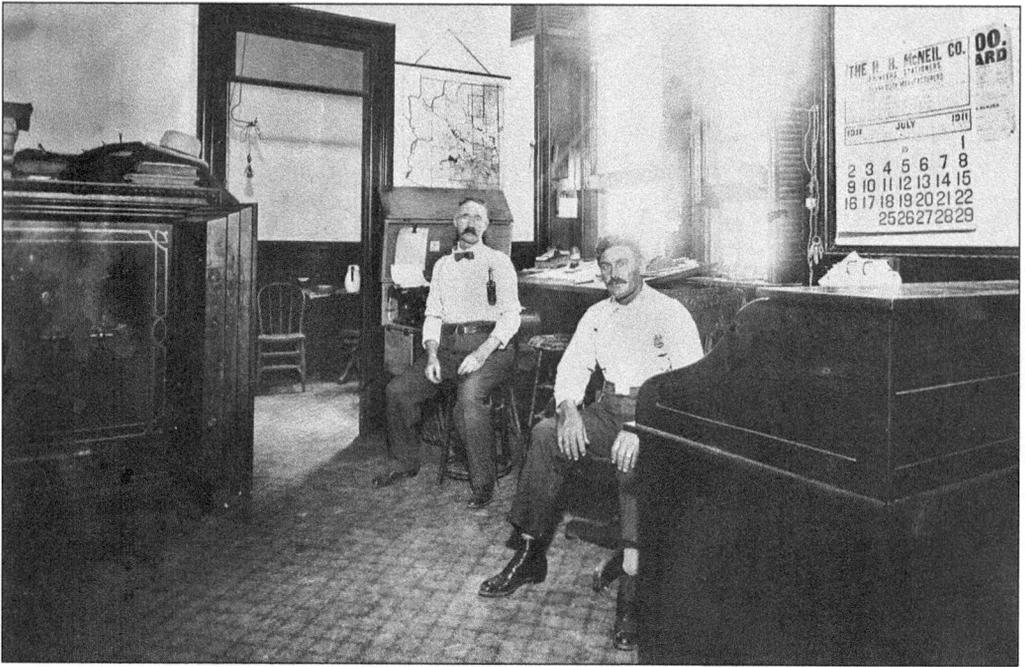

Nelson served two terms as territorial sheriff. He was reelected and became the first Pima County sheriff when Arizona achieved statehood in 1912. Working out of Tucson in 1911, Nelson (right, foreground) had a minimum staff to handle the job. (Courtesy John and Myron Nelson family.)

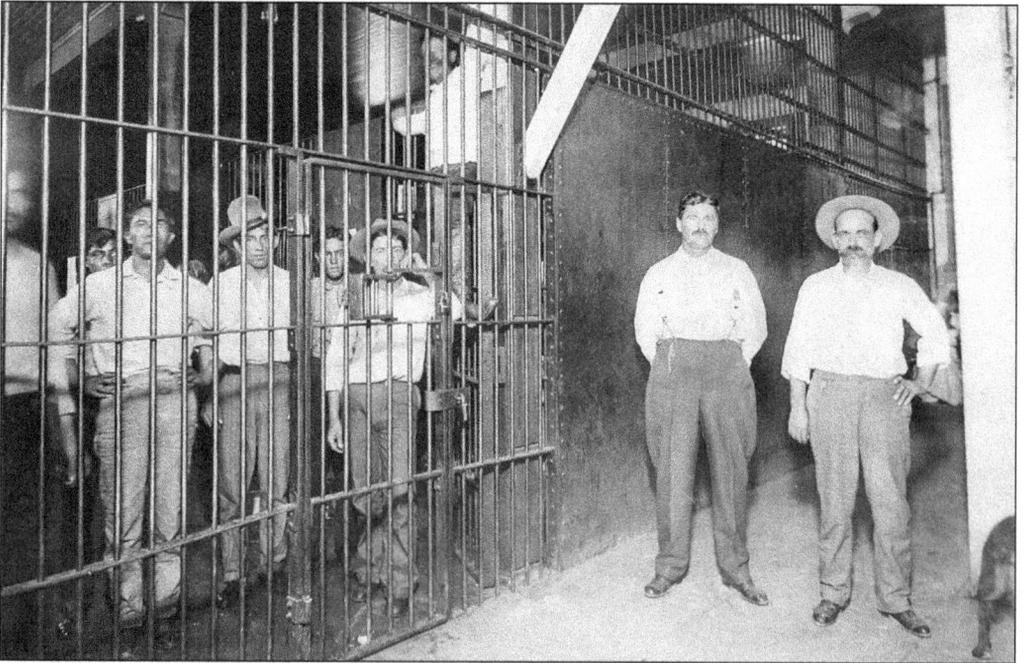

Nelson was known to be unrelenting in his pursuit of criminals. He successfully rid the county of cattle thieves, rustlers, and other lawbreakers, and won the confidence of the residents of the county. On a jail visit in 1914, accompanied by an unidentified jailer, Nelson (second from right) got a look at the criminals he had apprehended. (Courtesy John and Myron Nelson family.)

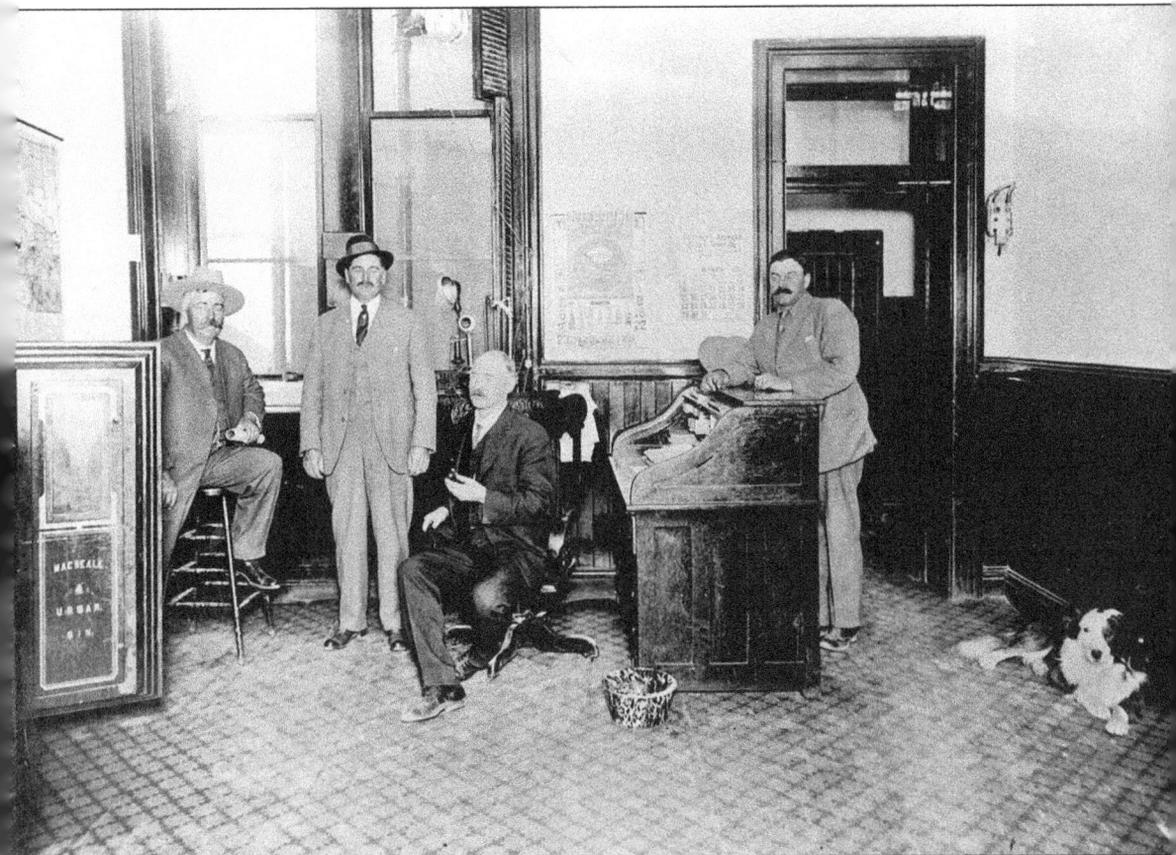

After statehood, Nelson's responsibilities grew, and so did his staff. In 1914, he was elected to serve as county supervisor. Sometime around 1914, Nelson, who is standing in the center of the group, was photographed in his office surrounded by unidentified staff members. (Courtesy John and Myron Nelson family.)

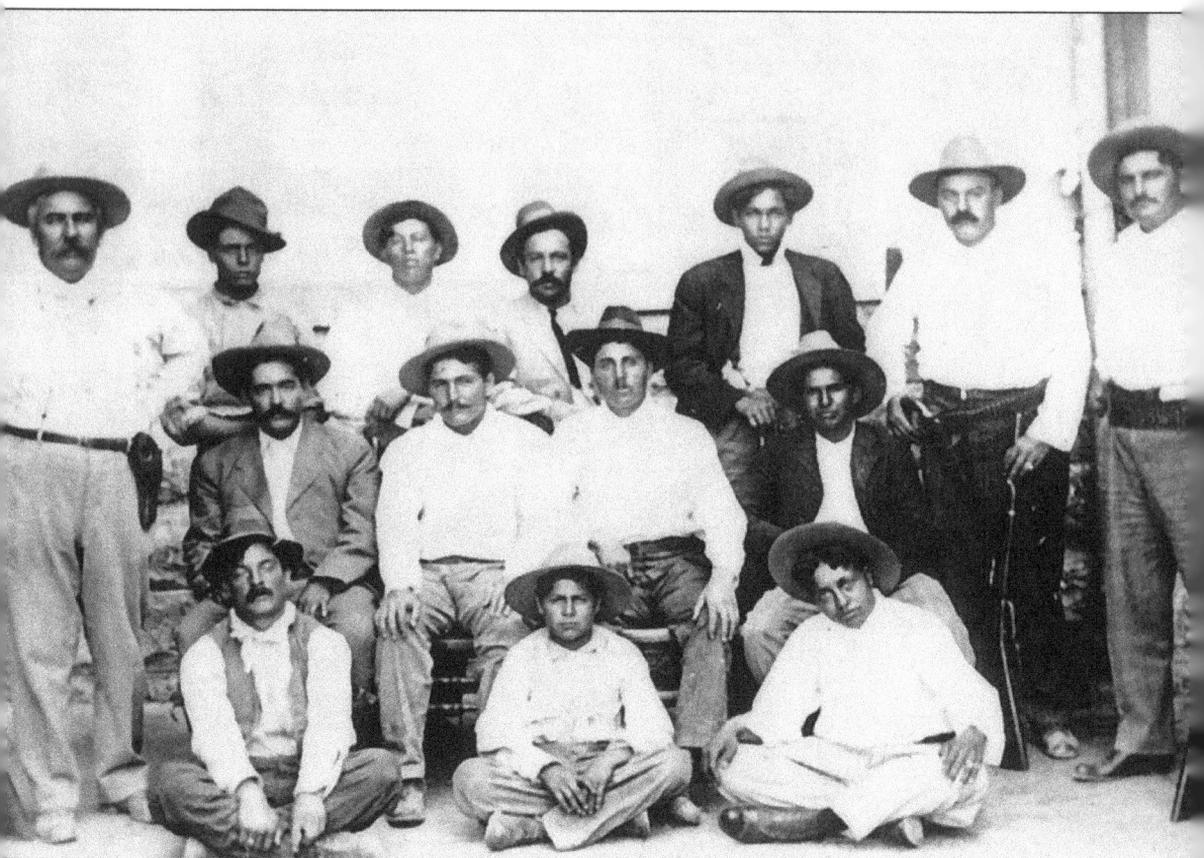

The West was still wild in the early 1900s. Saloon fights were a way of life. In a typical saloon disagreement on January 21, 1913, Calistro Villareal killed a man in Ajo, Arizona. Hearing the gunfire, Sheriff Joe W. Meeks went to investigate. Villareal ran away from the murder site and was hiding somewhere in town. As Meeks started his search for the killer, Villareal ambushed him from the brush, killing Meeks. Villareal escaped across the border to Mexico. When Sheriff Nelson got the news of the Meeks killing, he mounted a posse from Tucson and followed Villareal into Mexico. Once across the border, Nelson discovered that the authorities in Mexico refused to assist him in apprehending the killer. Nelson was forced to return empty-handed. However, he was successful in other arrests. Here is a group of villains that Sheriff Nelson, standing on the right, had arrested. The other men with rifles are his deputies. (Courtesy John and Myron Nelson family.)

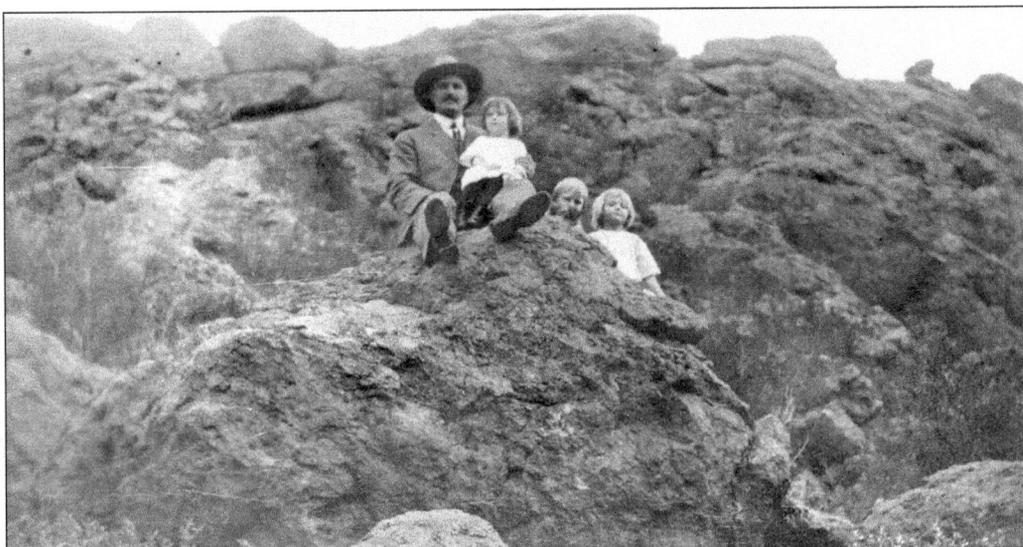

John Nelson often climbed the rocks of the Santa Catalina, which bordered his MS Ranch, with his children, Hanna (left), Myron (center), and Ina. He instilled in the children a respect and appreciation for the mountains that were very much a part of ranches in this area. (Courtesy John and Myron Nelson family.)

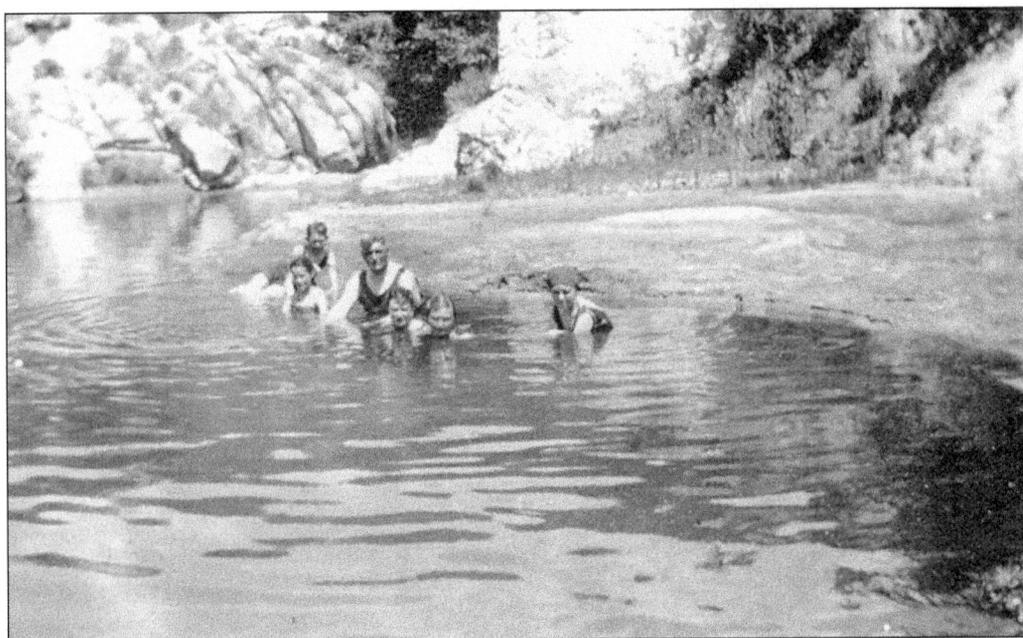

In 1920, the Cañada Del Oro, gushing down from the Santa Catalina Mountains, formed a pool on the Nelson Ranch. The pool offered an ideal swimming hole for the Nelson children, and seen here (in no particular order) are Myron, Hanna, Ina, and other family members. (Courtesy John and Myron Nelson family.)

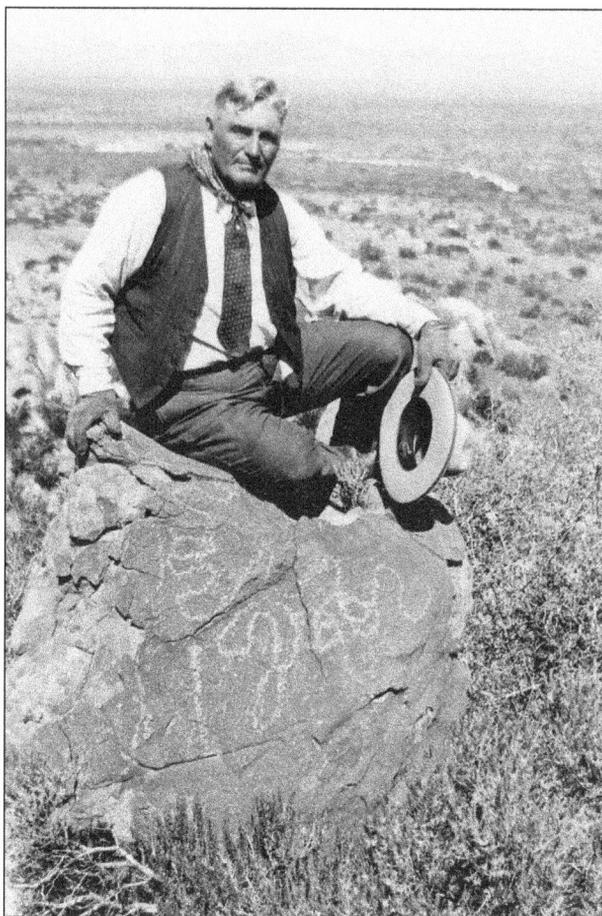

In 1915, a white-haired Nelson sits atop one of the treasurers of his ranch, a petroglyph rock carved out by the ancient hands of the Hohokam. Behind him is the Cañada del Oro, the water that attracted the Hohokam and made Nelson's land so valuable. (Courtesy John and Myron Nelson family.)

A very young Myron Nelson learns to ride on the ranch under the watchful eye of his aunt Angelina in 1911. His mother's sister came to take care of the Nelson children when their mother died. The gas iron she was using exploded, severely burning her. She never recovered. (Courtesy John and Myron Nelson family.)

54

Boys and girls were expected to do ranch chores in the 1920s. Many of the chores required riding. By the time she was 13, Hanna Nelson was an accomplished rider. Growing up on the MS and Last Chance Ranches, Hanna's main means of transportation was her horse. (Courtesy John and Myron Nelson family.)

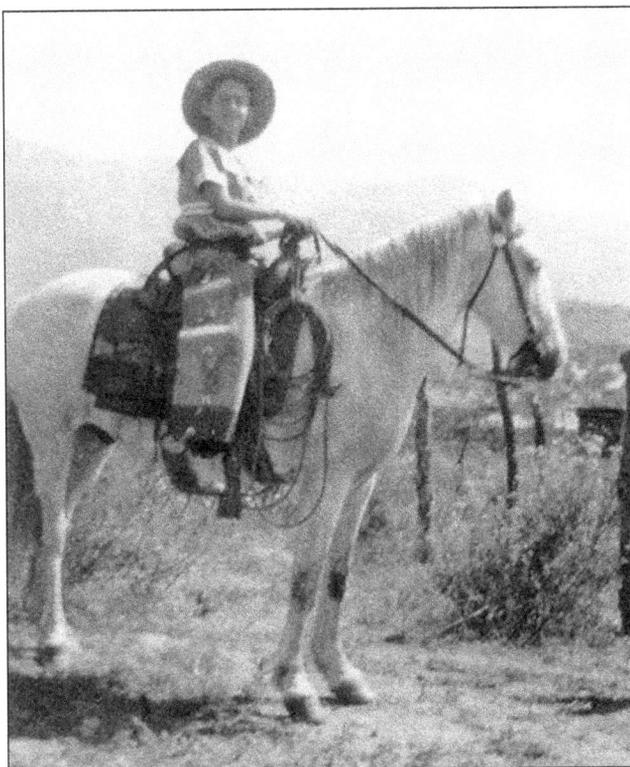

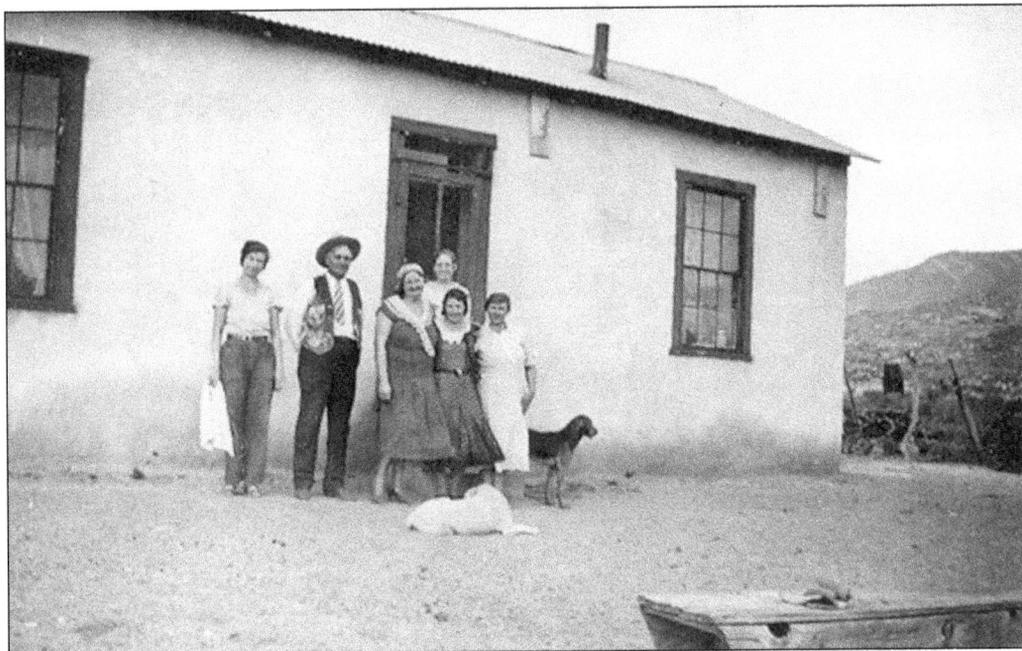

Nelson maintained the adobe ranch house that was originally built by the Sutherlands. When his son Myron married, they moved into the adobe at the MS Ranch. In 1930, John Nelson was still using the house and often played host there to family and friends. (Courtesy John and Myron Nelson family.)

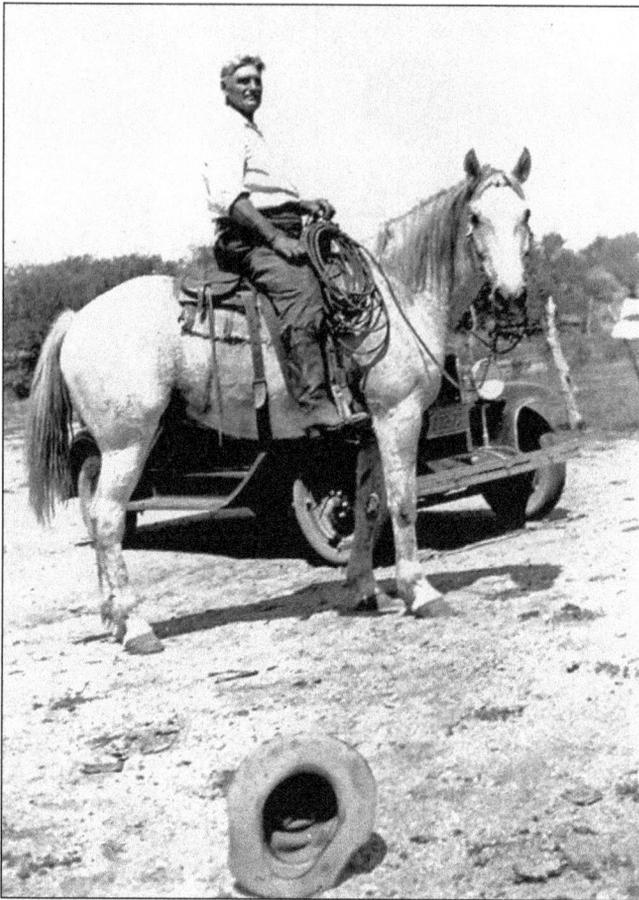

When Nelson was on his ranches, he used his favorite horse, Doc, to get around. The mountainous terrain in the foothills of Oro Valley made wagon or automobile travel difficult. Nelson's ranches made him a wealthy man despite the ups and downs of droughts, floods, and the cattle market. (Courtesy John and Myron Nelson family.)

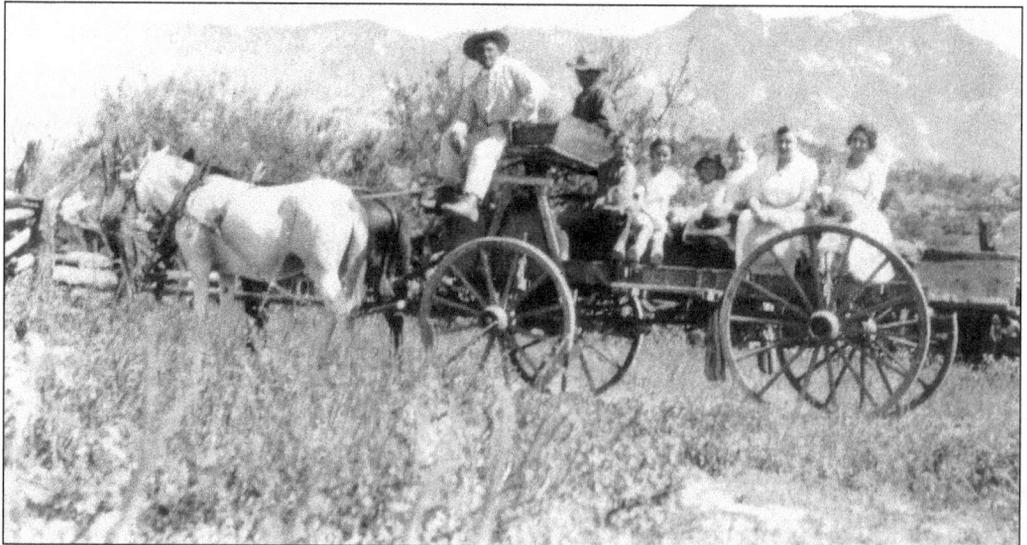

Life on a ranch in the 1920s provided opportunities to load up the hay wagon with friends and family and go for a ride. In the hard times of the 1920s, a wagon ride was one of the few entertainments the ranchers could afford. (Courtesy John and Myron Nelson family.)

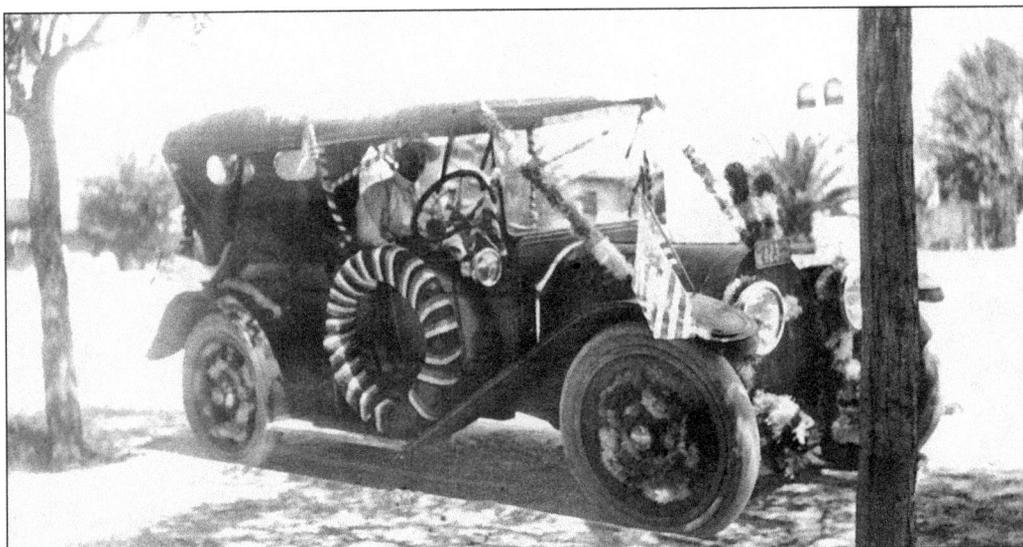

John Nelson's pride was his first car, a 1911 Mitchell. Parades and special occasions gave him an opportunity to dress the car up. This sturdy vehicle could hold its own on the rutted dirt roads that led from Tucson to the Nelsons' ranches. (Courtesy John and Myron Nelson family.)

In 1930, Myron Nelson headed for the University of Arizona, where he played baseball on the university team. However, Myron still worked on the ranches whenever he could get home from school. By the time he graduated, he knew the cattle business well. (Courtesy John and Myron Nelson family.)

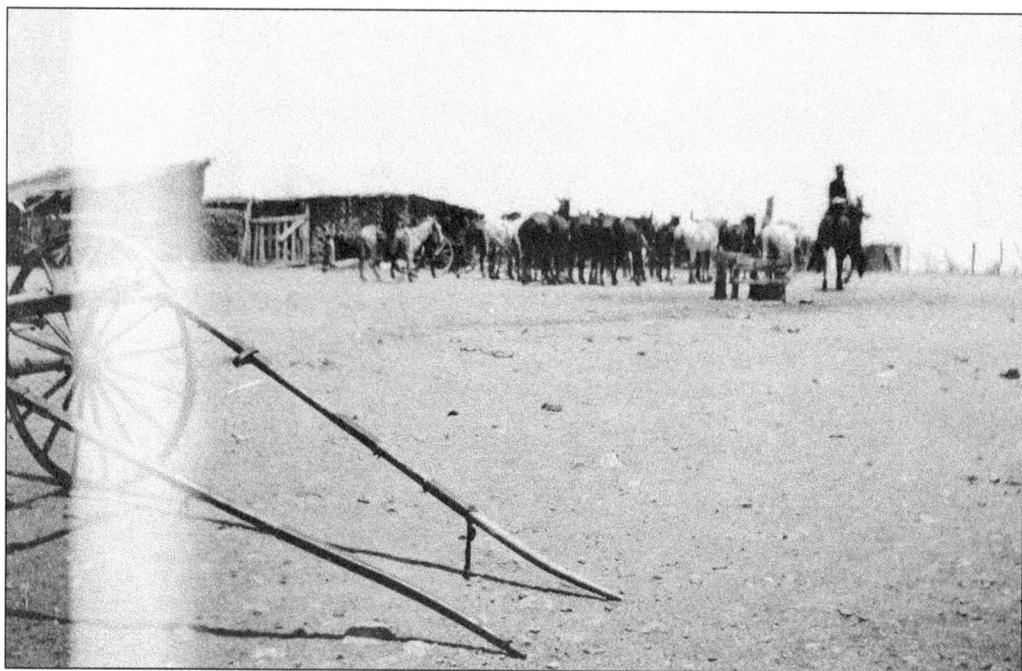

Work on the MS Ranch began in the corral, saddling up. The mountain terrain gave the cattle multiple places to hide, causing the cowboys to do some tricky riding to avoid the nasty needles. Even in open ground, the longhorns could find a stand of mesquites and cacti to hide in. It took clever horses, rough riding, and a lot of determination to get the stubborn cattle headed where they needed to go. The cattle market could be a series of ups and downs. In one good year, the Nelsons branded over 2,000 calves on their 30-square-mile range, but one drought caused them to lose 1,000 head, forcing them to sell their stock at $8 a head. (Above, courtesy Arizona Historical Society, #57594; below, courtesy John and Myron Nelson family.)

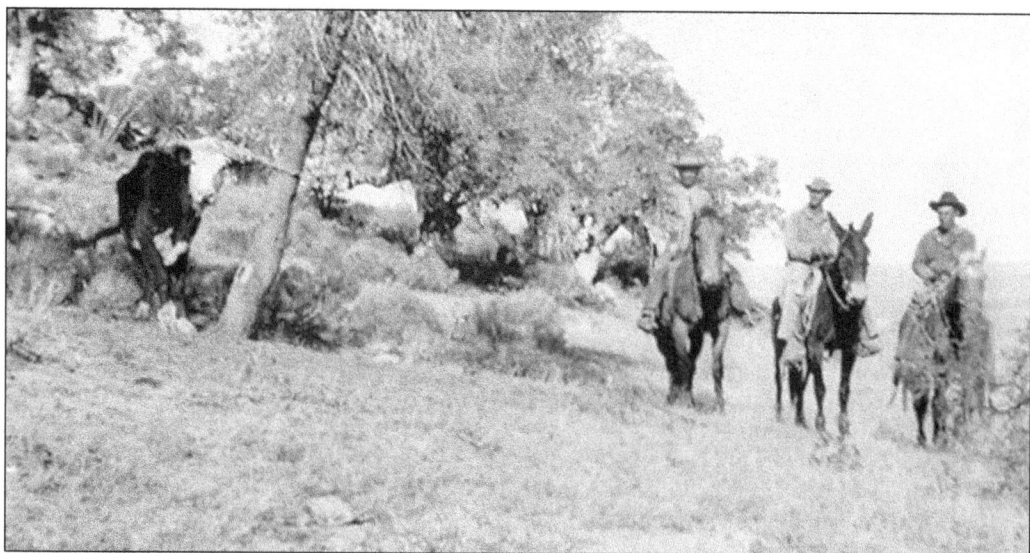

The MS land provided good range. Grass was plentiful and high. Even the cacti grew to unbelievable proportions. In 1930, Myron Nelson found this cholla that was well over 12 feet tall. During droughts, cattlemen burned the needles off cacti so cattle could feed on them. (Courtesy John and Myron Nelson family.)

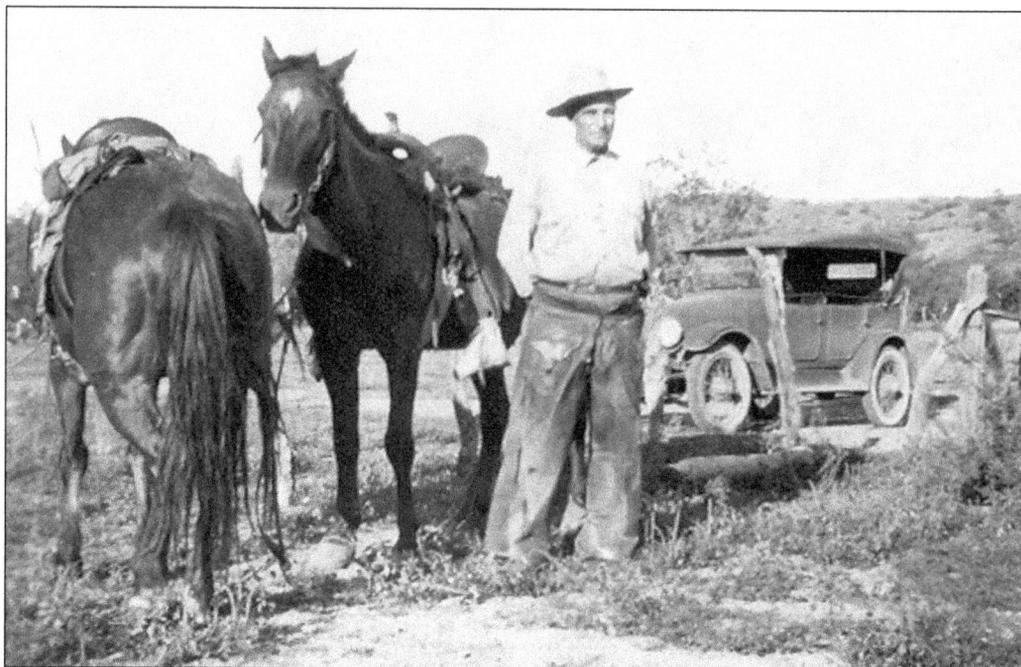

After college, Myron managed the Nelson ranches. At one time, his father had run up to 3,000 head, but over the years, Myron ran about 1,000 head. In 1938, the MS was sold to Mrs. Nicholas, and she sold the land to the Golder family. Today it is an upscale housing community. (Courtesy John and Myron Nelson family.)

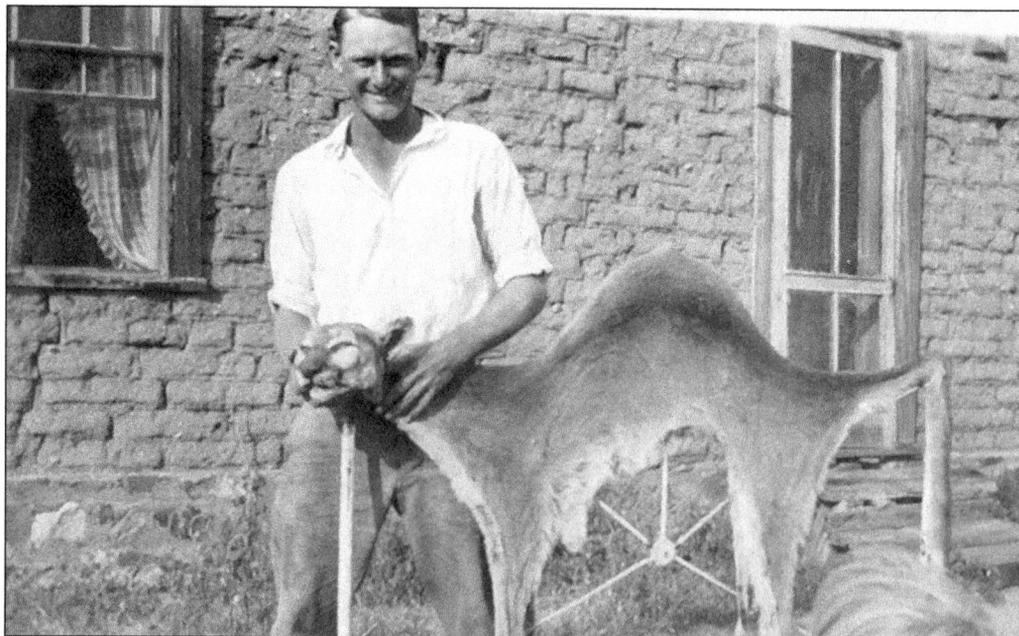

Every cattleman had to be a hunter to protect his stock. In the mountainous terrain of the MS Ranch, cattle ranged far and wide into gullies, washes, and ridges. There they became easy prey for the wild animals. In 1939, while protecting his cattle, Myron Nelson bagged this mountain lion. (Courtesy John and Myron Nelson family.)

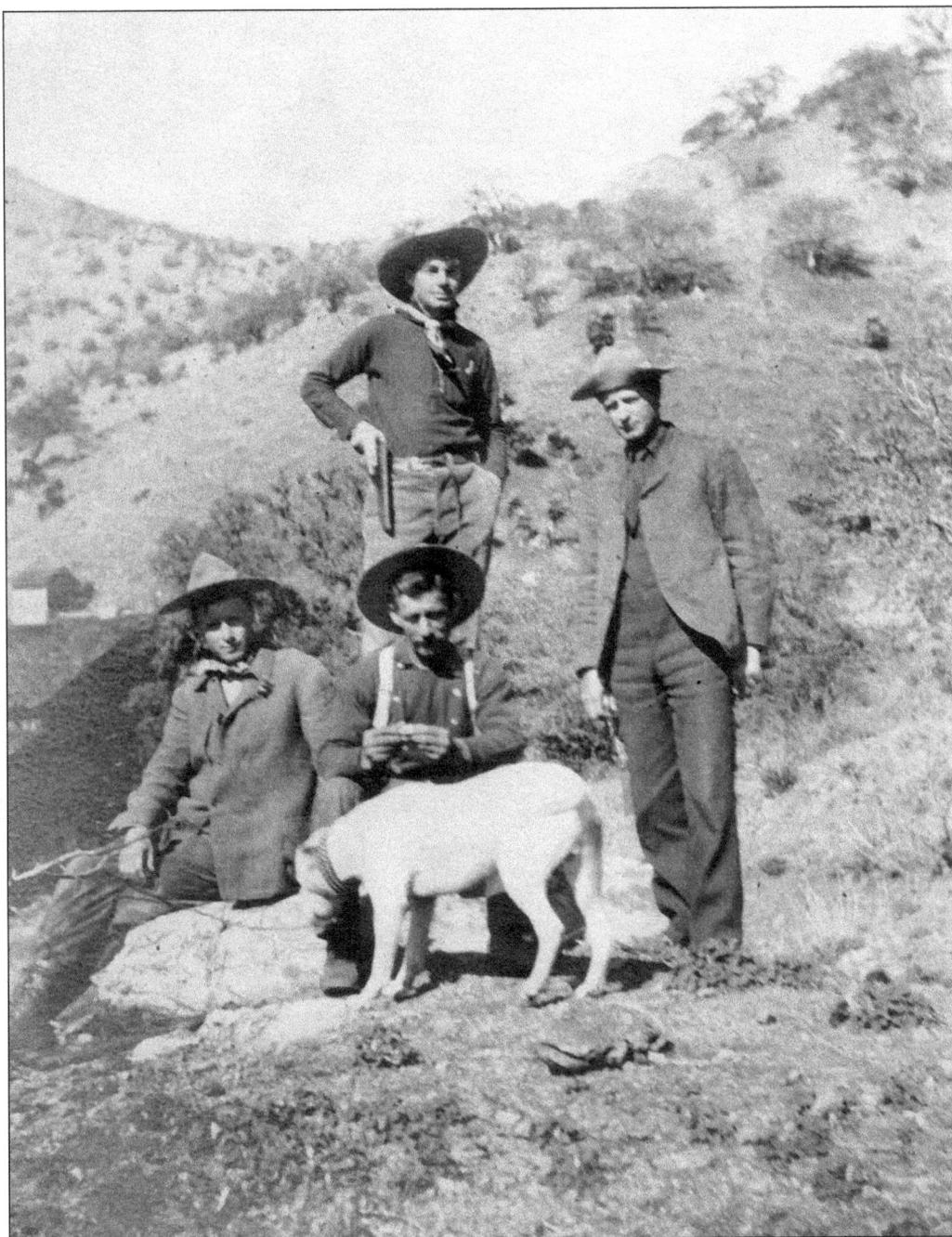

At the beginning of the 20th century, the mountains were safe from Native American attacks but not from wildlife attacks. The plentiful game, including mountain lions and wildcats, soon brought a new kind of settler: the game guides who hired out to hunters to help them bag the big ones. (Courtesy John and Myron Nelson family.)

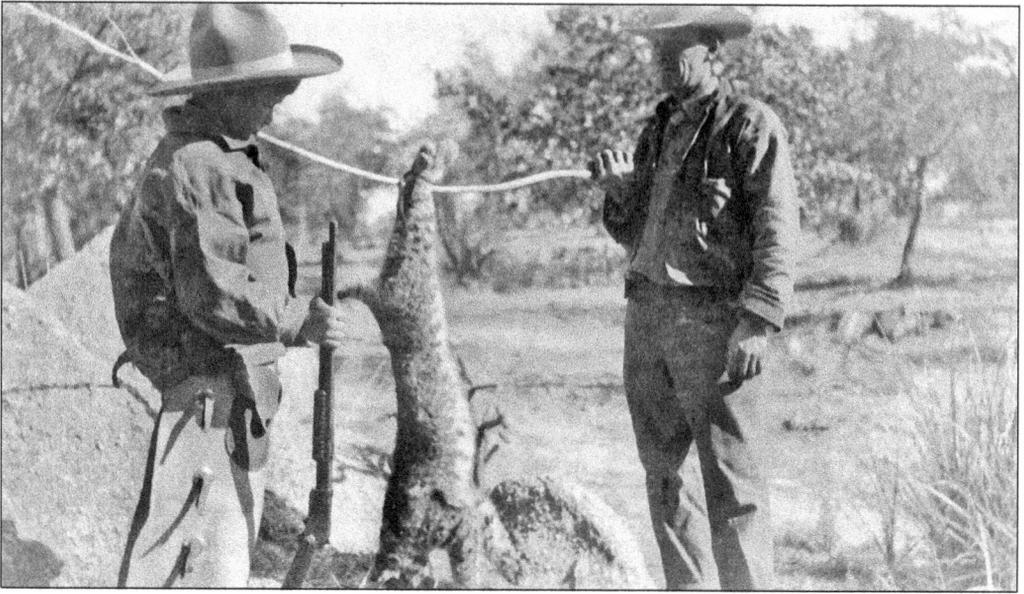

One of the biggest hunting prizes was the Santa Catalina mountain lion. Ranchers were supportive of any lion hunters, as the species was a threat to their livestock. Young ranchers learned early how to hunt the predators. In the 1930s, this young man got a big one. (Courtesy Arizona Historical Foundation.)

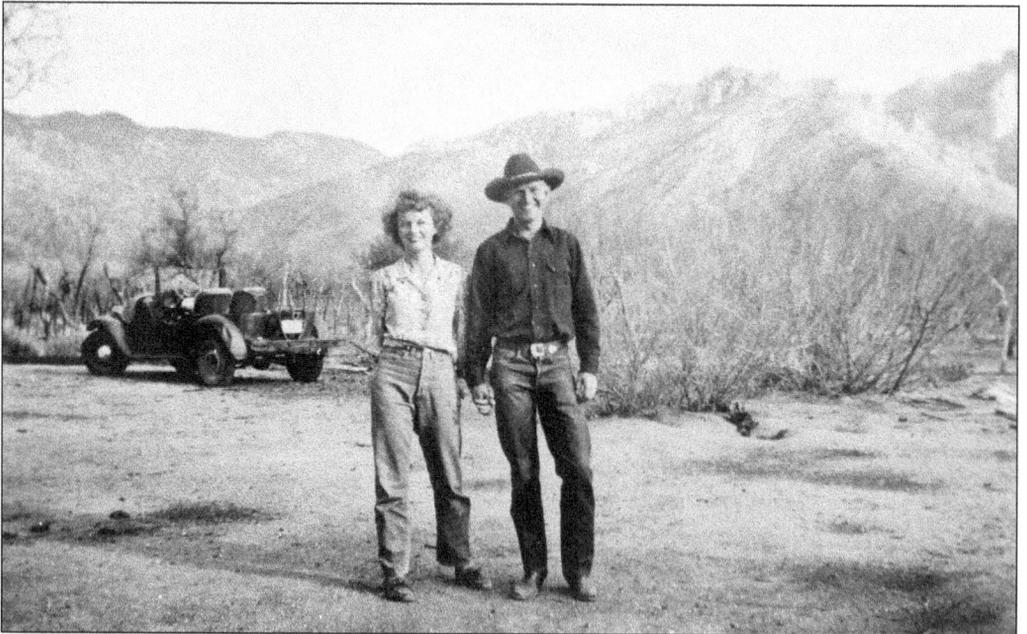

"Billy" Ann Chester and Ed Pietrie are pictured in 1942 at the Chester homestead on the east side of Oracle Road. She was the daughter of Billy Chester. No one knew where Billy came from or what his real name was, but he was one of the best mountain lion hunters in the area. (Courtesy Ed and Veda Pietrie.)

The most famous hunter in the Oro Valley area was Bee Dee Adkins. At 21 in 1924, he was a mature man out on his own. His work with the California and Arizona fish and wildlife departments gave him a passion for the outdoor life. (Courtesy Alpha Adkins Evans.)

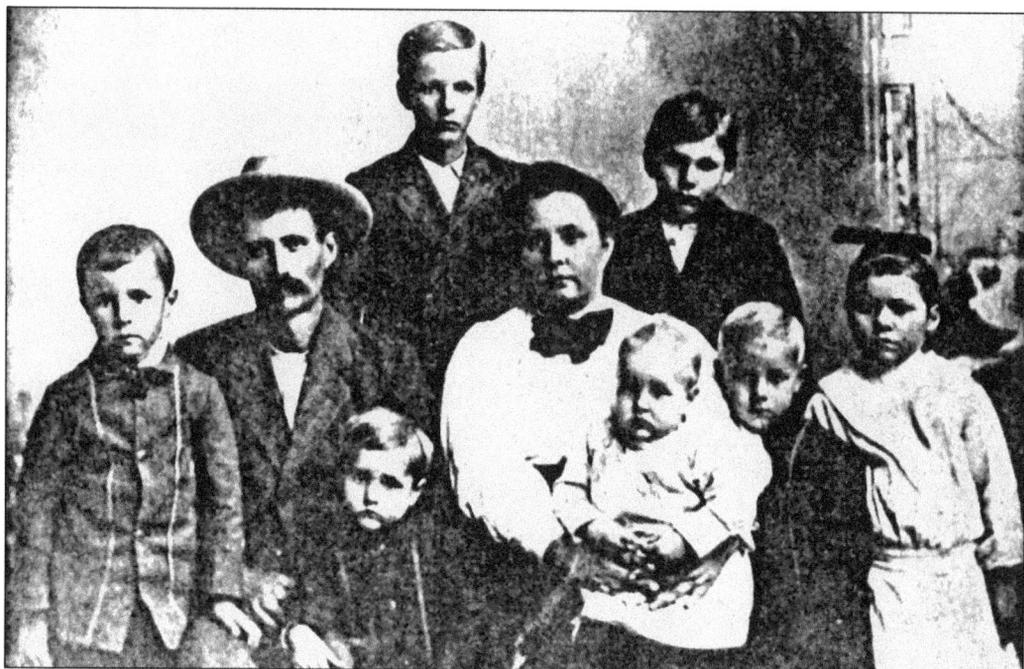

Twelve-year-old Bee Dee Adkins (back row, right) was born in 1903 into a family of 10 boys and one girl. He left home at 17 and came to Arizona during, as he put it, "the covered wagon days." He worked the old Baldwin place, now part of Catalina State Park. (Courtesy Alpha Adkins Evans.)

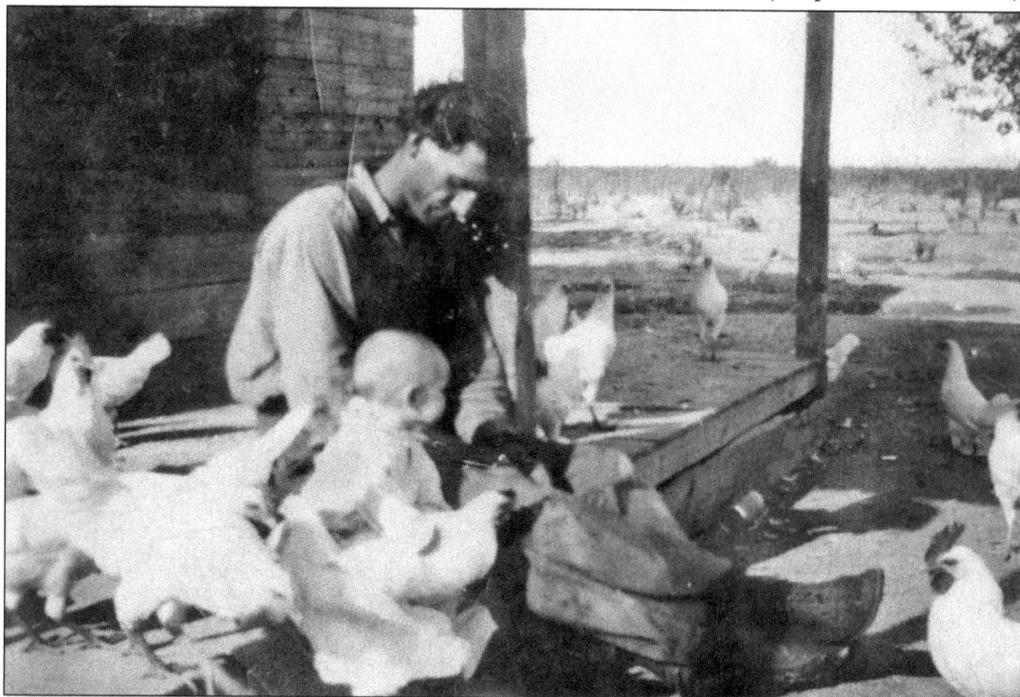

After his marriage, Adkins moved to the Oro Valley area. Before he became a famous mountain lion hunter, he did some farming and owned a poultry farm. In 1927, he introduced his six-month-old daughter Alpha to feeding time in the pecking yard. (Courtesy Alpha Adkins Evans.)

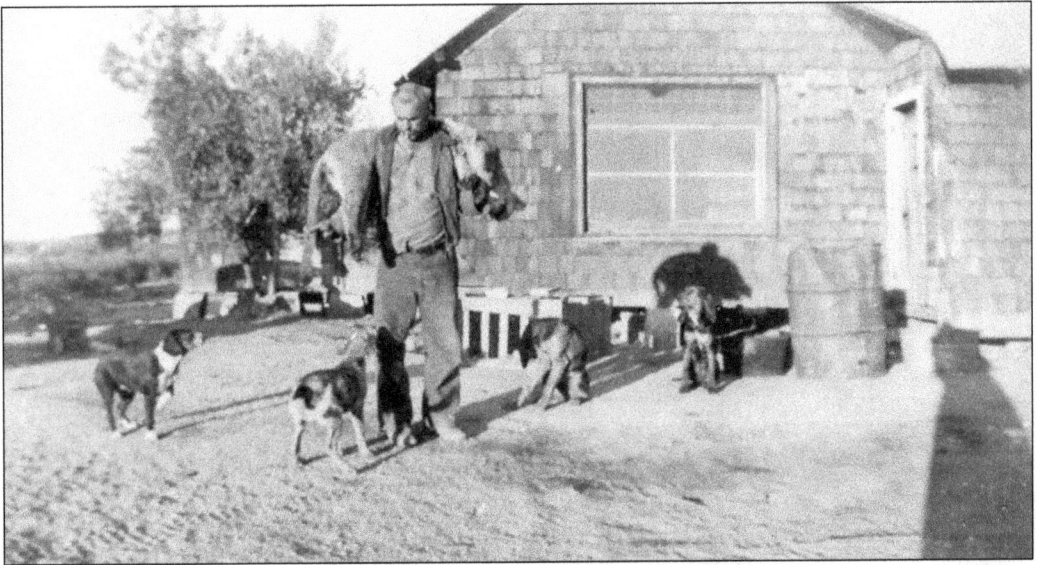

Adkins's hunting dogs were known as some of the best-trained hounds in the nation. They were often featured in magazines and were even the inspiration for a popular movie. His dogs were so well trained they could follow the scent of a mountain lion carried on horseback. (Courtesy Alpha Adkins Evans.)

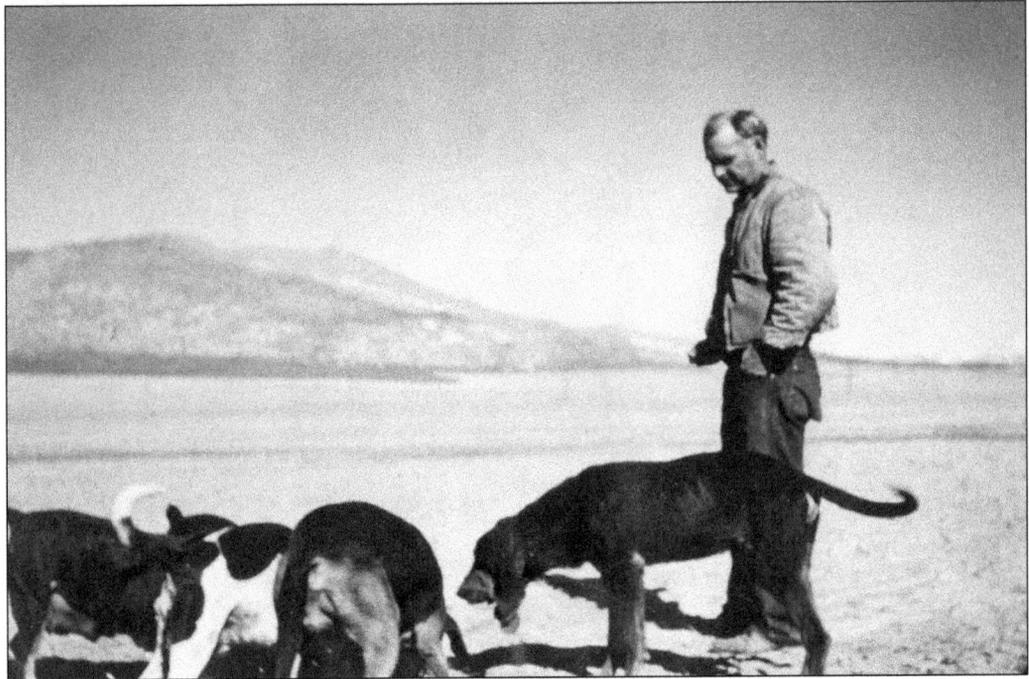

Adkins is pictured with his favorite hunting dog, Copper, standing next to him. Daniel Mannix hunted with Adkins and was so impressed with Copper that he wrote a series of children's books featuring the dog. Disney made one of the books into a movie titled *The Fox and the Hound*. (Courtesy Alpha Adkins Evans.)

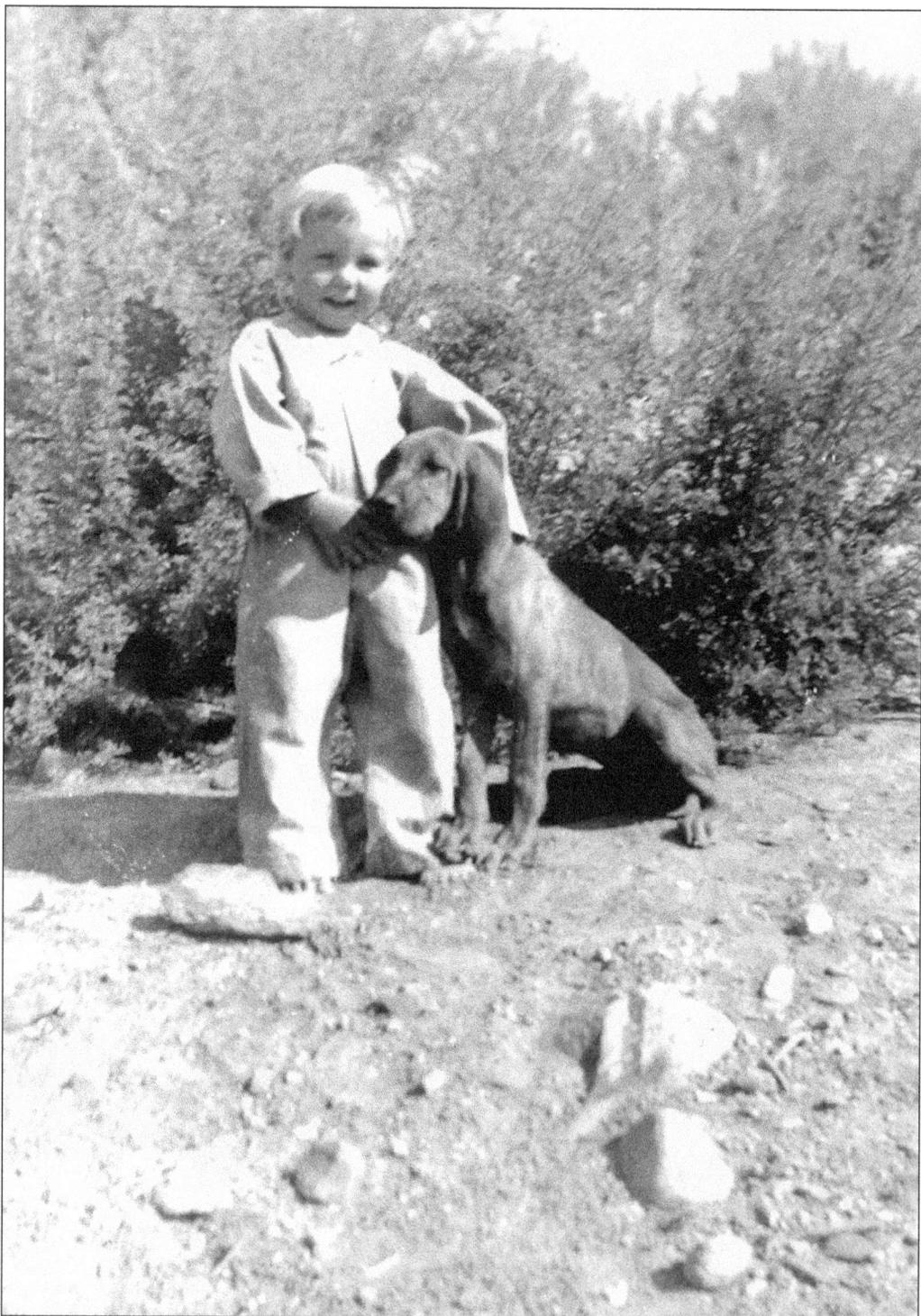

In 1930, Jinx, one of Copper's pups, plays with Vina, one of Bee Dee Adkins's daughters. Although his dogs were known nationally as some of the finest hunters, they were by nature very gentle dogs and at home were often play pals for his children. (Courtesy Alpha Adkins Evans.)

Adkins's hunting partners were Billy Chester and Dr. William Lackner. Lackner, a Tucson dentist, came to Arizona in 1930 from Canada. He lived in Oracle and drove the 30-plus miles every day to work. An avid hunter and a good friend of Adkins, he and his wife were Alpha Adkins's godparents. (Courtesy Alpha Adkins Evans.)

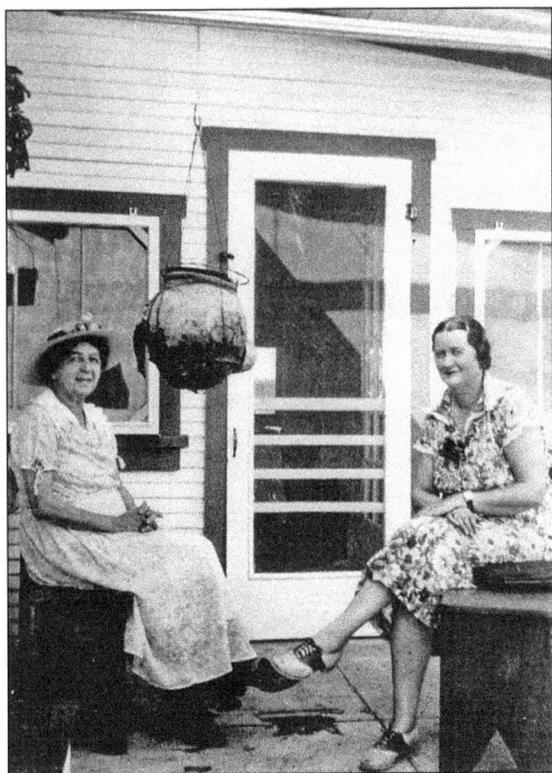

When Mannix wrote *The Fox and the Hound*, he based some of his characters on local people. The barn owl in the movie was patterned after Gladys Lackner, pictured on the right in the 1940s. She never dreamed her voice and character would be so accurately caught in the movie. (Courtesy Alpha Adkins Evans.)

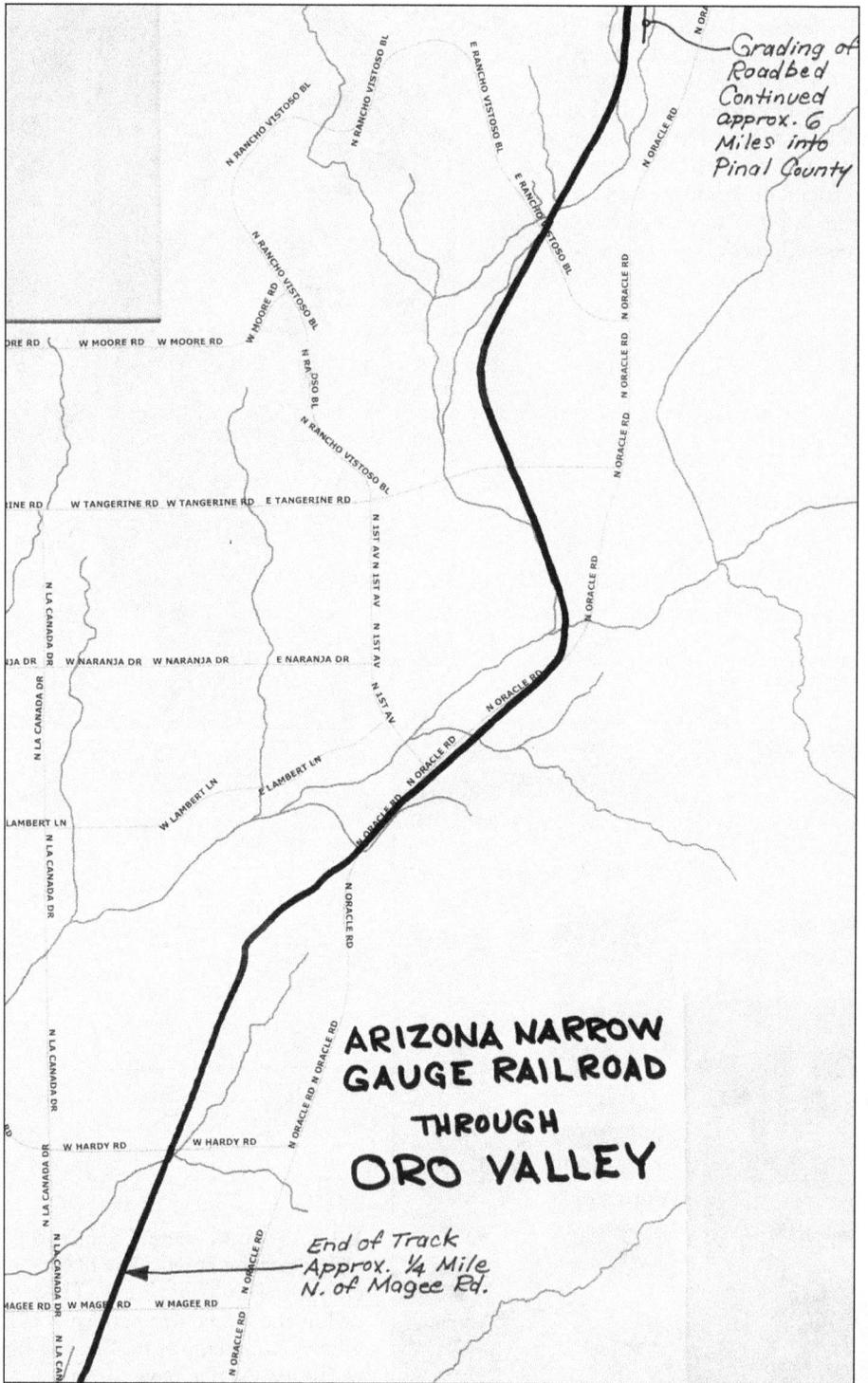

Grading of Roadbed Continued approx. 6 Miles into Pinal County

ARIZONA NARROW GAUGE RAILROAD THROUGH ORO VALLEY

End of Track Approx. ¼ Mile N. of Magee Rd.

Plans were made 125 years ago to build a narrow-gauge railroad track from Tucson through Oro Valley. The tracks for the Arizona Narrow Gauge (ANG) were laid to Magee Road, north of the city, but they were never extended beyond. (Courtesy Southern Arizona Transportation Museum.)

All that is left of the ANG railroad that connected Tucson to the northern end of Pima County is this railroad bed, which could still be seen in the 1950s. The railroad bed was graded for 30 miles into Oro Valley, but no tracks were laid. (Courtesy Southern Arizona Transportation Museum.)

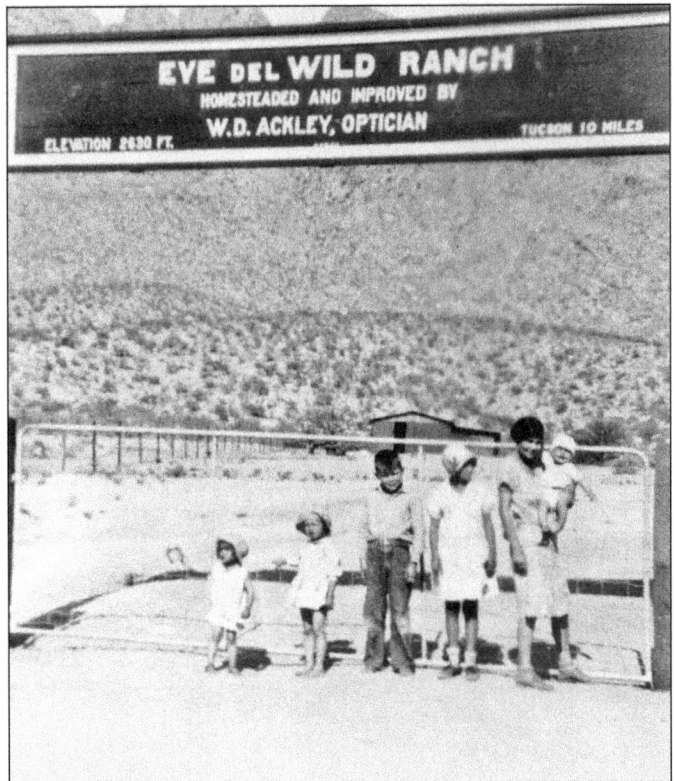

Optician William Dickenson Ackley cleverly named his Oro Valley homesteaded the Eye Del Wild Ranch. The ranch is now the site of apartments. Standing at the ranch gates in 1929 (from left to right) are Veda and Edith Ackley, two cousins, Mrs. Ackley, who is holding her son Dick. (Courtesy Ed and Veda Ackley Petrie.)

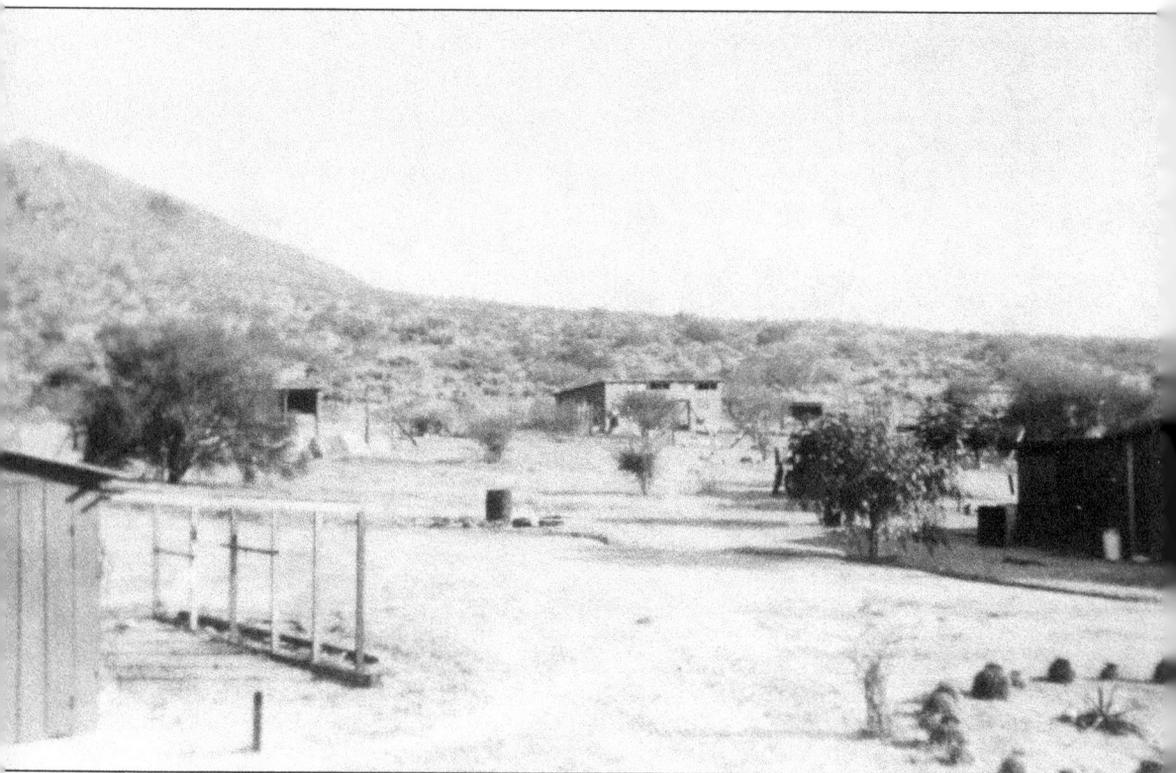

This view from the Eye Del Wild homestead looks east toward the mountains. The chicken coop and pecking yard are on the left, and the Ackley house is on the right. The Ackleys homesteaded 400 acres on the east side of Oracle Road and 240 acres on the west side. (Courtesy Ed and Veda Ackley Petrie.)

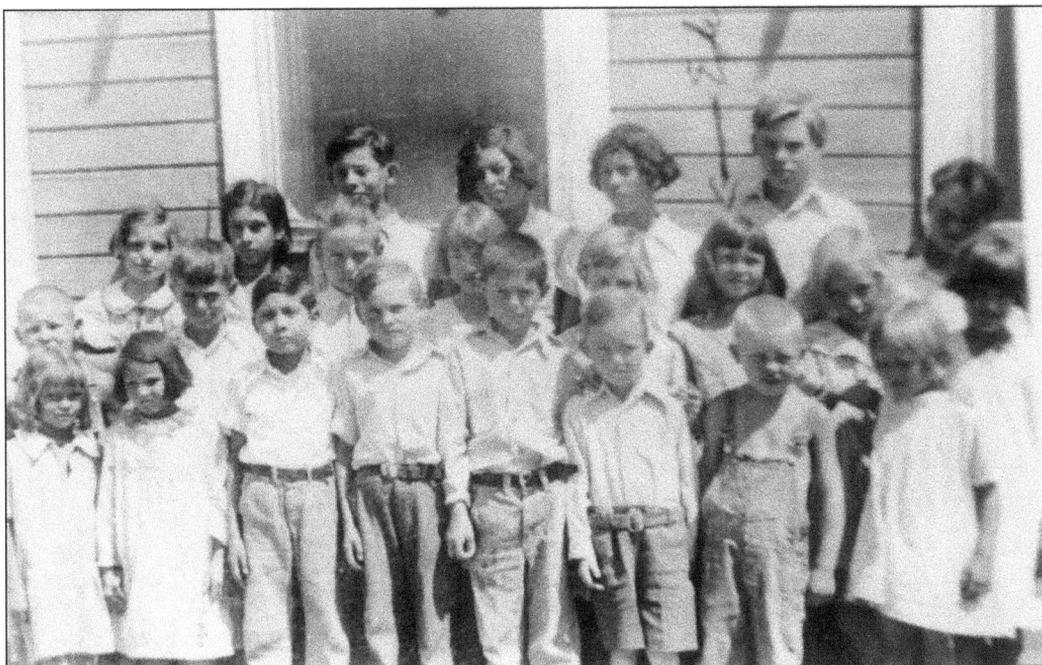

Veda Ackley (first row at left) and her sister (marked by the arrow) pose for a picture with the whole school at the Catalina School. The one-room schoolhouse had eight grades. Mrs. Foxwell was the teacher, and there were two students in first grade. Veda was one of them. (Courtesy Ed and Veda Ackley Petrie.)

In the early 1930s, the two hills by the Catalina School were for playtime. One was the boys' hill; the other hill was the girls'. The boys and girls always kept to their own hills. There was only one outhouse, but it did have two holes. (Courtesy Ed and Veda Ackley Petrie.)

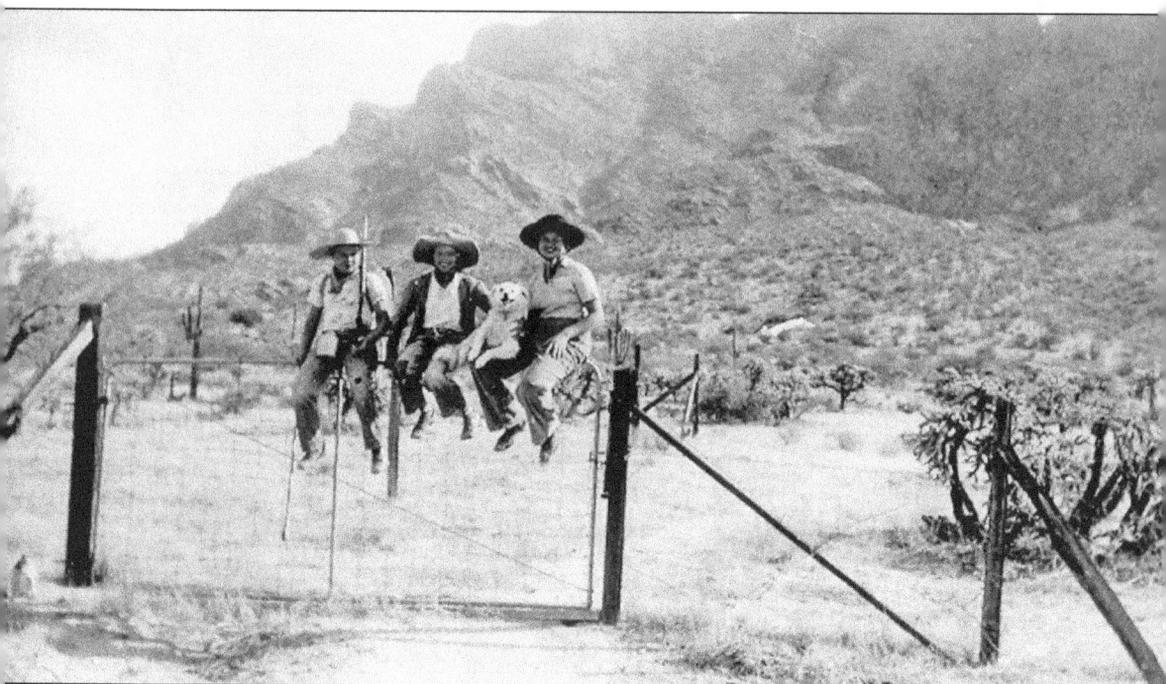

Veda Ackley (center), her sister Edith, and brother Dick pose with their favorite dog on their ranch's east gate. In the background are the Santa Catalina Mountains. The Ackley homestead was on what is now called Hardy Road and spanned both sides of Oracle Road. (Courtesy Ed and Veda Ackley Petrie.)

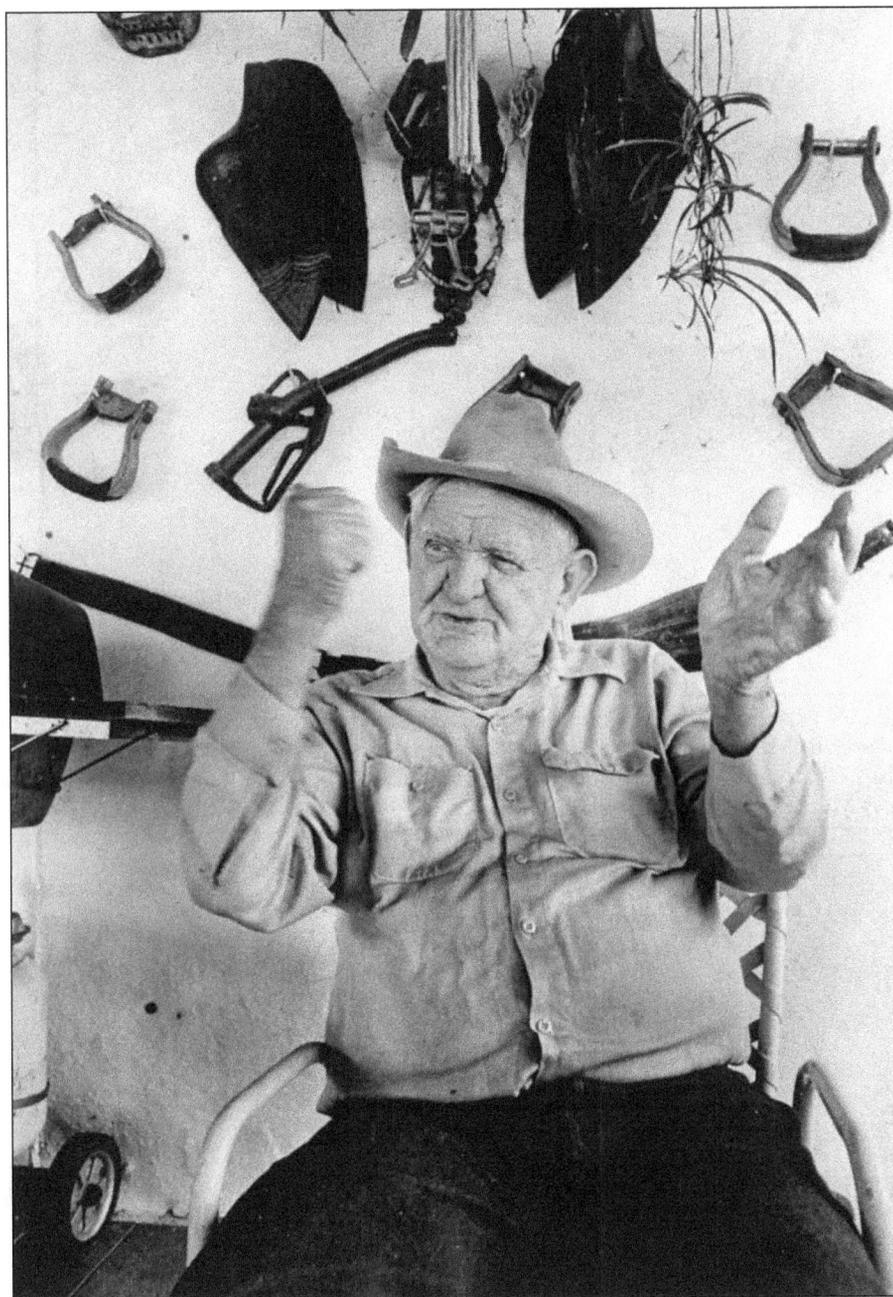

Buster Bailey, one of the early homesteaders and a mountain legend, arrived in 1927 with his parents but stayed on when they returned to Texas. Part of his homestead is now in the Catalina State Park. Buster left a legacy of historical information in wry comments and stories. (Courtesy Arizona Historical Society, #90746.)

Buster Bailey worked his family's homestead for years. When he retired from ranch life, he sold the property to Mrs. Love, who sold it to Dr. Frank Russell. From the late 1920s to the early 1950s, Russell ran an exclusive school for boys and built several small buildings on the property. (Courtesy Mike Marriott.)

The outbuildings on Russell's ranch served a variety of purposes. This building was the laundry and is now apartments. Some of the small outbuildings were used for stables. One included a tack room and a small apartment. Dr. Russell also had a large, open, screened-in classroom to accommodate the Arizona weather. (Courtesy Mike Marriott.)

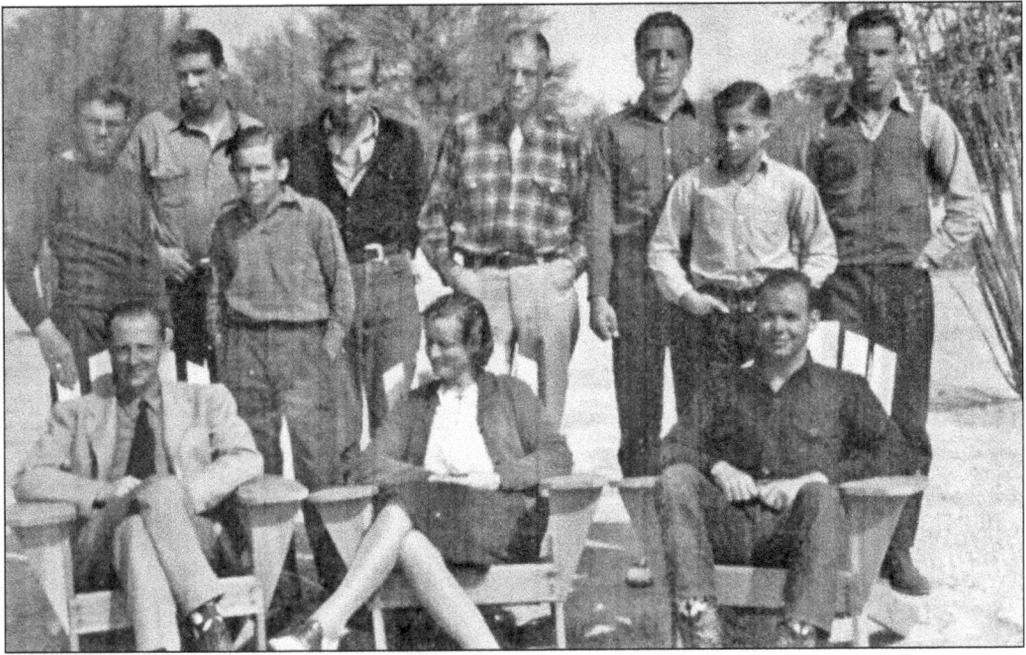

L. F. Rooney from Oklahoma suffered from a mild case of polio. He and his family wintered on their ranch next to the Steam Pump. He enrolled his sons in Dr. Russell's school in 1939. Larry Rooney is in the back row on the far left; John is third from left. (Courtesy John Rooney.)

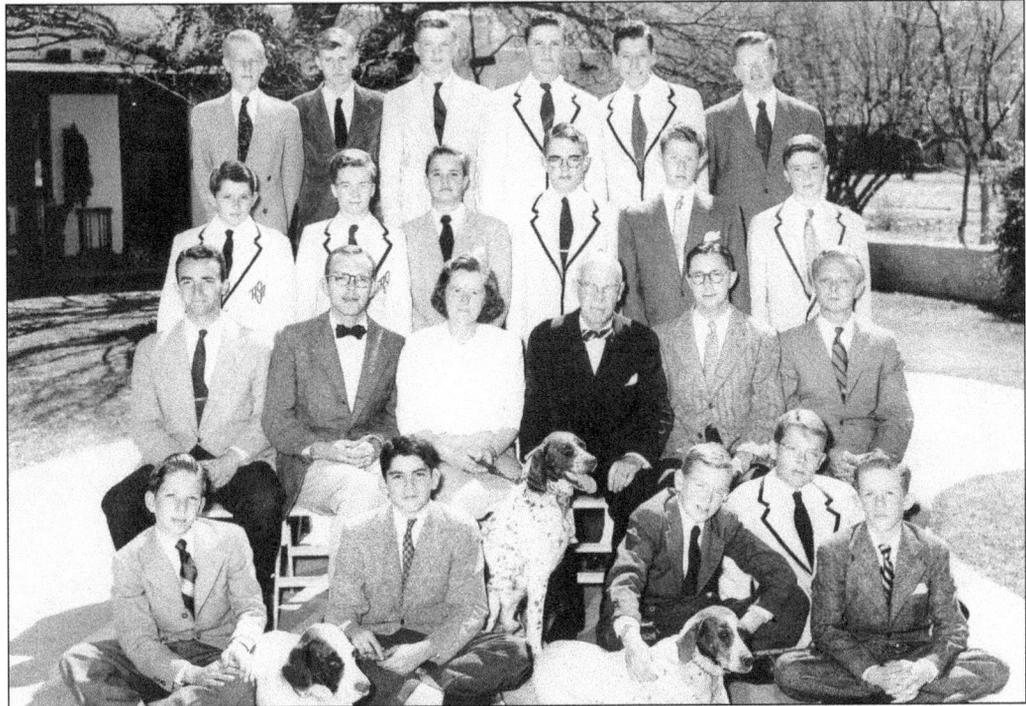

Ten years later, in 1949, Dr. Russell's school was still going strong. The graduating class that year included Rev. William "Bill" Haugh, standing second from left in the last row. Dr. Russell is in the dark suit with the snappy bow tie. The school closed in 1952. (Courtesy William Haugh.)

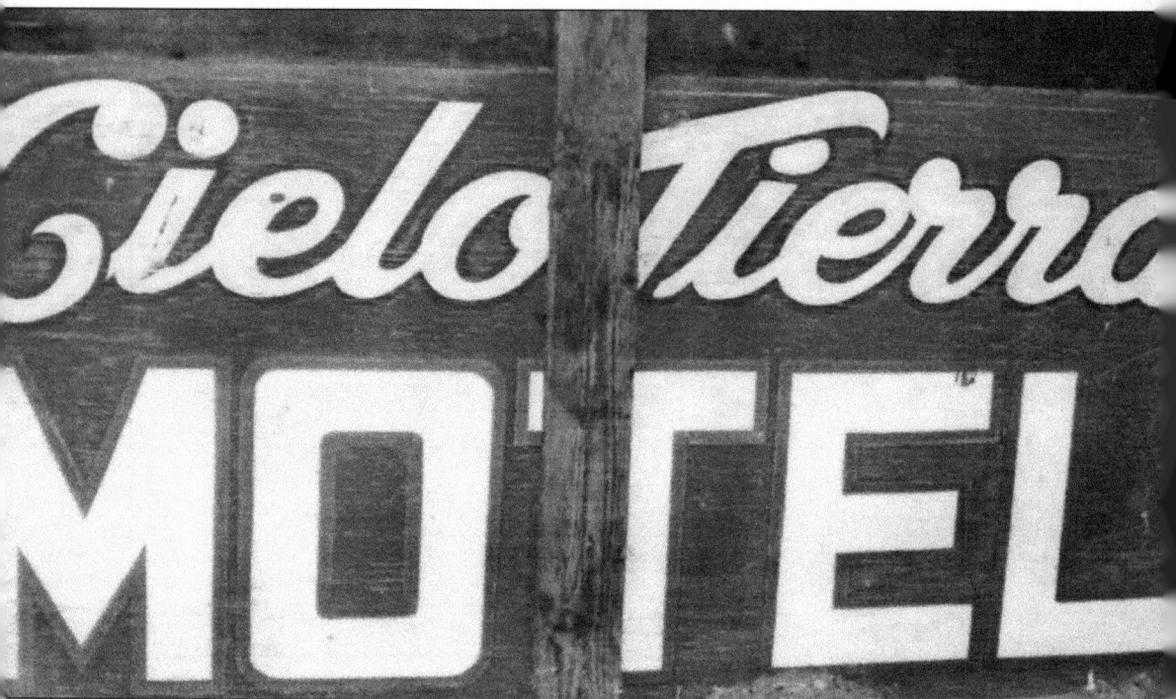

After the Russell school closed, the property changed hands and became many things, including a motel. The Cielo Tierra Motel had a very short and unsuccessful life, even though it offered impressive views of the Santa Catalina Mountains. Although the motel closed, the houses on the property continued as rentals. (Courtesy Mike Marriott.)

The main route from north to south followed the Cañada del Oro wash part of the way, and then skirted the western slopes of the Santa Catalinas. The road north is now Highway 77, a well traveled four-lane highway, but back in 1915, it was not much more than a dirt track. (Courtesy Jim and Catherine Reidy family.)

1559

4—1007.

The United States of America,

To all to whom these presents shall come, Greeting:

WHEREAS, a Certificate of the Register of the Land Office at Phoenix, Arizona,

has been deposited in the General Land Office, whereby it appears that, pursuant to the Act of Congress of May 20, 1862,

"To Secure Homesteads to Actual Settlers on the Public Domain," and the acts supplemental thereto, the claim of

James B. Reidy

has been established and duly consummated, in conformity to law, for the south half, the south half of the

north half, and the northwest quarter of the northwest quarter of Section

twenty-three, the north half of the northeast quarter of Section twenty-six

and the southeast quarter of the southwest quarter of Section twenty-eight

in Township eleven south of Range thirteen east of the Gila and Salt River

Meridian, Arizona, containing six hundred forty acres,

according to the Official Plat of the Survey of the said Land, on file in the GENERAL LAND OFFICE:

NOW KNOW YE, That there is, therefore, granted by the UNITED STATES unto the said claimant the tract of Land above described; TO HAVE AND TO HOLD the said tract of Land, with the appurtenances thereof, unto the said claimant and to the heirs and assigns of the said claimant forever; subject to any vested and accrued water rights for mining, agricultural, manufacturing, or other purposes, and rights to ditches and reservoirs used in connection with such water rights, as may be recognized and acknowledged by the local customs, laws, and decisions of courts; and there is reserved from the lands hereby granted, a right of way thereon for ditches or canals constructed by the authority of the United States. Excepting and reserving, however, to the United States all the coal and other minerals in the lands so entered and patented, together with the right to prospect for, mine, and remove the same pursuant to the provisions and limitations of the Act of December 29, 1916 (39 Stat., 862).

IN TESTIMONY WHEREOF, I, Franklin D. Roosevelt,

President of the United States of America, have caused these letters to be made

Patent, and the seal of the General Land Office to be hereunto affixed.

GIVEN under my hand, at the City of Washington, the TWENTY-FOURTH

day of OCTOBER In the year of our Lord one thousand

nine hundred and THIRTY-EIGHT and of the Independence of the

United States the one hundred and SIXTY-THIRD.

By the President:

By Secretary.

Recorder of the General Land Office.

RECORDED: Patent Number 1099369

Most of the present town of Oro Valley is west of Highway 77, but back in 1920, it was homesteads, ranches, and a few agriculture projects. It was here James Reidy homesteaded several sections, and he was awarded ownership of them by Franklin D. Roosevelt in 1938. (Courtesy Jim and Catherine Reidy family.)

Dan and Jim Reidy found ways to amuse themselves in their yard by climbing rocks. The simple adobe house and barren backyard were typical of the settlers' homes in the late 1920s and 1930s. The adobe bricks were usually made on-site. (Courtesy Jim and Catherine Reidy family.)

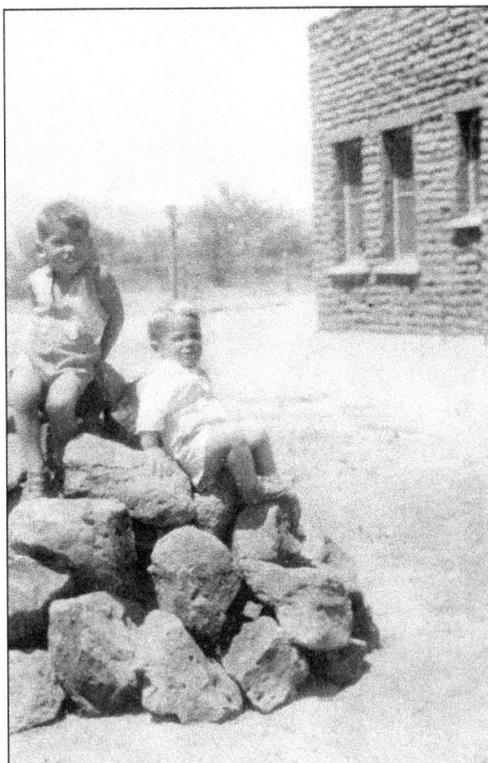

The adobes for the Reidy ranch house were made on-site by this Yaqui couple. The bricks that formed the walls of the house can be seen piled in neat rows behind them. The mud adobe bricks were ideal for the desert weather. (Courtesy Jim and Catherine Reidy family.)

The best way for the homesteaders to get to town in the 1920s was by car. They were the workhorses used for hauling what was needed. The nearest store was over 15 miles away in Tucson, and there was no such thing as a quick trip. (Courtesy Jim and Catherine Reidy family.)

James Reidy took time to teach his sons how to ride when they were young. The well structure in the background was a part of every homestead property. Settlers' homesteads consisted of at least a section (640 acres), and the only available water was with a well and pump. (Courtesy Jim and Catherine Reidy family.)

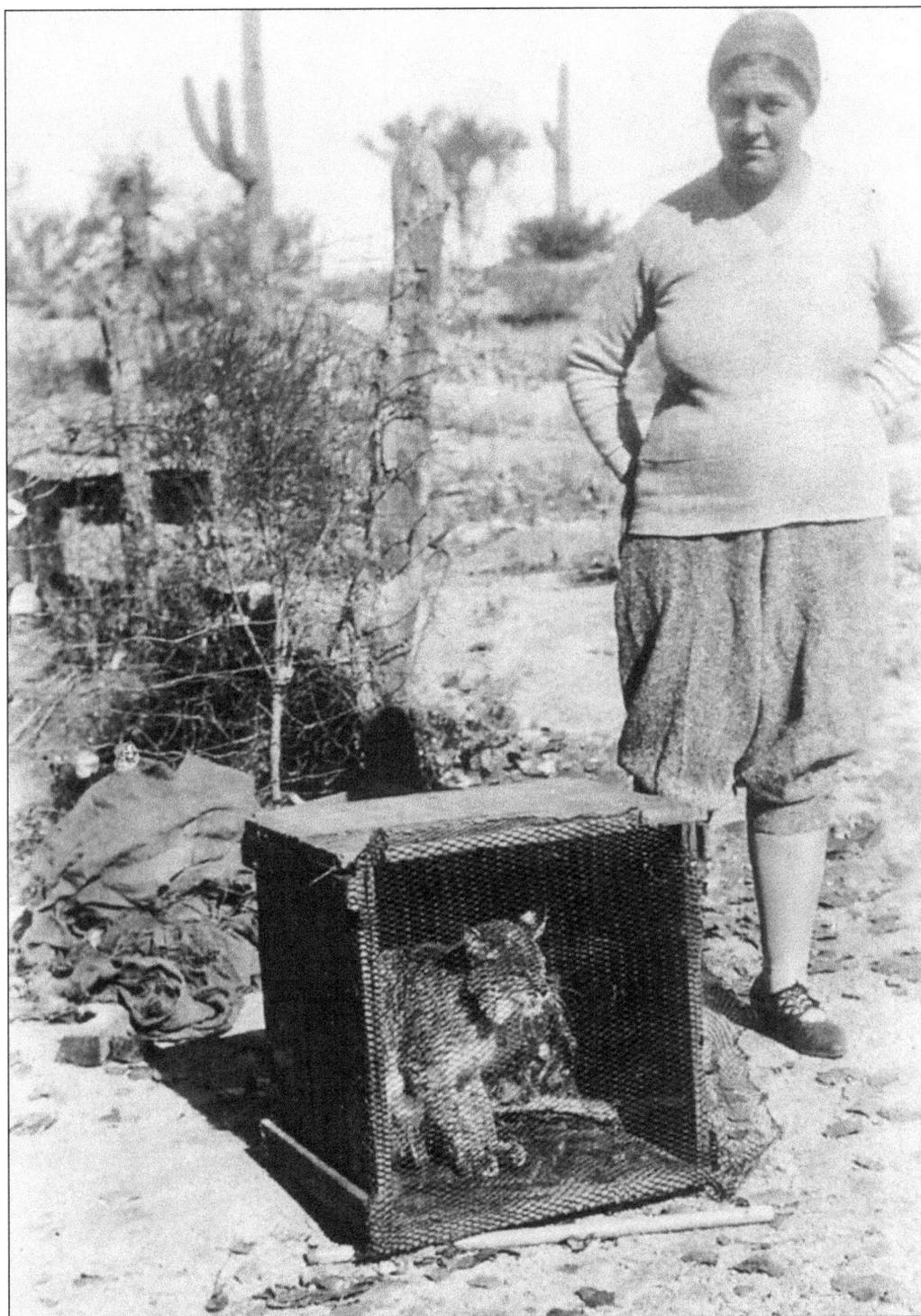

There was more wildlife than rattlesnakes roaming around the homesteads in the early 1930s. A variety of wildlife came down from the mountains. A neighbor of the Reidys captured one of these visitors and decided to cage this bobcat as a pet. (Courtesy Jim and Catherine Reidy family.)

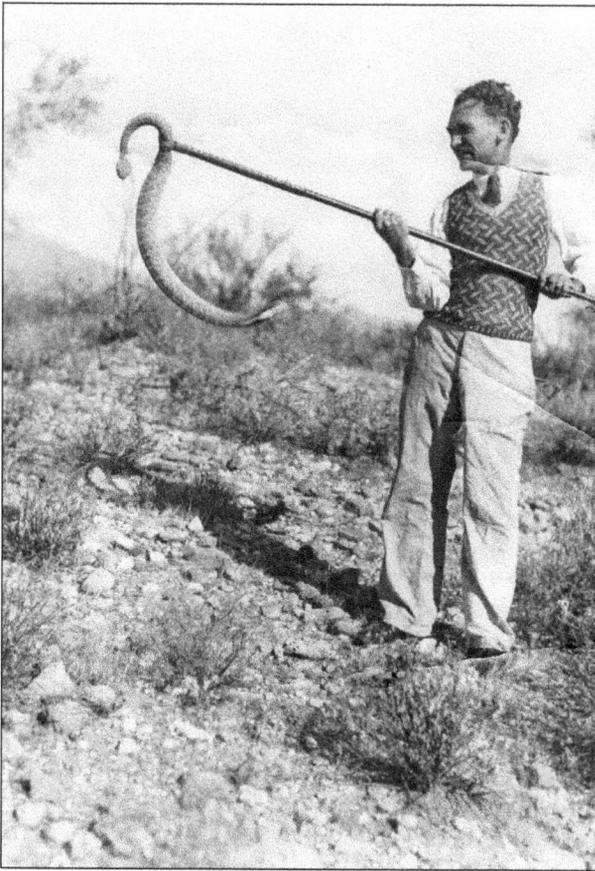

Catherine Reidy's business was making clothing and jewelry from rattlesnake skins. Most of the snakes were brought in from other locations, but Oro Valley desert land had its own rattlesnake population, and Jim and Catherine Reidy would search around their homestead capturing the critters for Catherine's business. Using a long-handled tool, they would pull the snakes from under rocks and cacti. After capturing a snake—still using the long-handled tool—they would chop off the snake's head. The carcass was then stored until Catherine was ready to work on it. (Both courtesy Jim and Catherine Reidy family.)

In the late 1920s, homesteaders did not go to the butcher shop for their holiday dinners. Turkey dinners meant settlers hunted the wild ones in the mountains or raised their own. Months before the holidays, the Reidy family fattened up this one in their backyard. (Courtesy Jim and Catherine Reidy family.)

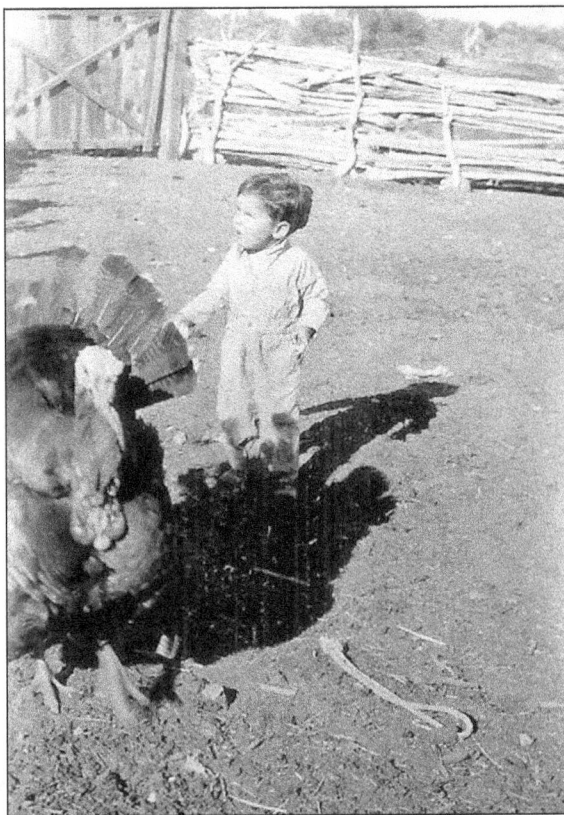

In the Depression, settlers found innovative ways to support their families. Catherine Carey Chapman Reidy put to good use a plentiful resource: rattlesnakes. Two brothers in Oracle would bring her snakes by the truckload, which they unloaded into a pit like the one behind her. (Courtesy Jim and Catherine Reidy family.)

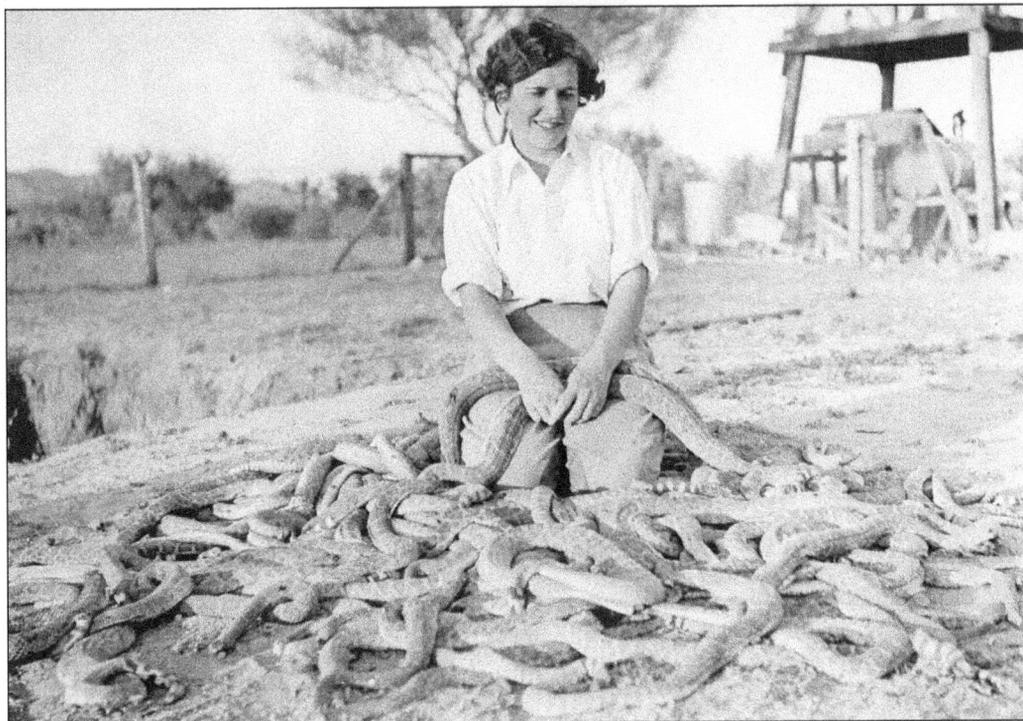

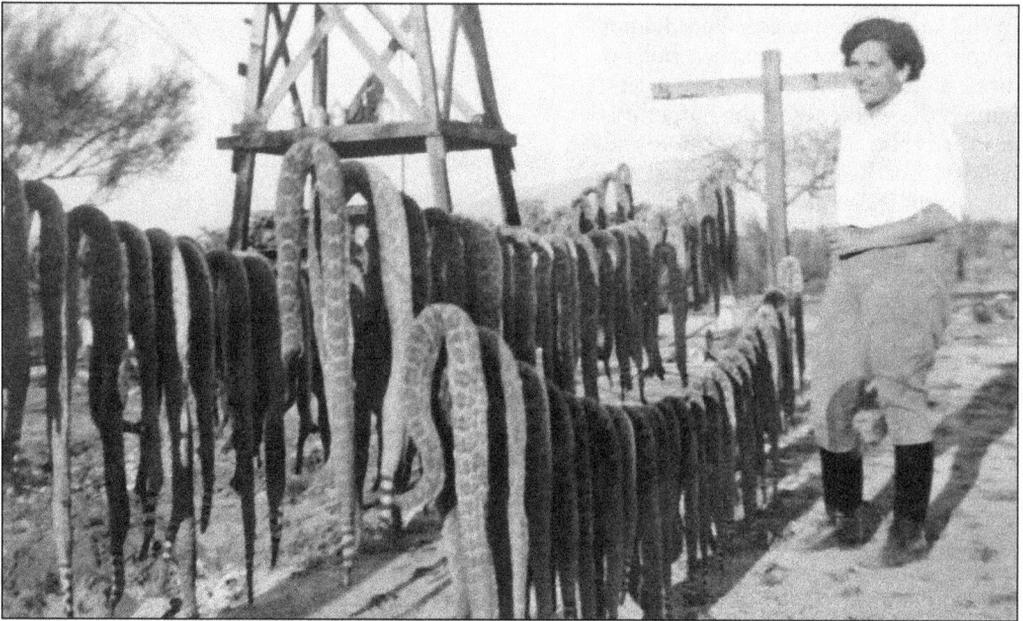

Reidy prepared the snakes for skinning in the 1930s by hanging the headless snakes on lines strung across the yard. While most of the snakes were killed and skinned, Reidy also supplied zoos with live snakes, and some were milked for their venom by a University of Arizona professor. (Courtesy Jim and Catherine Reidy family.)

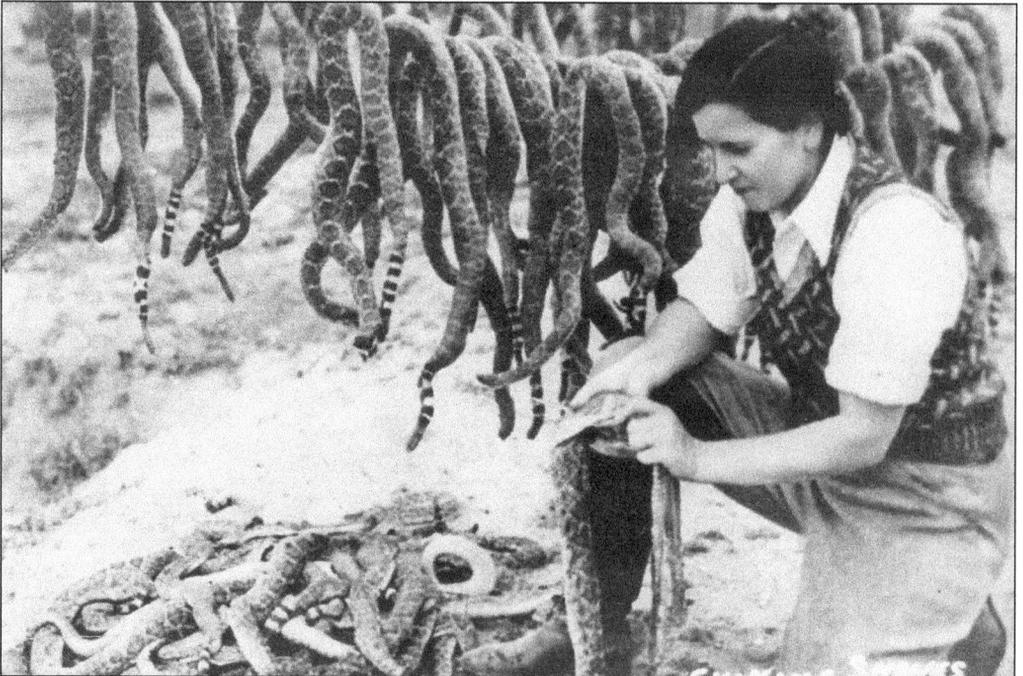

Catherine Reidy skinned the snakes and then used various parts to make jewelry and clothing. Reidy's work became quite popular, and her items were featured in local stores and through special orders. Her most popular items were the jewelry designs she made from the snakes' backbones. (Courtesy Jim and Catherine Reidy family.)

84

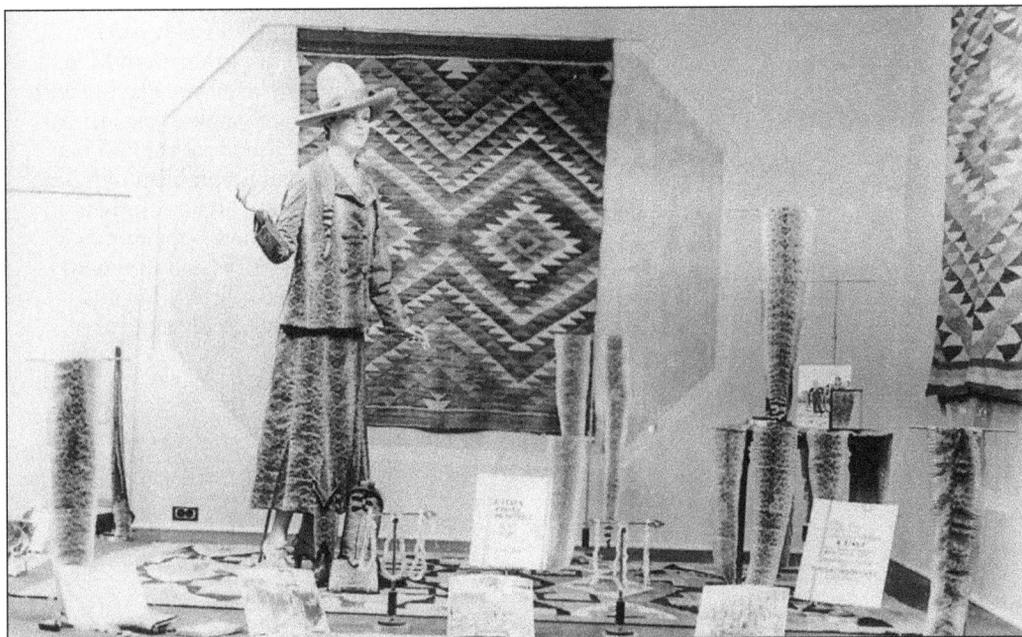

This window in a downtown Tucson department store was an eye-catcher. It featured a suit made from Catherine Reidy's snakeskin, complete with a matching hatband. A few pieces of her jewelry are also displayed, all against a background of western rugs. (Courtesy Jim and Catherine Reidy family.)

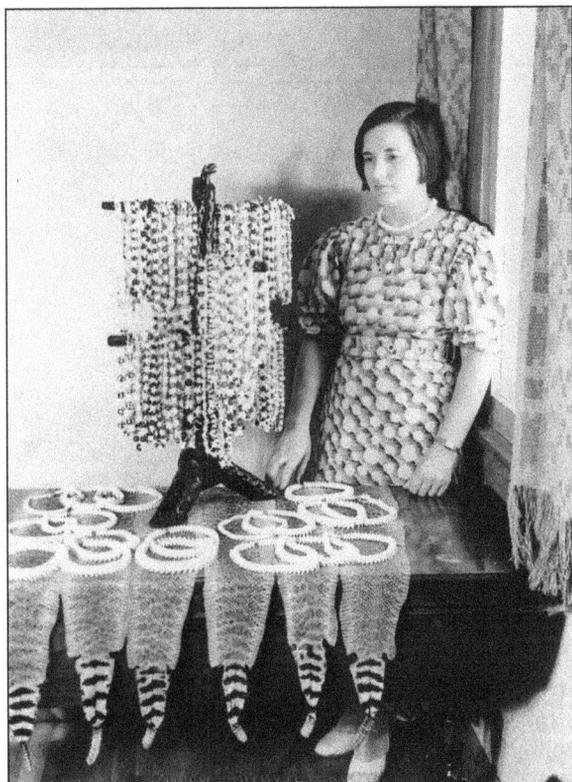

Reidy's work was featured in an individual display in one of Tucson's retail stores. The display table is covered with several of her necklaces, and the stand shows even more. An unidentified salesclerk is modeling one of Catherine's white necklaces. (Courtesy Jim and Catherine Reidy family.)

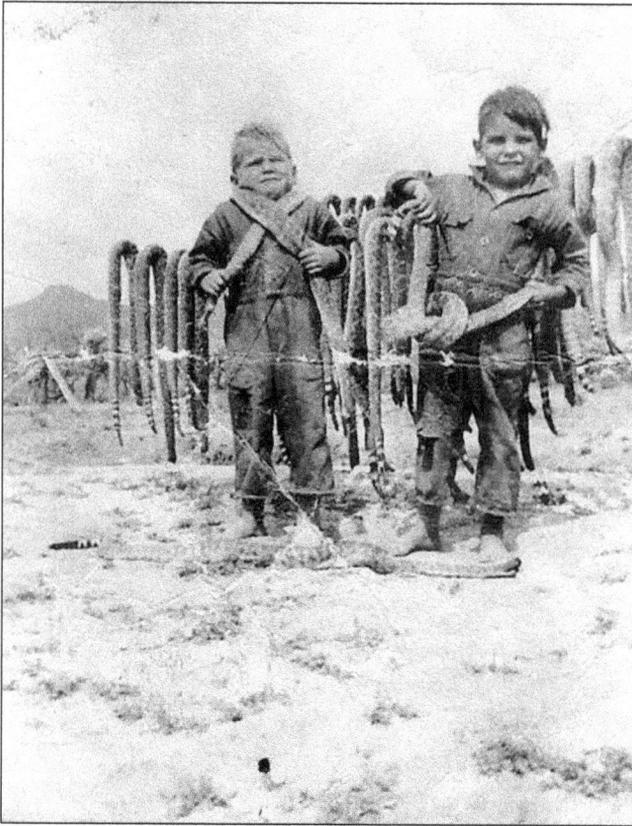

Jim and Dan Reidy used a couple of rattlers from Mom's line as playmates. Playing with dead rattlesnakes was just part of childhood for them. The boys had no problem handling the snakes and using them in creative ways—sometimes as scarves or twisted into new shapes. (Courtesy Jim and Catherine Reidy family.)

In the early 1930s, rustlers were still a problem. When the Stumps, neighbors of the Reidys, saw a strange truck with Colorado plates parked in the area, they called the police. Shortly after that, they came home one night to find their house burned to the ground. The message was clear. (Courtesy Jim and Catherine Reidy family.)

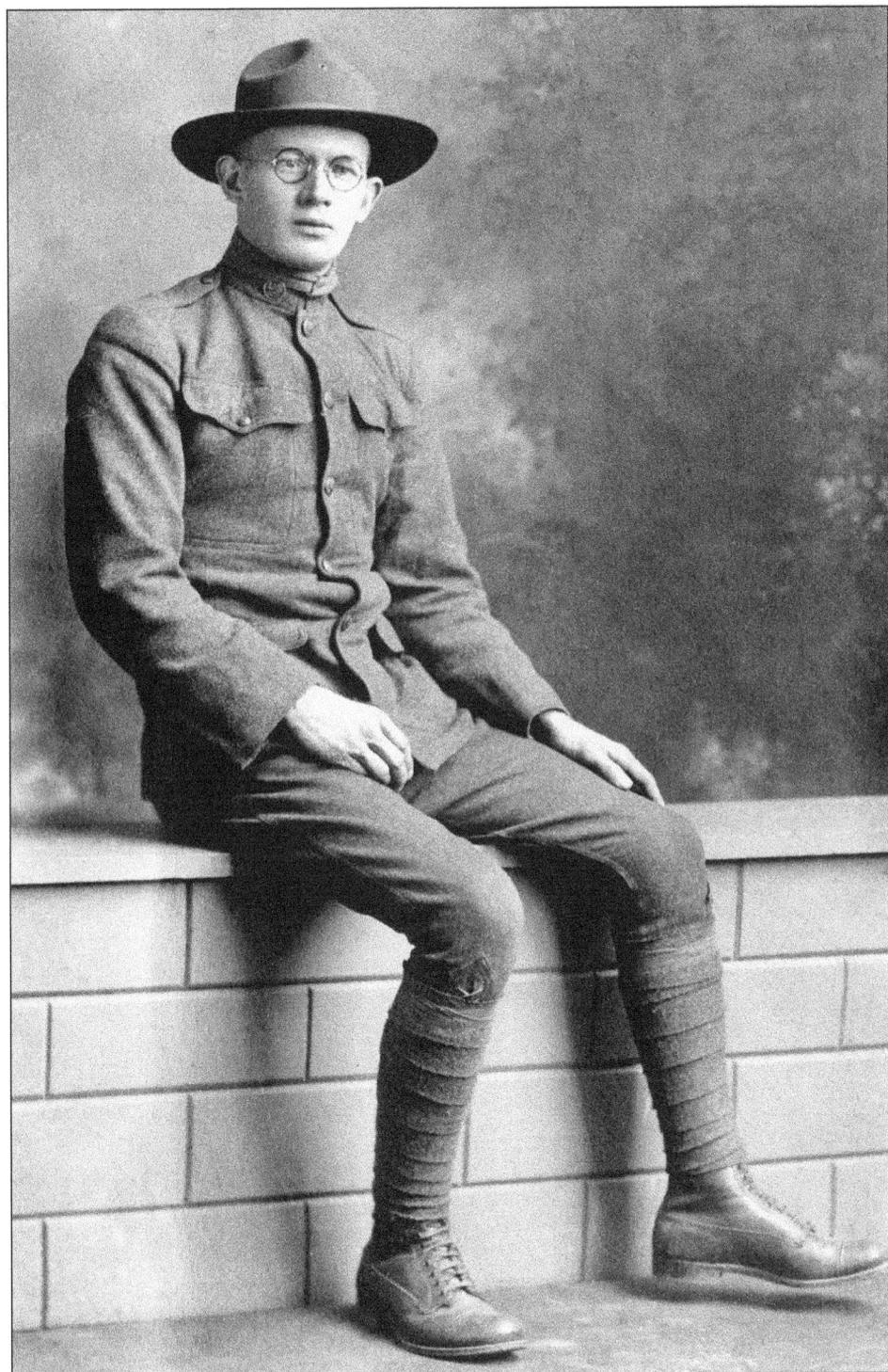

In 1919, Francis Hallett (Hal) Burns arrived in Tucson. A victim of mustard gas poisoning in World War I, he was advised by his physician to move to southern Arizona. After he left the army, he lived with his uncle in Kansas and learned the floral trade. (Courtesy Hal Burns Sr. family.)

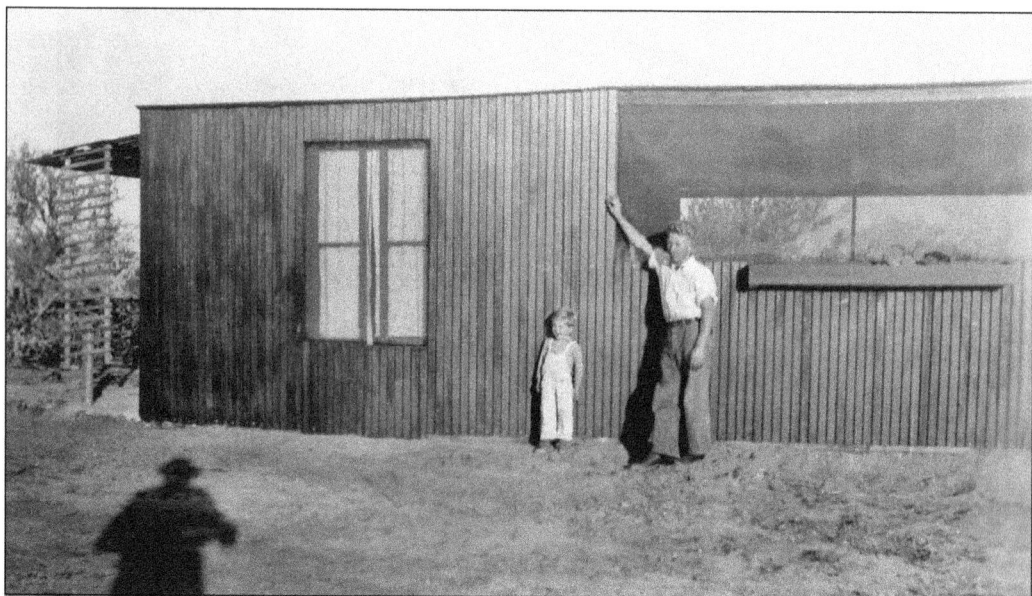

Burns homesteaded near what is now called Shannon Road. He named his land the Carolina Homestead after his home state and named the streets after his children, one of whom is standing next to John Gault, the builder of the house and sleeping porch. (Courtesy Hal Burns Sr. family.)

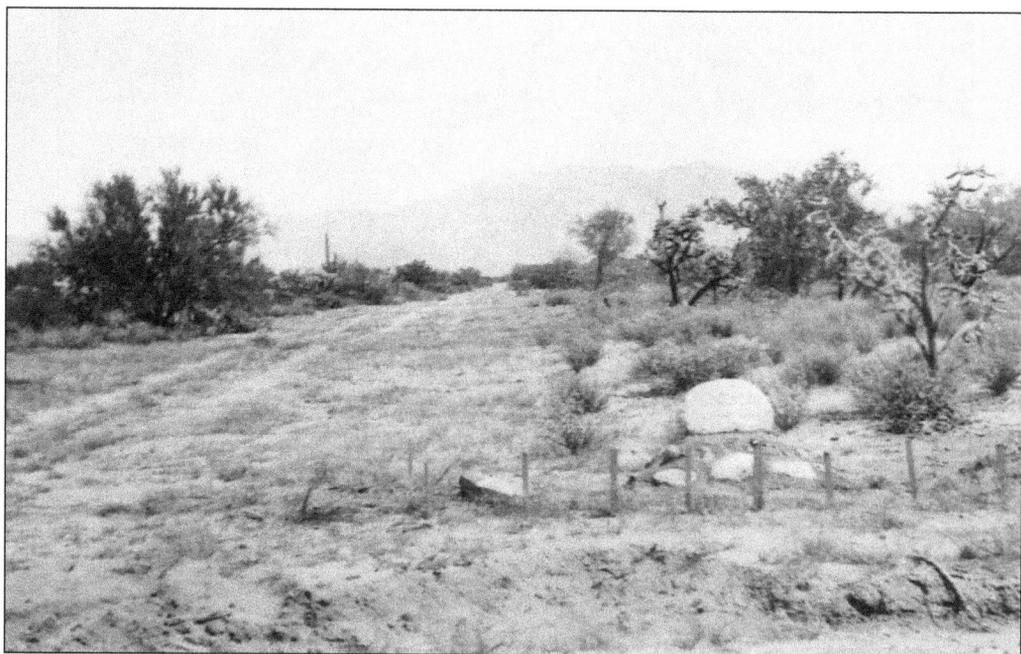

In August 1928, the main road leading out of the Burns homestead was nothing more than a wide dirt trail that was at times impassable during the monsoon rains. Burns named the road after his hometown: Sumter, South Carolina. Today it is a main thoroughfare. (Courtesy Hal Burns Sr. family.)

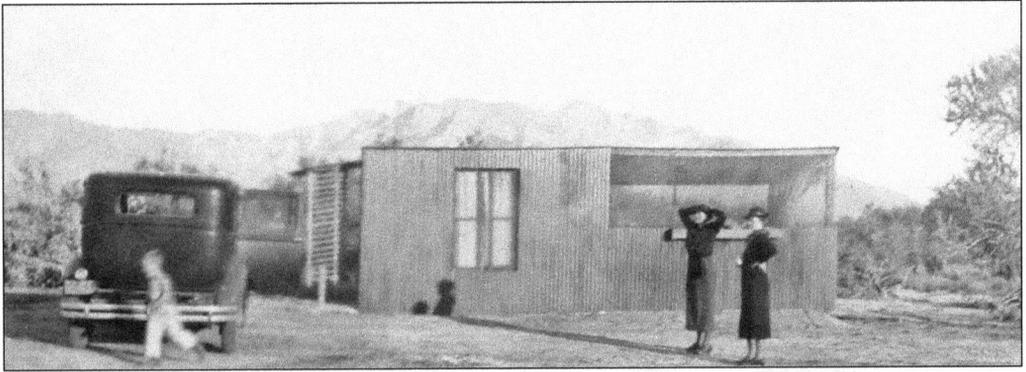

A sleeping porch was a necessity in the desert. Sometimes called an Arizona room, it was an area enclosed with screening. In 1927, May Burns, with her arms raised, and a friend watch her son running past the sleeping porch and around the property. (Courtesy Hal Burns Sr. family.)

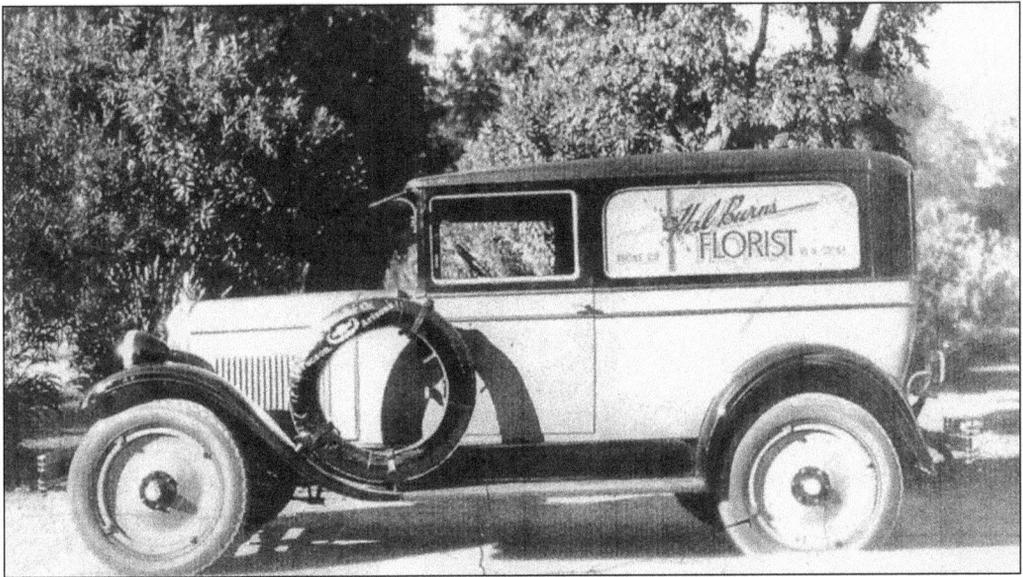

Using the Carolina Homestead and other resources, Burns obtained the plants needed to build a thriving floral business in Tucson. A successful businessman, he owned at one time five floral shops. Delivery trucks such as this one were seen all over town in the 1920s and 1930s. (Courtesy Hal Burns Sr. family.)

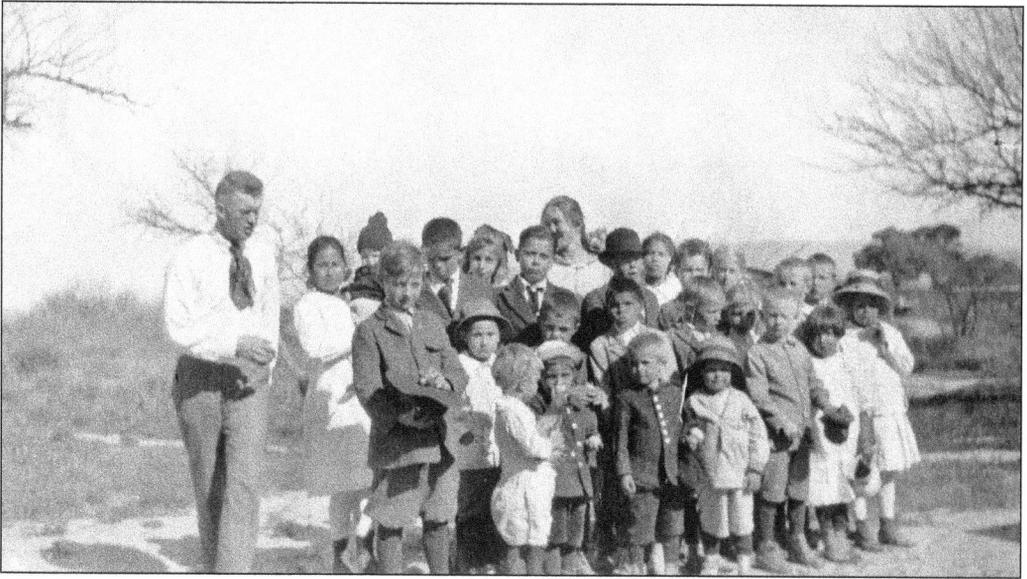

Hal Burns was a man supportive of, and active in, community projects. In the 1930s, he often invited school groups to his Carolina Homestead. He would show the children his various plants, talk about growing crops in Arizona, and give them a treat or two. (Courtesy Hal Burns Sr. family.)

The cultivation of plants in the Oro Valley desert required a lot of water. The washes and rivers were undependable in 1936. Burns contracted for a well. Frank Forsyth drilled for a month, reaching 430 feet at $1.50 per foot. It cost Burns $645 for his well. (Courtesy Hal Burns Sr. family.)

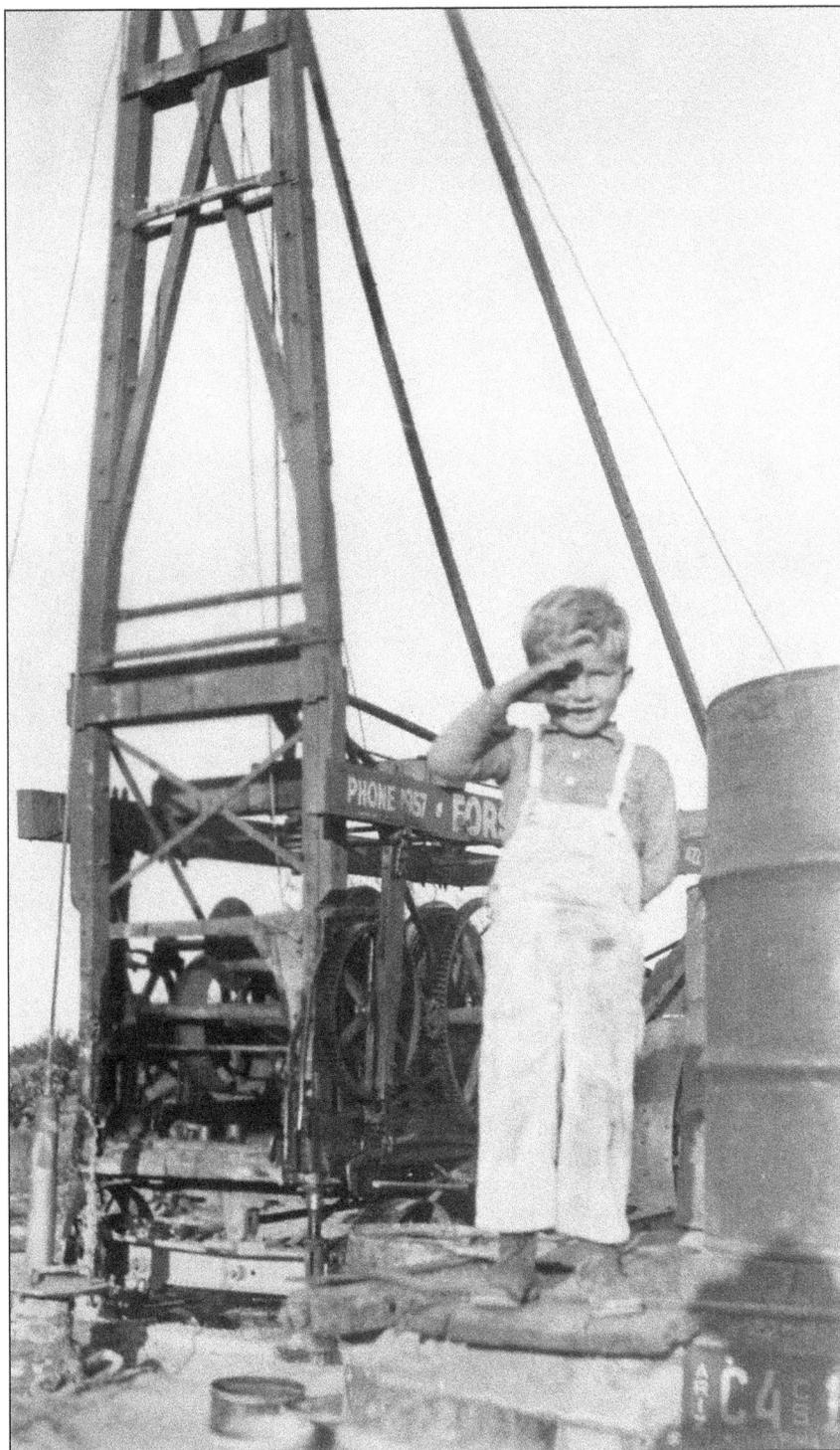

The structure for Burns's well was imposing and too much for a young boy to ignore. It made a great playground for son Hal Jr. Climbing up on the rig, Junior gave a smart salute to any visitors to the homestead. (Courtesy Hal Burns Sr. family.)

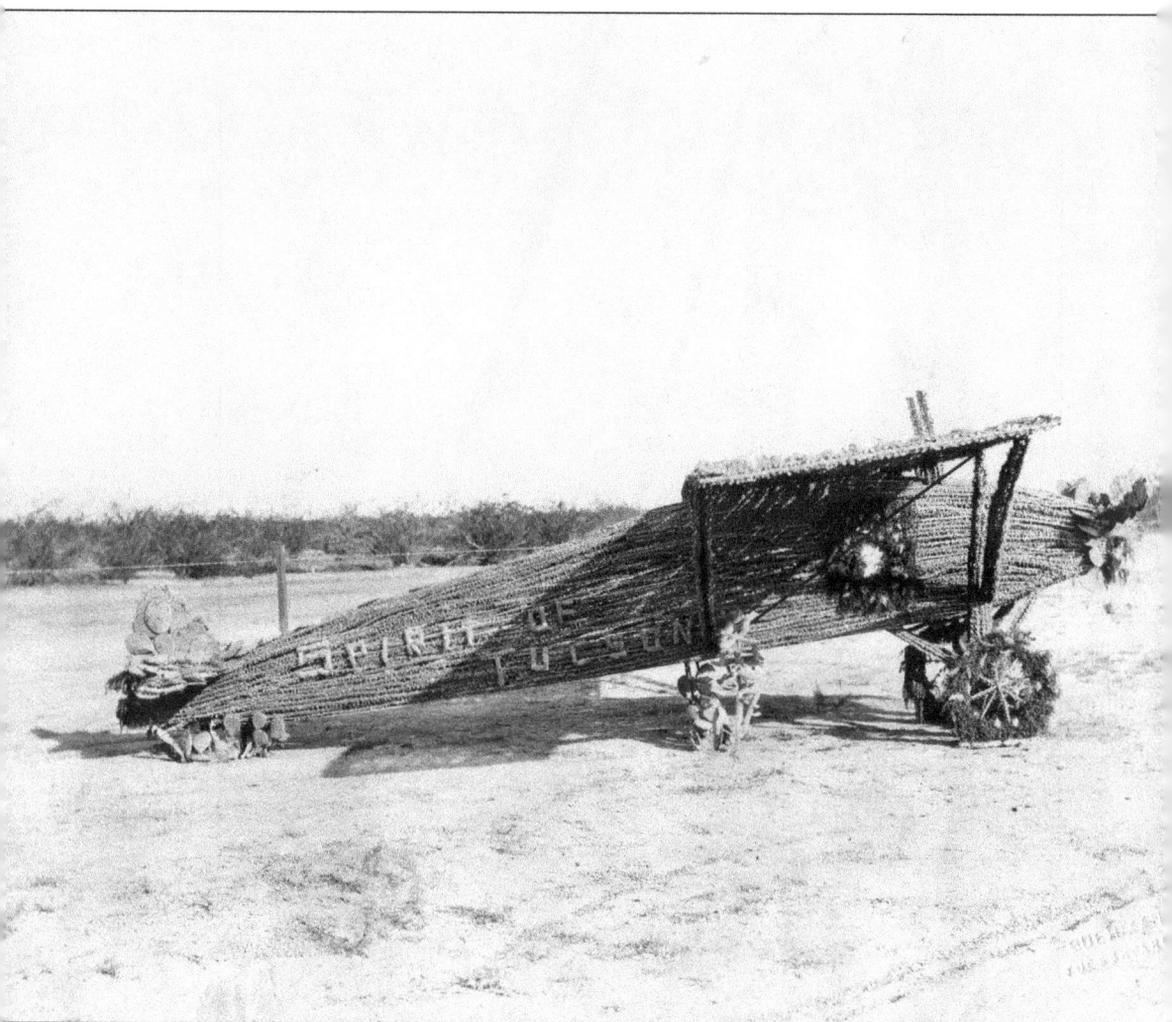

Four months after his world-famous non-stop Atlantic flight on May 21, 1927, Charles Lindbergh visited the Tucson Airport. It was September 23, 1927, and the town's fathers turned out in full strength. The town wanted something different and memorable to commemorate this occasion. They turned to Hal Burns. On his homestead, he gathered the cacti needed to build the *Spirit of Tucson*, a replica of the famous *Spirit of St. Louis* constructed on the same scale as Lindbergh's plane. Burns used ocotillo spines to form the fuselage and wings, prickly pear to form the propeller and tail, half a barrel cactus for the nose cone, and creosote around the cockpit and wheels. Burns completed the full-scale cactus plane in one week. Lindy's comment when he saw it was, "Surely you don't want me to get in that?" (Courtesy Hal Burns Sr. family.)

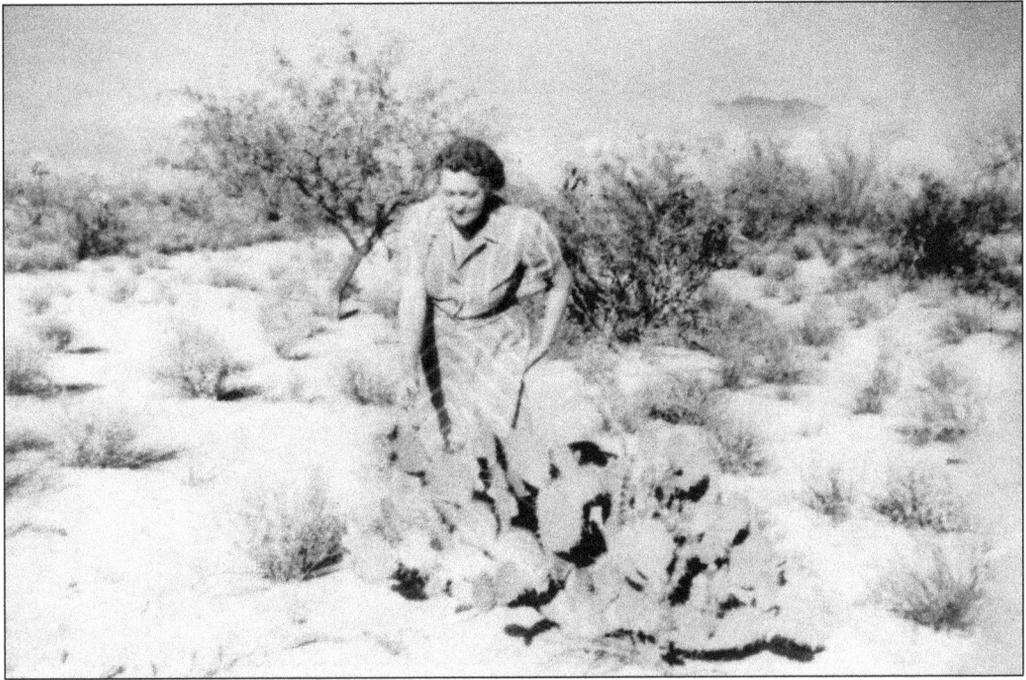
Hal Burns's wife, May, checks some of the cacti growing on the homestead land that was destined to play a unique role in the history of the area. Although Burns cultivated some of the land, he leased most of it out to ranchers for grazing. (Courtesy Hal Burns Sr. family.)

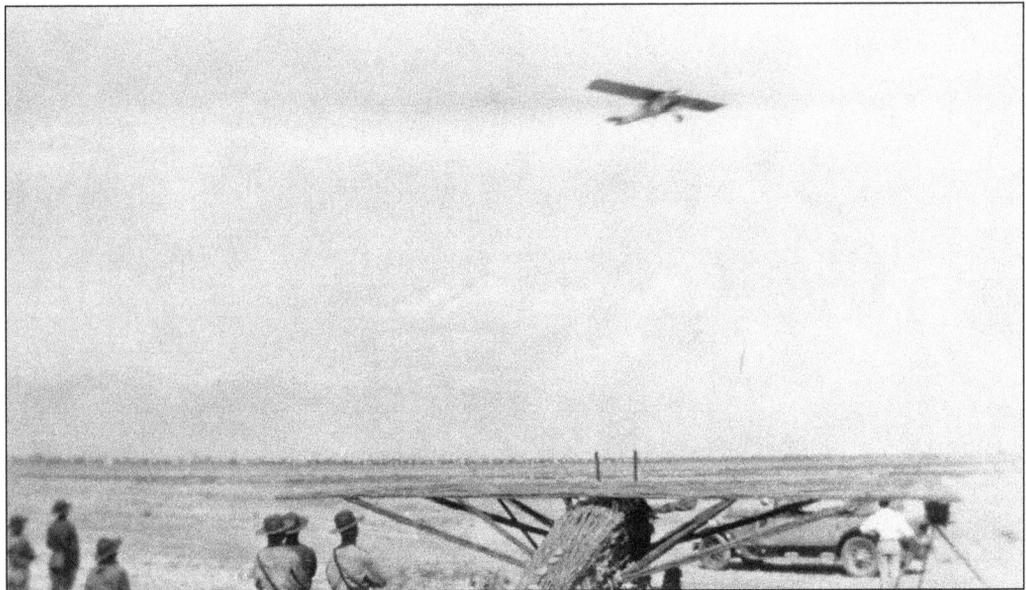
As Lindy approached the Tucson Airport in his *Spirit of St. Louis*, Burns made a hurried trip to his car to get what he needed to make last minute adjustments to his *Spirit of Tucson*. A military escort was on hand to greet Lindbergh. (Courtesy Hal Burns Sr. family.)

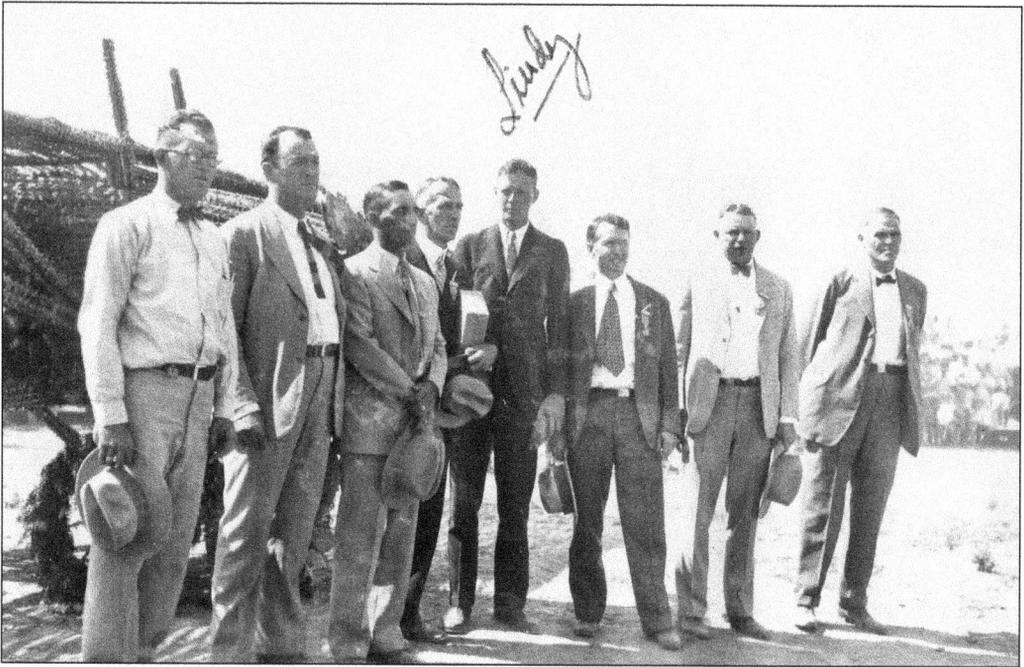

Gathered for the welcome and the presentation was this group of unidentified town officials. A jacketless Burns stands on the left. Lindy, in the middle, towers over everyone. The *Spirit of Tucson* was donated to the airfield. All that remains of it are photographs. (Courtesy Hal Burns Sr. family.)

The Johnsons had chickens and a few goats. One of them was particularly nasty, and the only one who could handle the goat was Carl Johnson. Every time it went to butt, he hit it with a 2-by-4. It did not improve the goat's disposition, but he did not butt Carl. Here a neighbor and Mabel's daughter look the goats over. (Courtesy Mabel Johnson family.)

Mabel Johnson's sister poses in front of the Johnson house. The frame house was 20 feet by 20 feet with one bedroom and a sleeping porch. Billy Coombs was Mabel's neighbor. Coombs was lonesome when Johnson moved to Arizona for her health and talked her sister into joining her. (Courtesy Mabel Johnson family.)

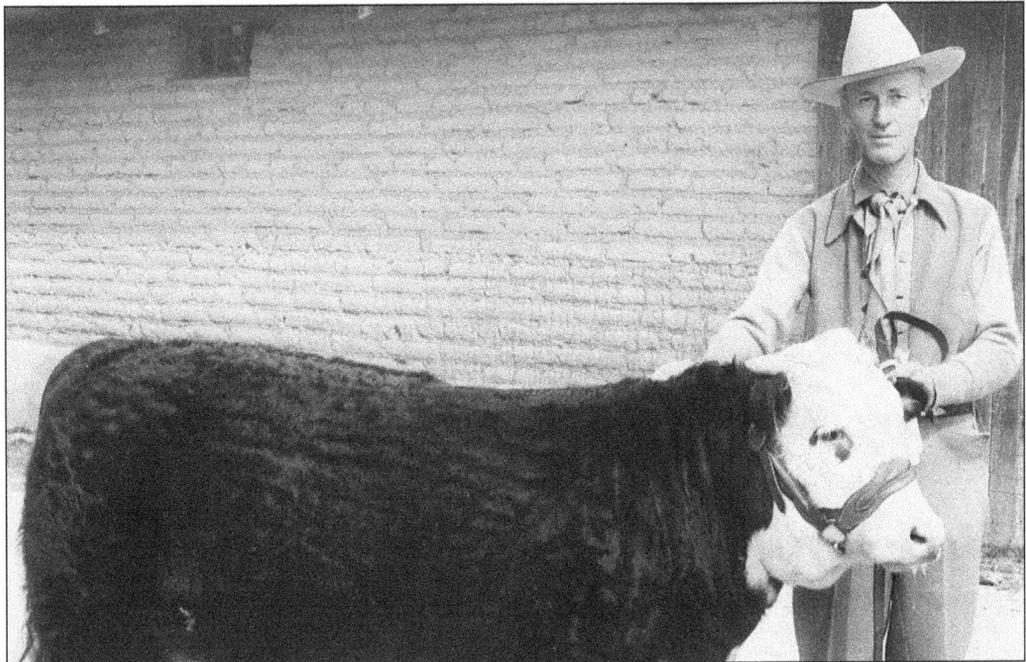

In 1933, the Steam Pump Ranch was purchased by Jack Monroe Proctor. Proctor owned the Pioneer Hotel in Tucson. He put the Steam Pump Ranch to good use by raising food for the hotel, and he stocked the ranch with prize cattle like this bull. (Courtesy Arizona Historical Society, #14-8875.)

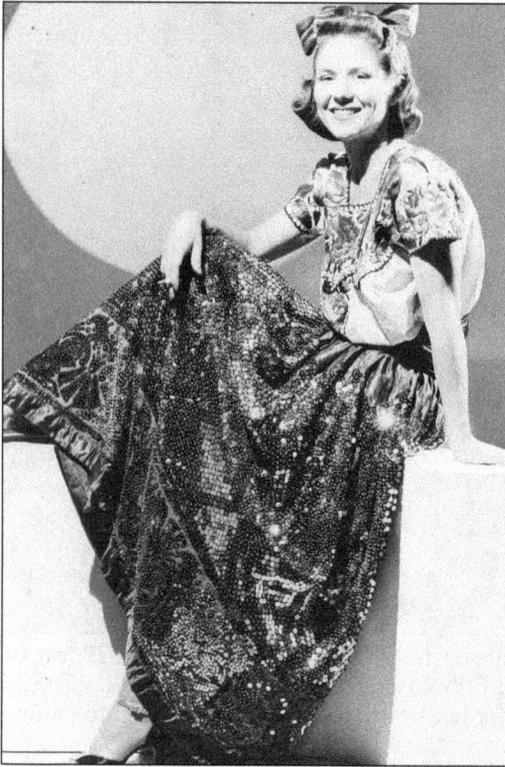

Betty Proctor, the Proctors' beautiful daughter, lit up the Tucson scene with her modeling assignments. While attending the University of Arizona, she modeled for the elegant Ceil Peters shop. The shop carried famous designers' clothes and had a nationally known Southwest line of designs. (Courtesy Arizona Historical Society, #9682.)

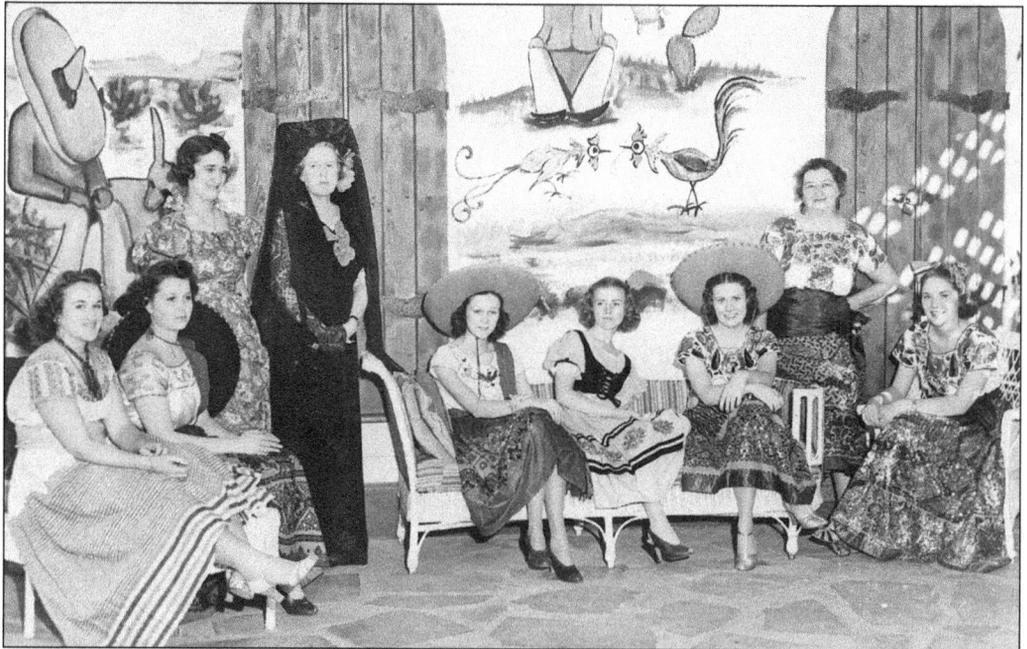

In 1939, Betty Proctor participated in the elite social event of the year, the Baile de las Flores charity ball. From left to right are Barbara Callander, Pauline Correl, Therese Ann Soloman, Mrs. Max Pooler, Jean Kendall, Mildred Cail, Jane Bayle, Marie Mansfield, and Betty Proctor. (Courtesy Arizona Historical Society, #6794.)

Professional baseball player Hank Leiber retired in Tucson and coached at the University of Arizona. He married Betty Proctor and they lived on the Steam Pump. As a famous sports figure, he participated with Byron Nelson in a 1942 Red Cross charity exhibition golf match. (Courtesy Arizona Historical Society, #14-9729.)

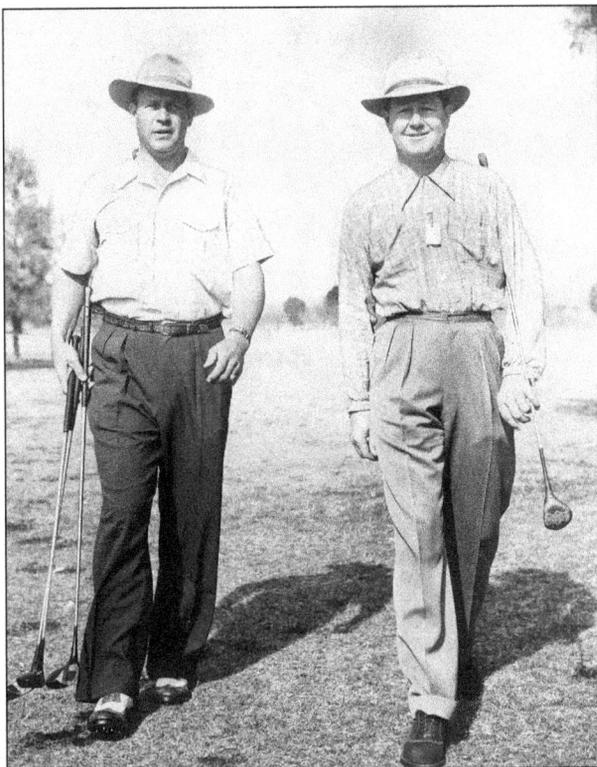

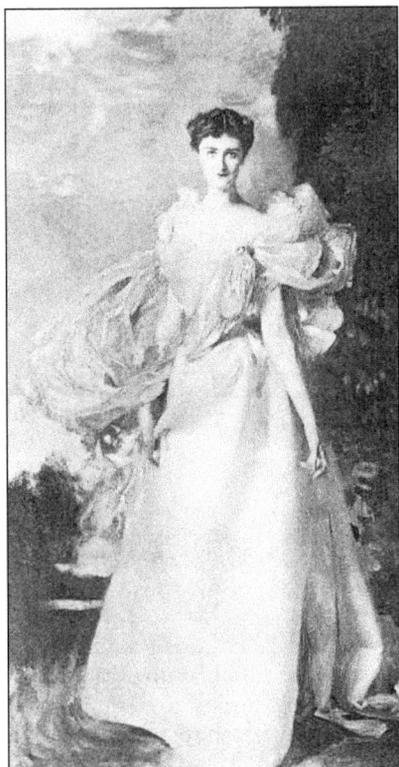

Oro Valley had is own royalty when the Countess of Suffolk bought property in 1934. Daisy, an American, was the daughter of one of the founders of Marshall Field. She lost her husband, the Earl of Suffolk, in World War I. This portrait by John Singer Sargent was painted in 1896. (Courtesy Sybil Needham.)

In 1935, Robert A. Morse designed a house that hinted at art deco for Daisy Leiter Howard, the Countess of Suffolk. It had five master bedrooms, a large kitchen with stainless steel appliances, a dishwasher, air-conditioning, and a bomb shelter that ran under the perimeter of the house. (Courtesy Mike Marriott.)

In 1940, Joe McAdams hired Josias Joesler to design a home for his Santa Catalina Mountain property. Joesler was originally brought to Arizona in 1927 by John Murphy to design a new development of Southern California–inspired homes. (Courtesy Arizona Architectural Archives, College Architecture and Landscape Architecture, University of Arizona.)

Four

NEW DIRECTIONS

In the 1950s, a series of events occurred that forever changed the land northwest of Tucson. It started with the "discovery" of southern Arizona by people from the north and northeast who migrated west looking for jobs, better weather, and a new start.

Meanwhile, a man with dreams who had spent several winters here decided the area needed another golf course. Louis F. Landon heard that Francis Rooney was selling a portion of his Cañada del Oro Ranch. Landon formed a partnership with Joseph Timan, a New York lawyer who was negotiating for the property. They purchased 1,600 acres. In 1958, Landon bought 375 of those acres for an exclusive resort community surrounded by luxury homes. Construction on the golf course started that year. By 1965, the Oro Valley Country Club was well established, and so was the community of Oro Valley Estates.

Late in the 1960s, another event occurred that set the area on an irreversible path. Jim Corbett, mayor of Tucson, made the bold announcement that the city planned to annex the land north of the city. This announcement alarmed the small northern communities. They wanted no part of city politics. A group of concerned residents met in the home of Jim Kriegh. "We wanted to control our own destiny," remembers Kriegh.

They investigated incorporating their area. The law stated no area could be incorporated if it was within six miles of a town. The interested citizens drew up a town plot that was mostly well away from the six-mile limit. The group filed their incorporation papers, which were approved by a lower court. Meanwhile, Tucson moved its boundaries considerably closer to the proposed new town's boundaries and counter filed. The case eventually made it to the state supreme court, and a decision was rendered in favor of the new town. In 1974, it was incorporated with 2.5 square miles and 800 residents.

Several names for the town were initially considered, and Palo Verde was favored. However, hoping to get the support of the Oro Valley Country Club and Estates, the townsfolk officially named their town "Oro Valley."

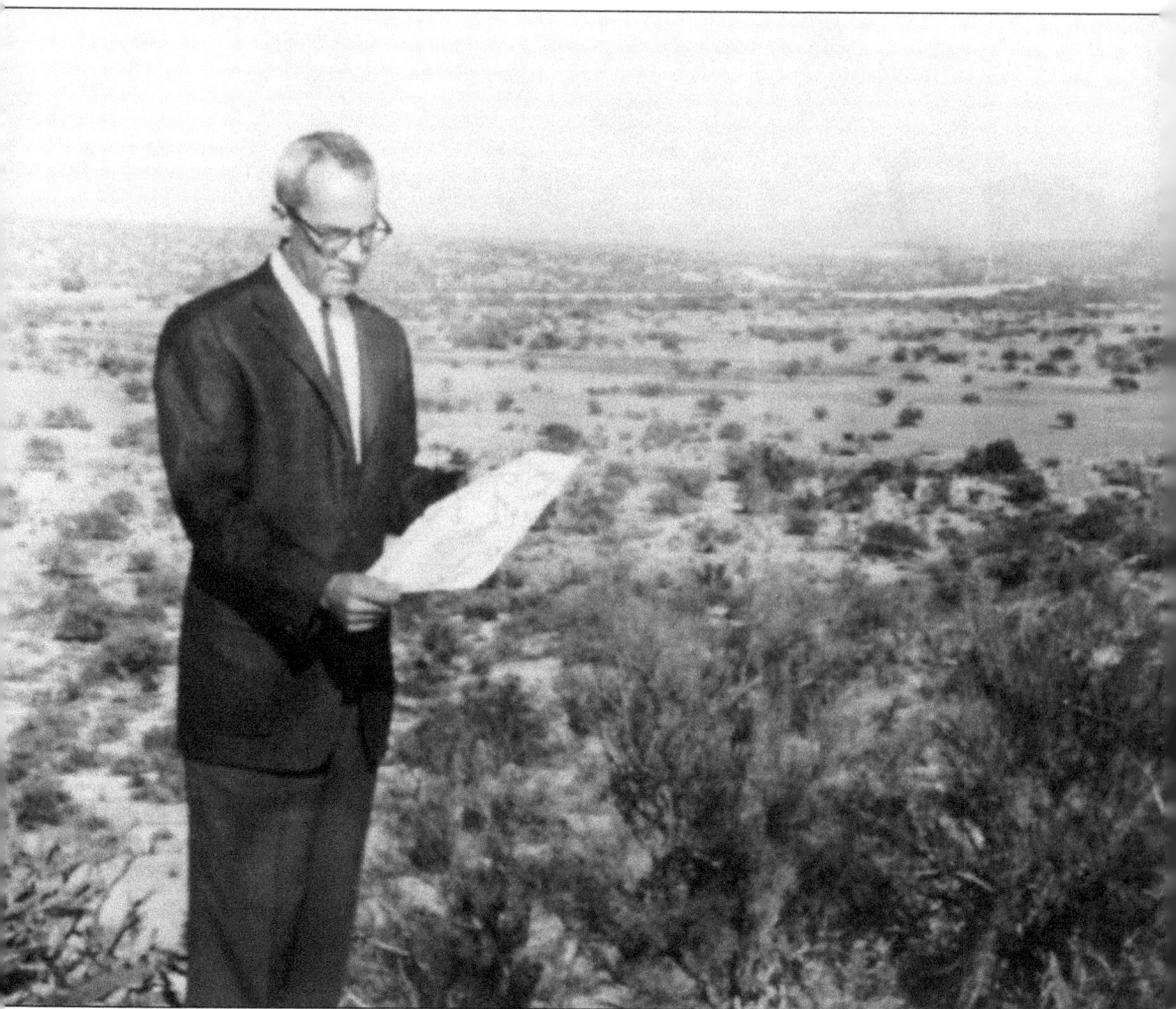

Louis Landon was a man of vision. He was also an avid golfer. He believed the area could use another golf course and set about in 1958 to develop a resort area called Oro Valley Estates that would have a golf course, tennis courts, pool, and luxury homes. (Courtesy Oro Valley Country Club.)

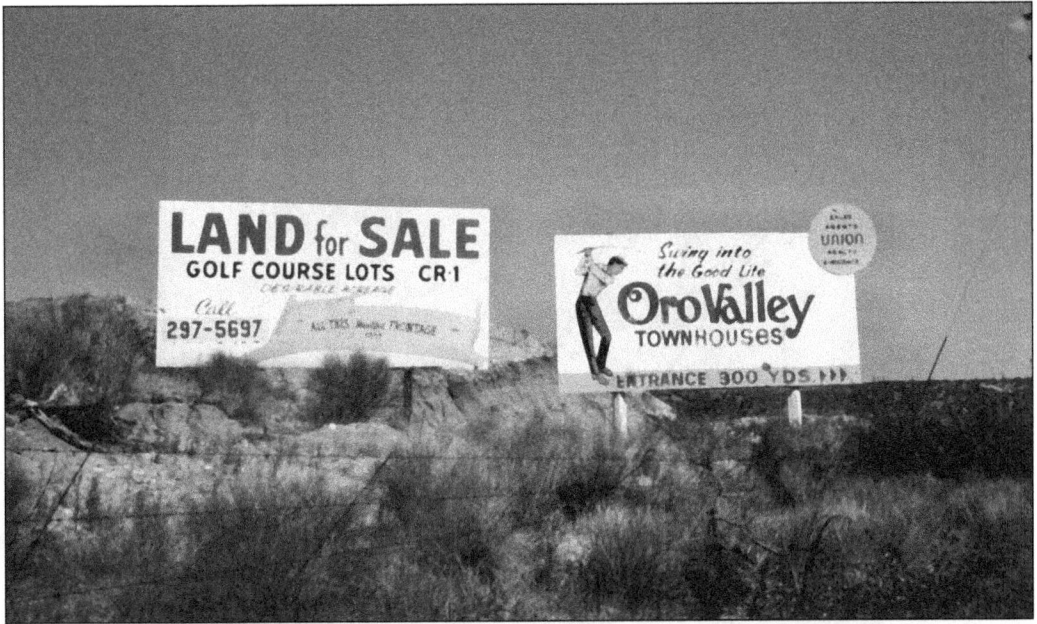

The new development was touted to include an artificial lake for boating, a championship golf course, two plush hotels, health spas, Olympic swimming pools, and a tennis club. However, only the golf course, the Oro Valley Estates subdivision, and a mobile home park were completed. (Courtesy Oro Valley Country Club.)

The Cañada del Oro crossed the property, and it was necessary to dredge the area to prepare the site. As part of the deal, Landon guaranteed that he would complete of the golf course. Good as his word, the completed golf course opened on December 28, 1958. (Courtesy Oro Valley Country Club.)

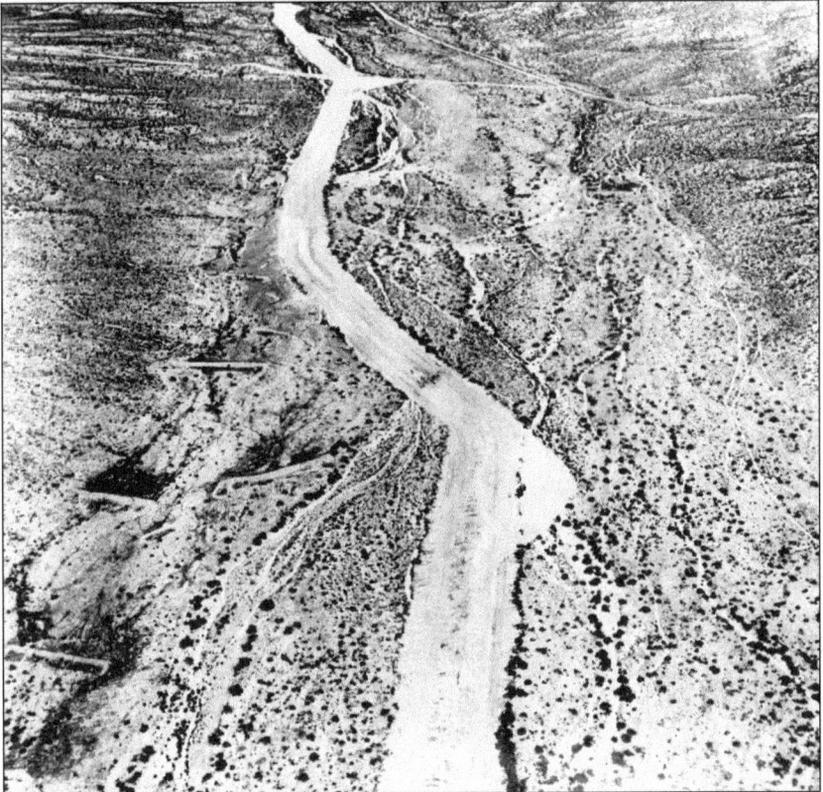

There were few subdivisions and developed land in the area except for the Oro Valley Estates and the country club. On March 1, 1961, the developers agreed to sell the golf course, pro shop, pool, home sites, and the water company to the members for $1.6 million. (Courtesy Oro Valley Country Club.)

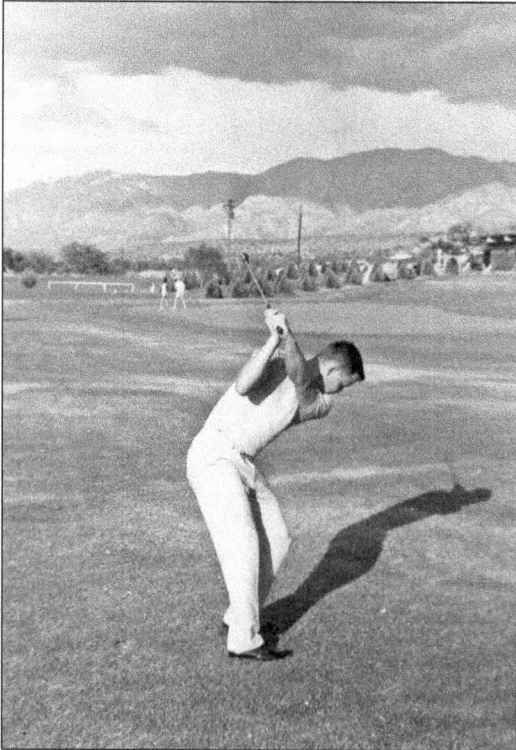

By 1963, the golf course was a prestigious venue for golfers. There were over 200 members and 25 or more houses in the Estates section. The Oro Valley Country Club and the Tucson Country Club were the only equity member clubs in the Tucson area. (Courtesy Oro Valley Country Club.)

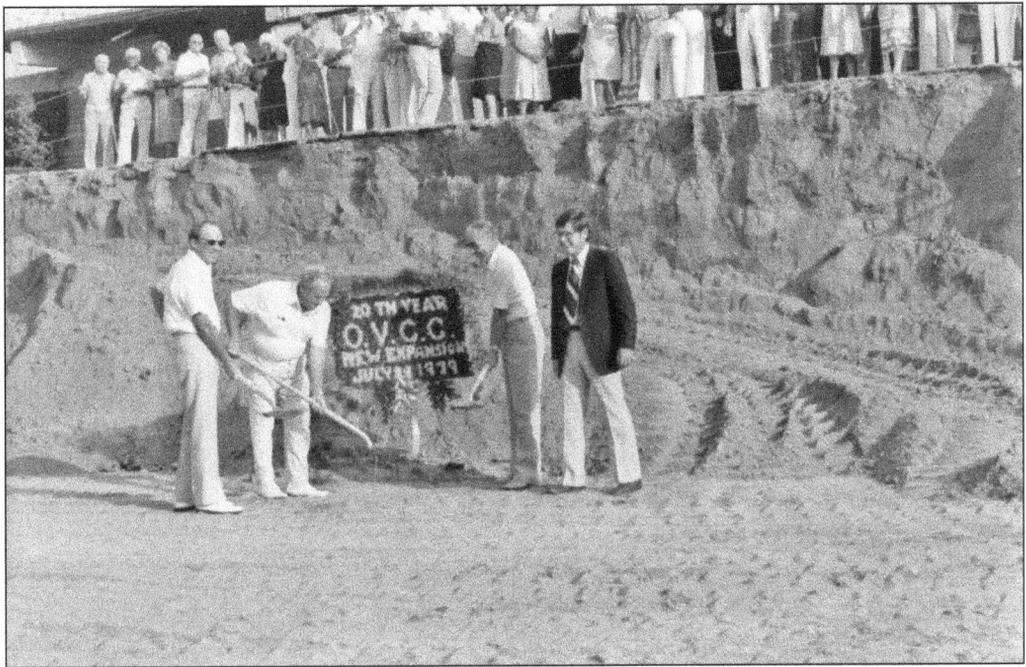

The Oro Valley Country Club celebrated its 20th anniversary in 1979 by implementing expansion plans. The diggers are unidentified members. That also was the year the government soil-cemented the banks of the Cañada del Oro, which removed the area from the 100-year flood plain. (Courtesy Oro Valley Country Club.)

The original plat of Oro Valley Estates called for 235 homes. Sales were slow until the roads were paved. By 1980, the Oro Valley Country Club and Oro Valley Estates were a full-fledged elite community with paved roads and underground utilities. (Courtesy Oro Valley Country Club.)

In 1957, small orchards, chicken farms, and ranches were the norm north of Tucson. That year, Orville Shields planted his peach orchard. But in 1963, after years of crop problems, he replanted first plum trees then citrus trees and invited people to come pick their own. (Courtesy Mike Marriott.)

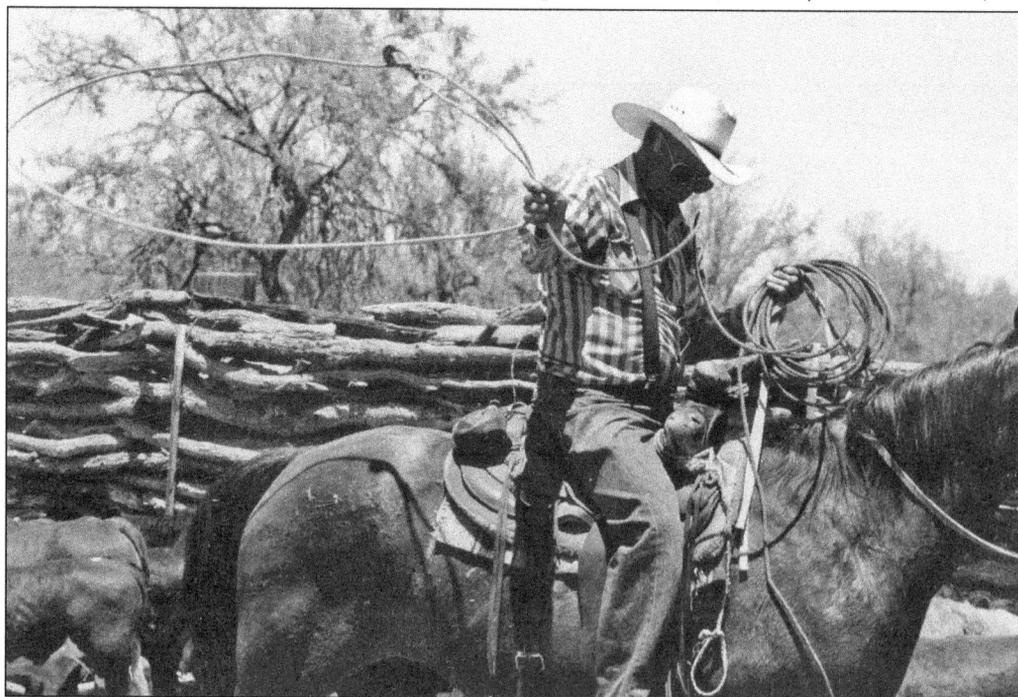

Ranch work never changed over the years. In 1960, it was much the same as it was in the 1800s. By the late 1900s, the Steam Pump was a much smaller ranch, but still Dan Kretschmer needed all of the old cowboy skills in the round-up. (Courtesy Dan Kretschmer.)

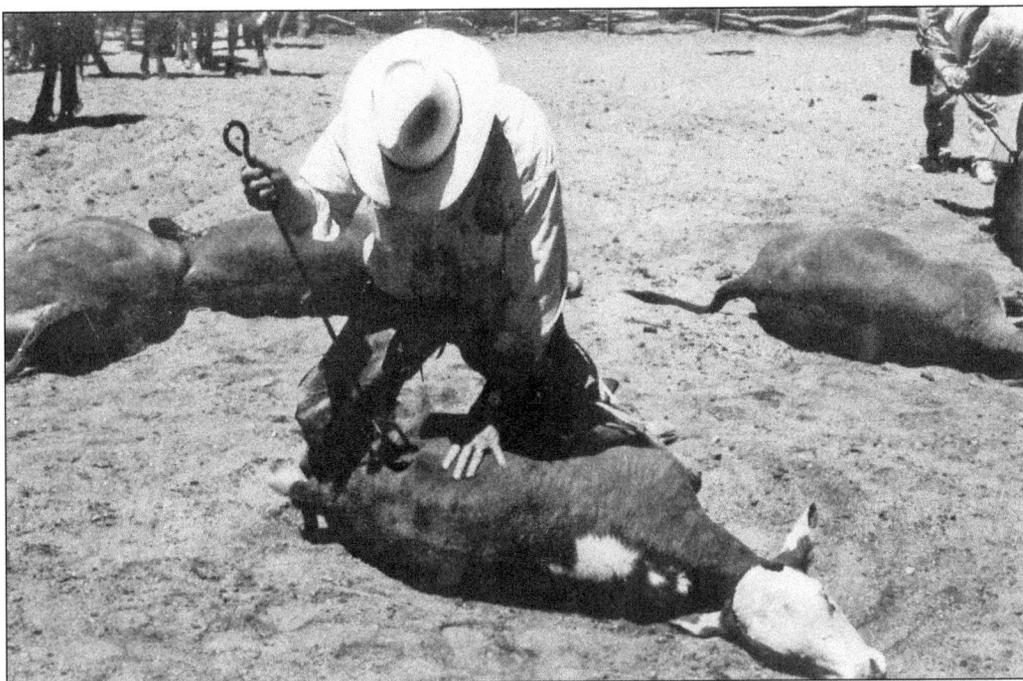

In the 1960s, Steam Pump Ranch cowboys branded cattle after calving in the spring and after roundup in the fall. Cattle are branded on their sides or their butt, and ear marking, dehorning, and the administration of shots are all done at the same time. (Courtesy Dan Kretschmer.)

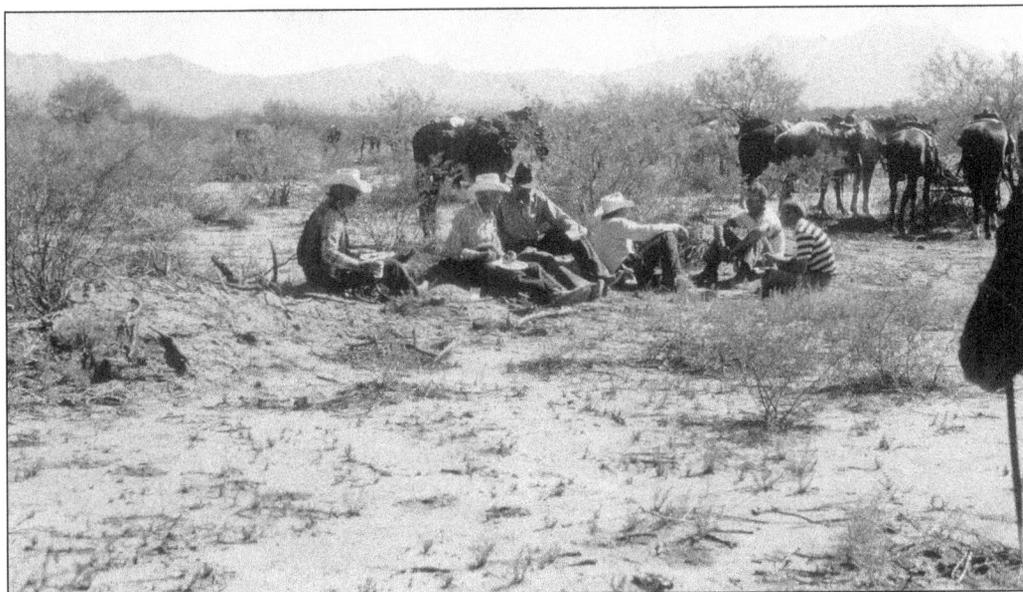

Steam Pump hands take a break out on the range from rounding up cattle. The cacti make roundups harder for cowboys and horses that need to run down the cattle while steering clear of thorns. Usually ranchers will bring in extra cowboys during roundup time. (Courtesy Dan Kretschmer.)

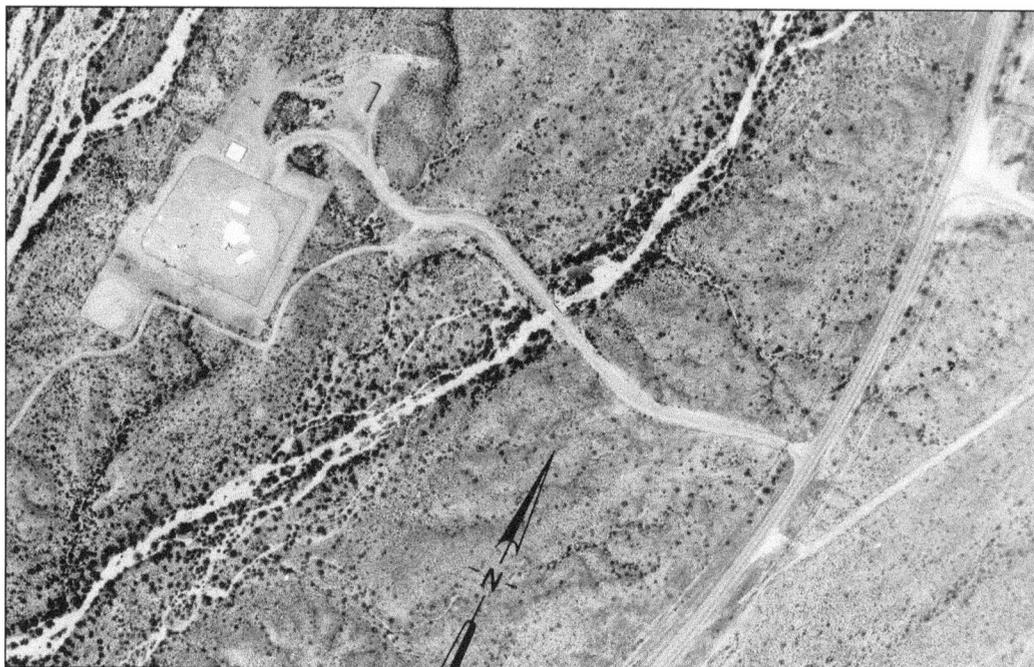

In 1960, the U.S. Air Force picked this site for a Titan missile compound. Access was from Oracle Road. In 1963, progress on the site consisted of the cleared and marked land. Work on missile sites was dangerous, and five construction workers died around the country. (Courtesy U.S. Air Force, Titan Missile Museum, Sahuarita, Arizona.)

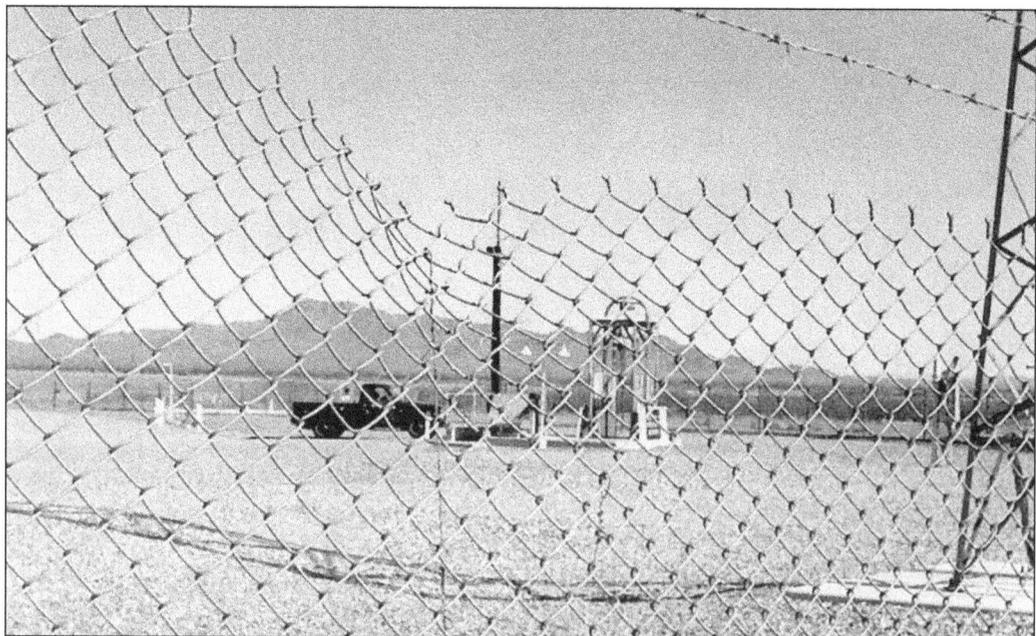

Eighteen Titan missile sites ringed the Tucson area. One of these sites was in the northern tip of Oro Valley. Travelers up Oracle Road could see the chain-link fence and an unidentified truck, but little else. Nothing hinted that this was a government missile site. (Courtesy U.S. Air Force, Titan Missile Museum, Sahuarita, Arizona.)

106

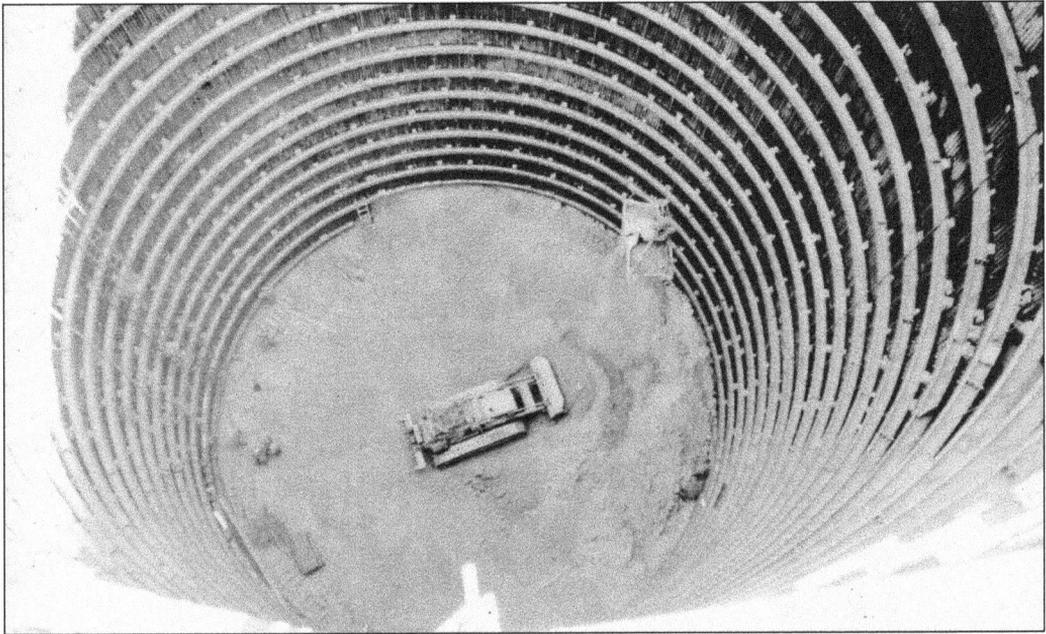

One of the most demanding and difficult jobs on the construction site was digging the silo, which was 150 feet deep, 55 feet in diameter, and built of heavily reinforced concrete. Nine levels of equipment rooms and access space were built into the silo's sides. (Courtesy U.S. Air Force, Titan Missile Museum, Sahuarita, Arizona.)

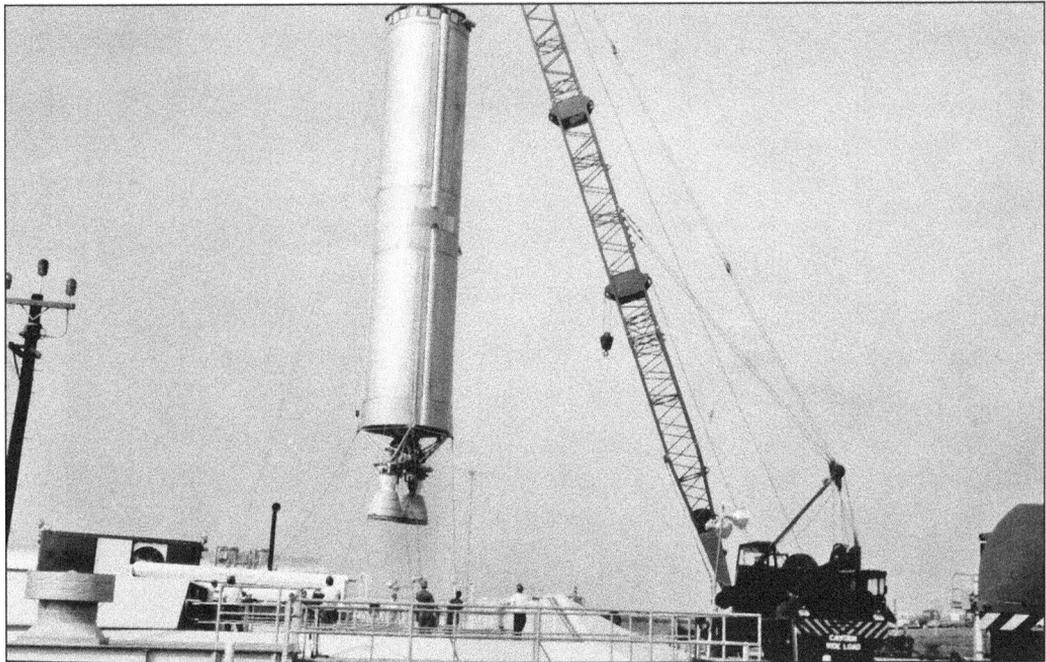

On September 24, 1963, the northern Oro Valley missile site inserted a Titan II missile into the silo. The complete missile airframe weighed 15,000 pounds, but with a full load of propellant, the weight soared to over 330,000 pounds. (Courtesy U.S. Air Force, Titan Missile Museum, Sahuarita, Arizona.)

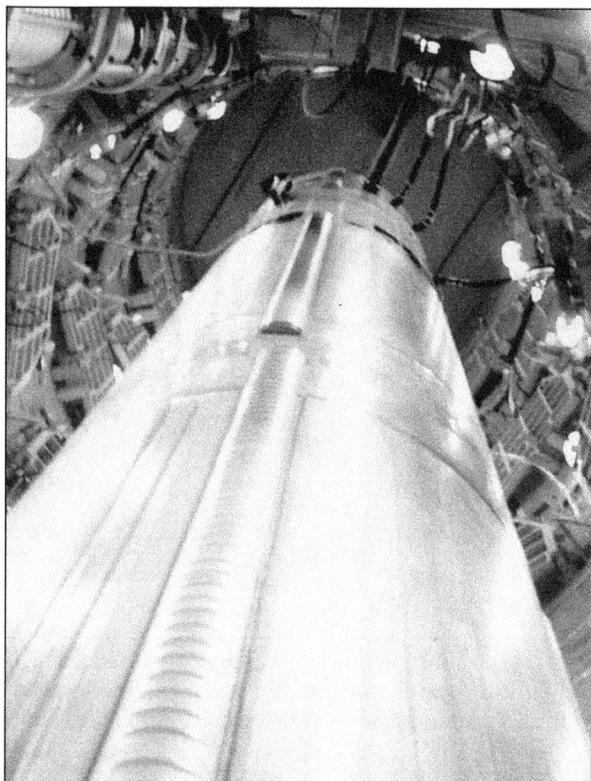

The Titan II missile in the Oro Valley silo in 1963 could hit targets 5,500 miles away from it launch site, and it would reach its destination in 35 minutes. The Titan II was a two-stage booster using liquid hypergolic propellants as fuel. (Courtesy U.S. Air Force, Titan Missile Museum, Sahuarita, Arizona.)

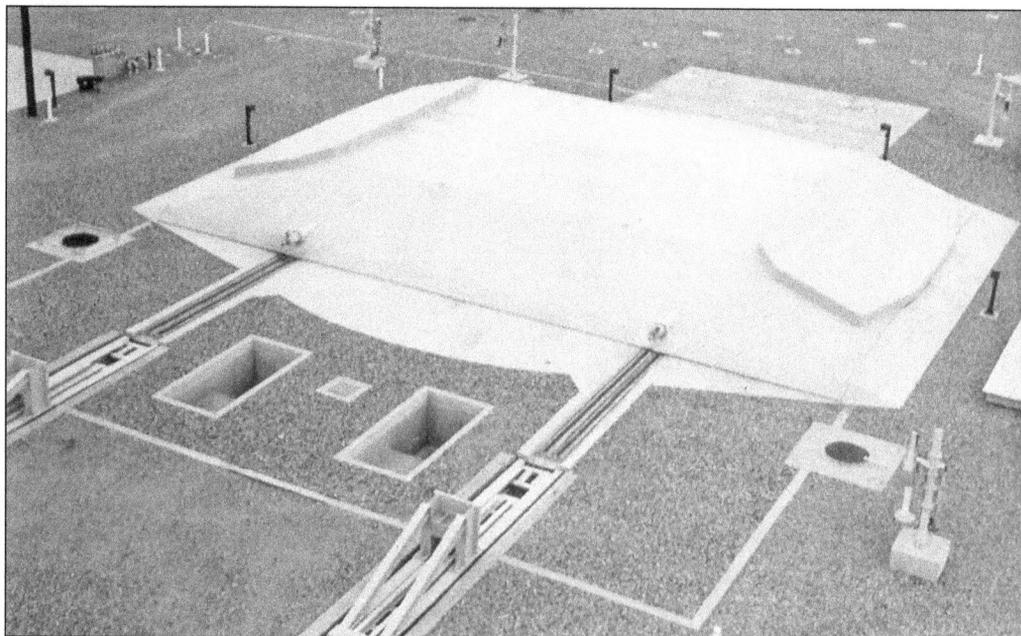

The missile surface in 1963 revealed a 600-foot-by-600-foot area covered by a steel and concrete door that weighted 750 tons and could be opened in 20 seconds. Two exhaust ducts that ran the length of the silo vented on the surface. (Courtesy U.S. Air Force, Titan Missile Museum, Sahuarita, Arizona.)

The silo, blast lock, and launch control center were connected by a 250-foot cableway or walkway. Electrical cables lined the walls of the corridor. The walkway was mounted on hydraulic shock absorbers to stabilize it during a launch or in case of a surface attack. (Courtesy U.S. Air Force, Titan Missile Museum, Sahuarita, Arizona.)

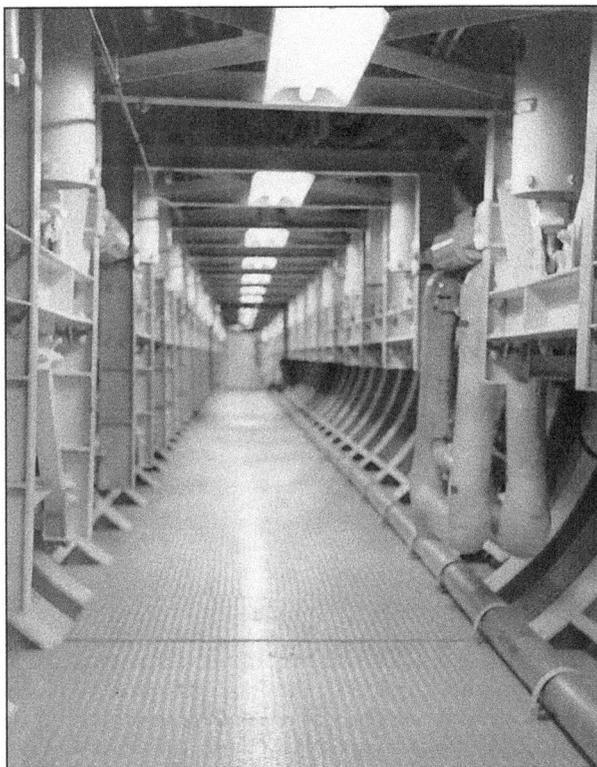

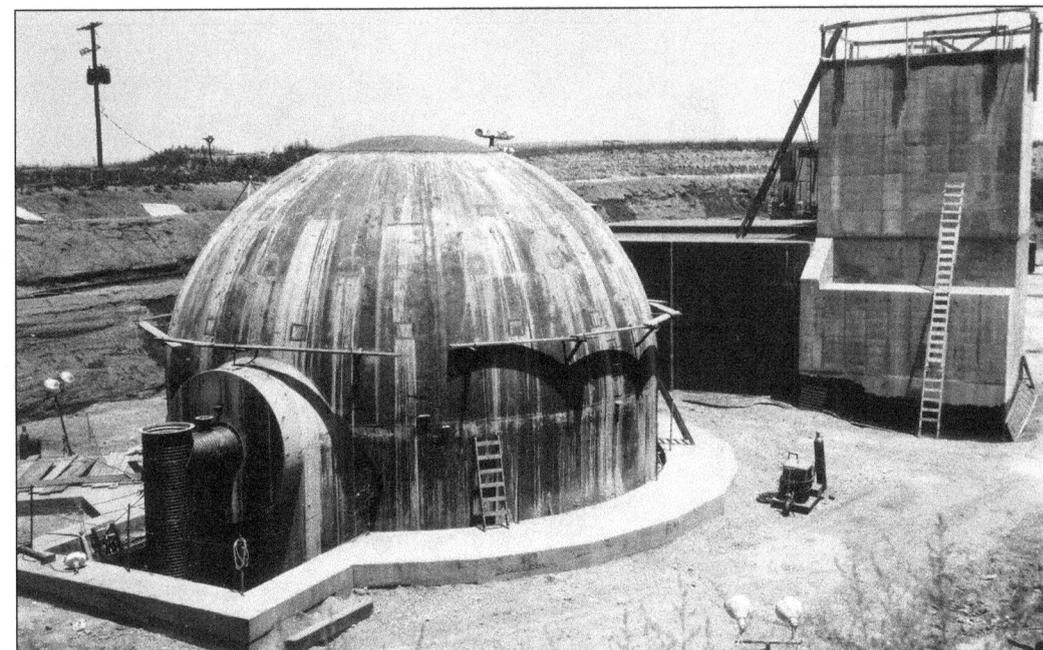

In the 1963 construction stage, the dome-shaped structure looked more like an observatory than a military center. The reinforced concrete structure is 37 feet in diameter with three stories containing the control center, communications equipment, a mess, and sleeping quarters for all the combat crew. (Courtesy U.S. Air Force, Titan Missile Museum, Sahuarita, Arizona.)

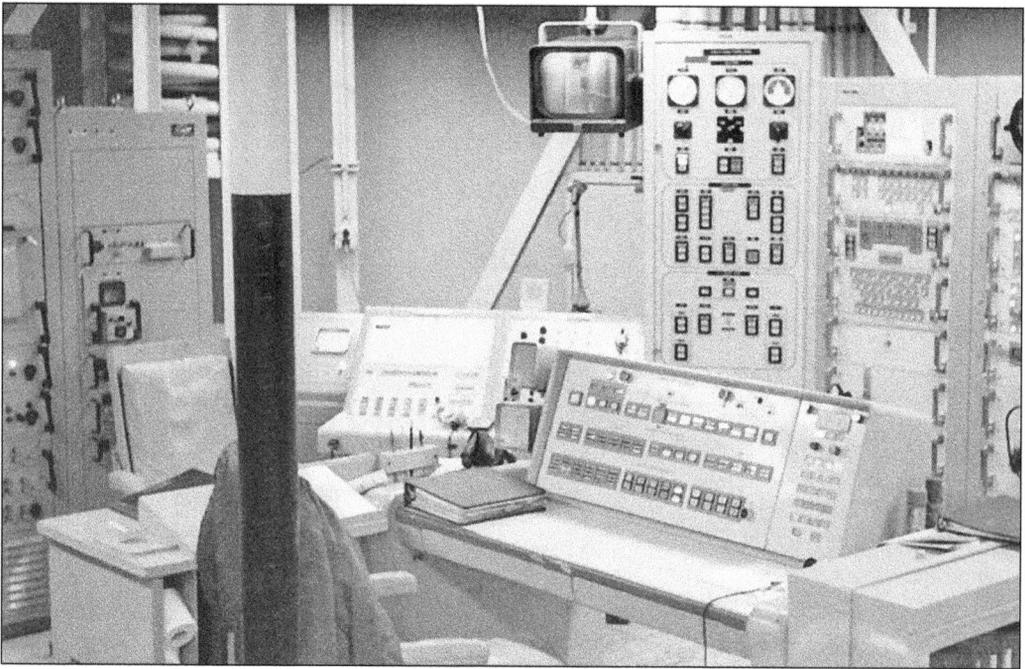

The command center's complex computerized system operated the launch and its vital communications system. The fuel used was highly toxic, but the Oro Valley site remained safe during its 20 years of operation. Nine airmen were killed in Kansas late in the 1970s when their silo leaked. (Courtesy U.S. Air Force, Titan Missile Museum, Sahuarita, Arizona.)

In 1963, two unidentified crews in the Oro valley missile site take a break. Crews worked a 24-hour shift. Each crew consisted of a missile combat crew commander, a deputy missile combat crew commander, the ballistic missile analyst technician, and the missile facilities technician. (Courtesy Vista de la Montaña United Methodist Church.)

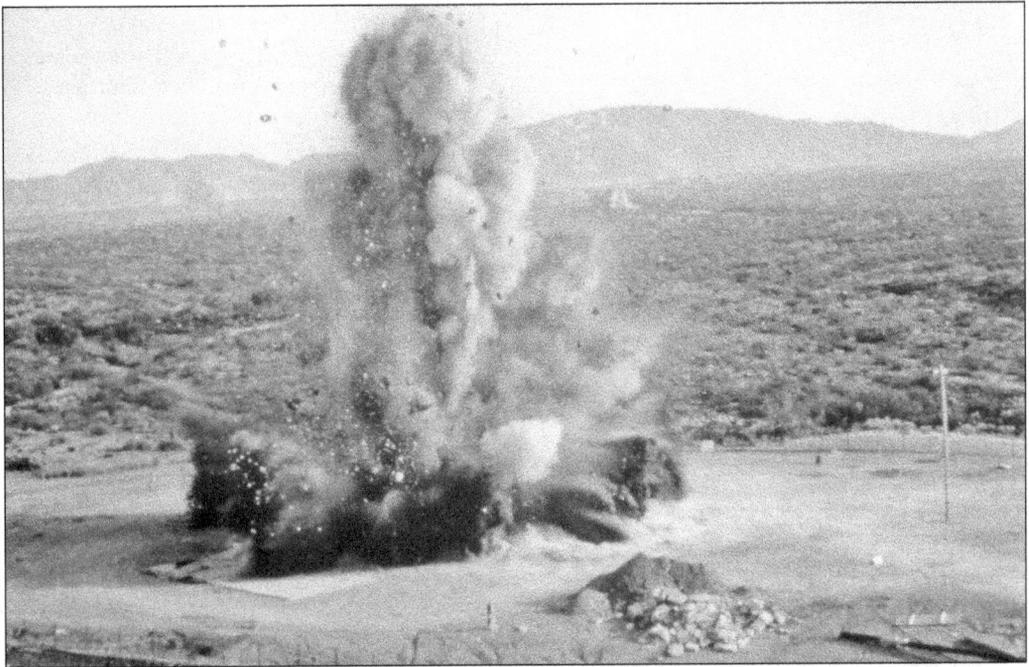

On November 30, 1983, the U.S. Air Force deactivated the Oro Valley missile site. About 2,800 pounds of high explosives were used to destroy the top 25 feet of the silo. Debris was plowed into the silo and capped with three feet of concrete. (Courtesy U.S. Air Force, Titan Missile Museum, Sahuarita, Arizona.)

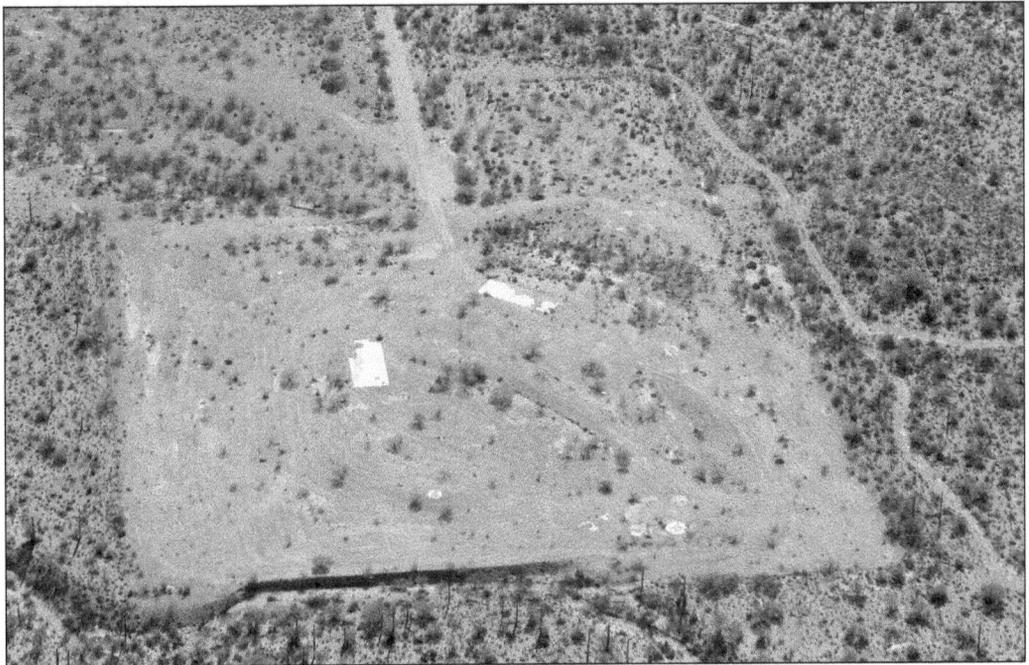

All that remained above ground of the Titan missile complex in Oro Valley after the 1983 demolition was the cleared land and the road that connected Highway 77 to the site. However, below ground are the rubble of the silo, the command center, and the blast block. (Courtesy Chuck Penson.)

In 1970, Jim Kriegh presided over another incorporation meeting in his living room. While the residents researched solutions, no action was taken until the problem became critical. Then, in one weekend, they collected over 200 signatures on a petition for incorporation. This represented almost 71 percent of the taxpayers. (Courtesy James Kriegh.)

Richard Kolt was the second mayor of Oro Valley and served in that position from April 1975 until May 1976. The first mayor, Kenneth Holford, served only six months. As Oro Valley has grown, so has the mayoral office term. The mayor as of 2007, Paul Loomis, will serve until 2010. (Courtesy Town of Oro Valley.)

Until 1987, this was the official town hall and was home to all of the town's official departments. All departments except the Oro Valley Police Department moved out in 1987. It is now the home of the parks and recreation department and a portion of public works. (Courtesy Town of Oro Valley.)

Lois M. Lamberson, who served as Oro Valley's third mayor from May 1976 until May 1978, discusses business with E. S. "Steve" Engle in the mayor's office in the original town hall. Engle followed Lamberson in office when he became Oro Valley's mayor from May 1978 until May 1990. (Courtesy Town of Oro Valley.)

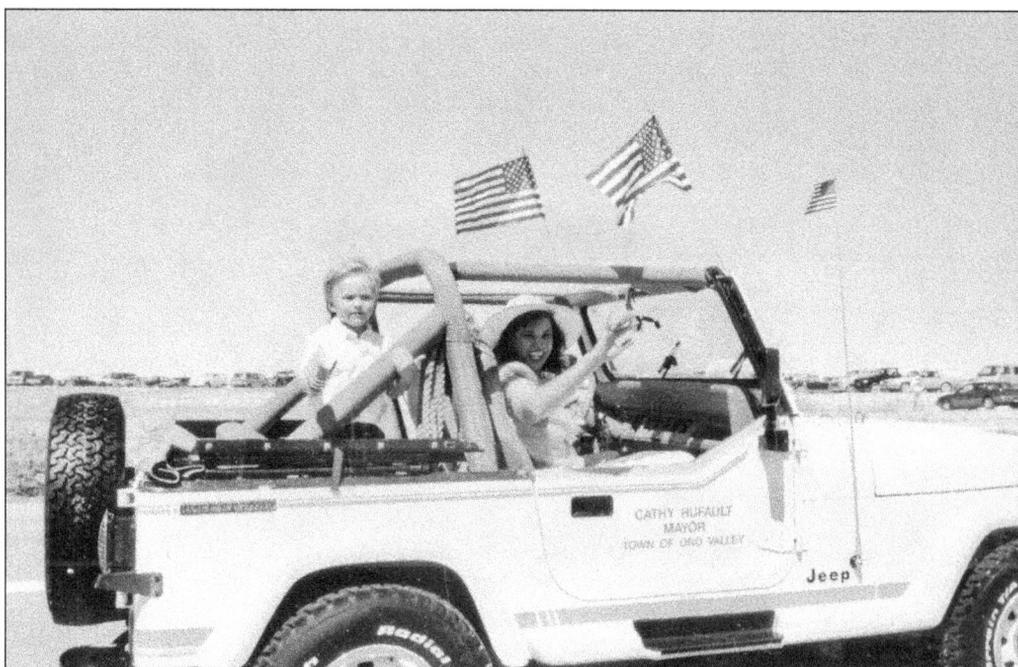

Oro Valley's first parade celebrated of the dedication of their new town hall complex in 1991. The parade was led by Mayor Cathy Hufault, who is seen here waving to the crowd from a jeep decorated with American flags. Her grandson surveys the crowd from the rear. (Courtesy Cathy Hufault.)

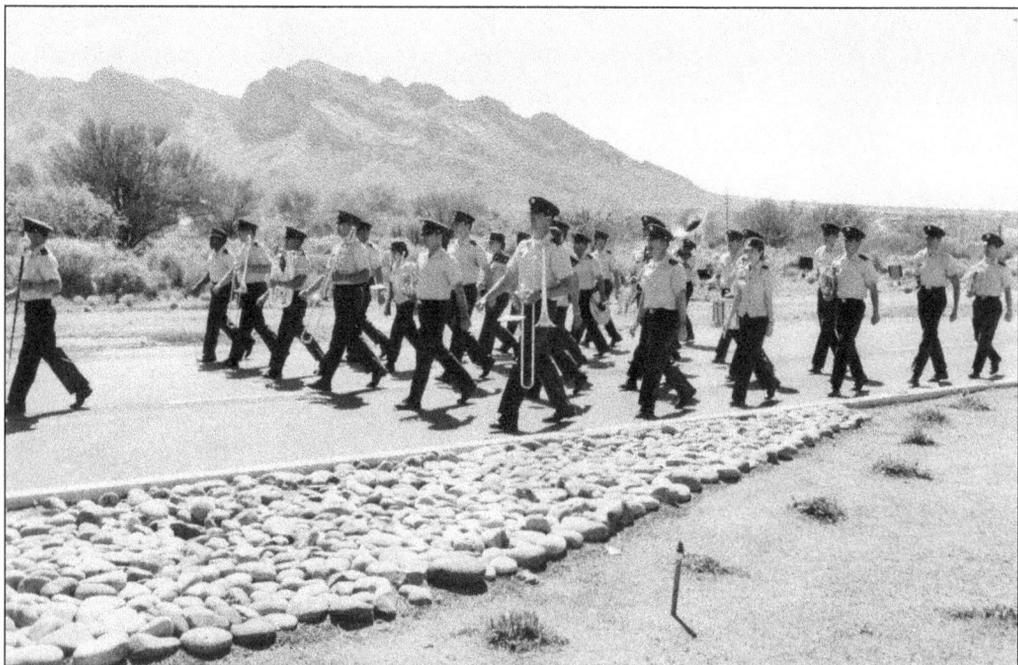

The dedication parade lived up to all the expectation of small-town America. It included not only town dignitaries, but also marching units from the U.S. military. However, the hit of the parade was a local high school ROTC band that proudly strutted their stuff. (Courtesy Cathy Hufault.)

The new red-roofed town hall complex, completed in 1991, is framed by the Santa Catalina Mountains. It is the venue not only for town business, but also for a multitude of town activities, including such things as library presentations, cultural performances, and a farmers' market. (Courtesy Cathy Hufault.)

When the town found itself divided by a new phone districting plan in 1990, they asked Congress for help. Sen. John McCain came to get the facts first hand and was able to get the town redistricted into one unit. Mayor Cathy Hufault, on the left, greets Senator McCain and his wife. (Courtesy Cathy Hufault.)

Oro Valley citizens have always had an interest in global affairs and looked to broaden their knowledge by inviting special speakers to the town. In 1989, Oliver North spoke after his congressional testimony and shared his views, his knowledge, and his experiences in dealing with world leaders. (Courtesy Cathy Hufault.)

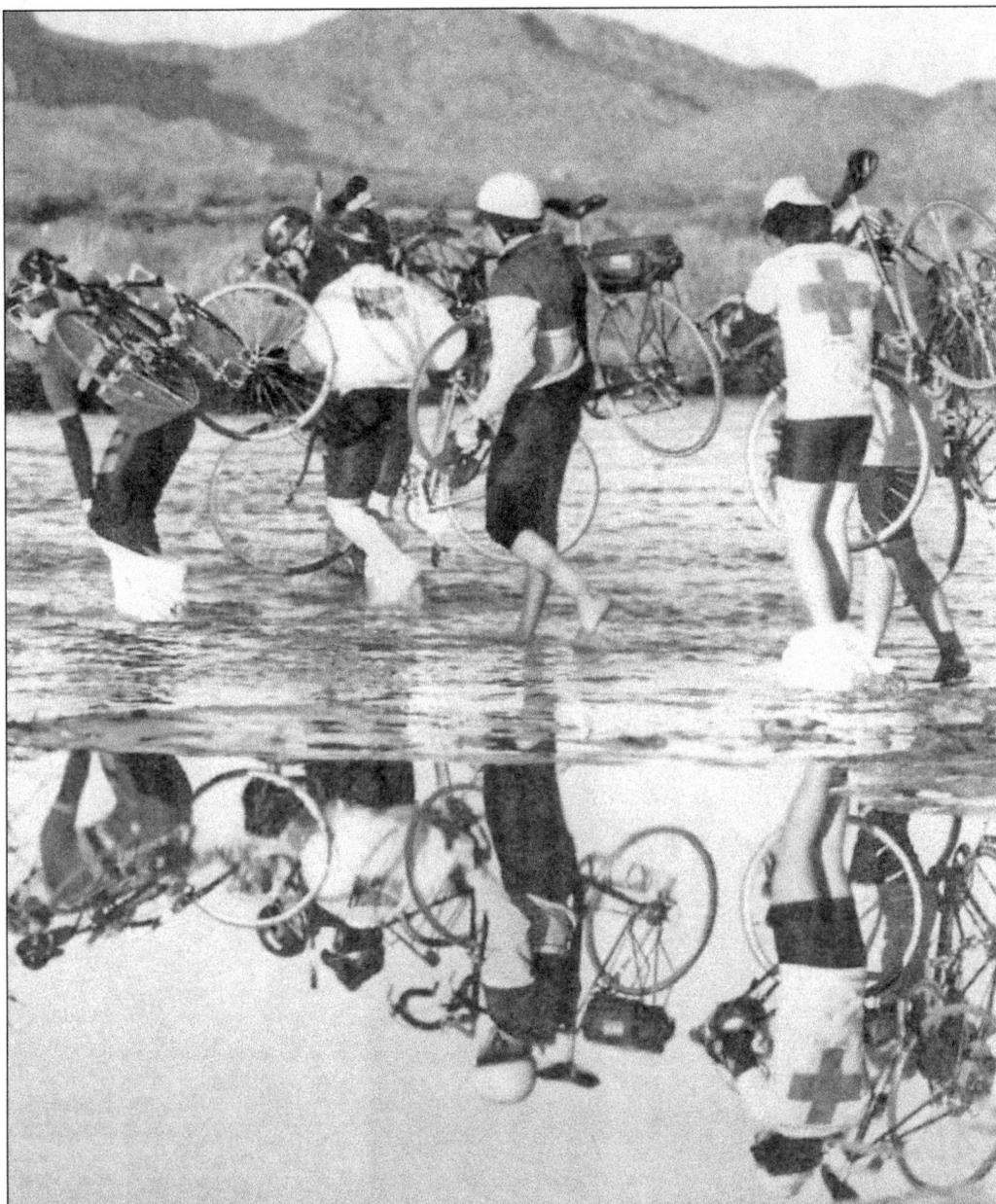

From the beginning, Oro Valley encouraged and sponsored national sporting events. In 1987, the very prestigious El Tour de Tucson started at the El Conquistador Resort and faced some unusual barriers for Tucson. The tour is the largest perimeter bicycle race in the United States. (Courtesy Town of Oro Valley.)

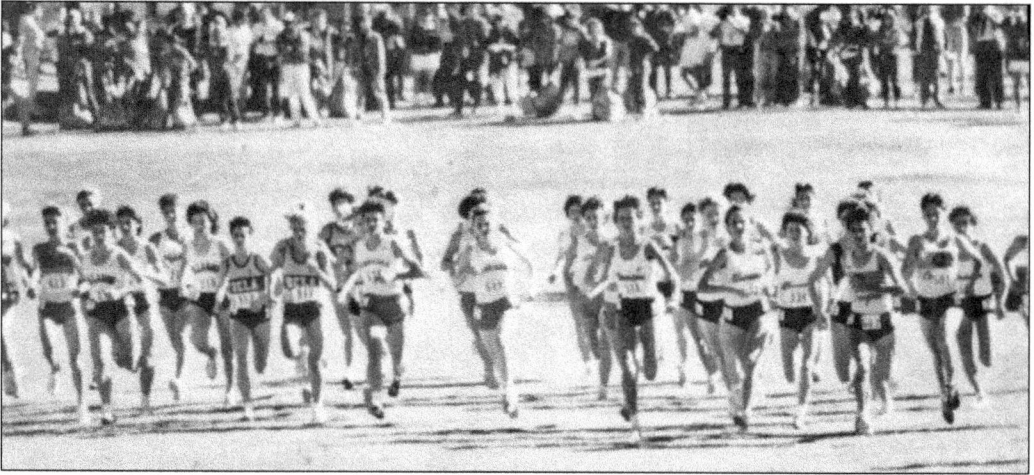

In 1987, the town of Oro Valley sponsored a major collegian event. The NCAA women's cross-country meet was held in a section of town known as Cañada Hills. The meet drew participants from all over the country, with volunteers from the community helping. (Courtesy Town of Oro Valley.)

The 1980s were an important growth year for the town. In 1982, the luxurious El Conquistador Resort was completed, snuggled against beautiful Pusch Ridge. In 1986–1987, Oro Valley grew even larger when it annexed 8,687 acres, which included over 7,000 acres of the community of Rancho Vistoso. (Courtesy Hilton El Conquistador Resort Hotel.)

Oro Valley has always taken great pride in its military men and women. Kevin Kriegh was the first military person from Arizona to return home from the Gulf War, and the town turned out to show its appreciation. He rode in his welcome-home parade in this antique car. (Courtesy Jim Kriegh.)

In 1987, Oro Valley added over 7,000 acres when it annexed a section of land north of the town called Rancho Vistoso, which included the Del Webb community of Sun City. The 1,000 acres of Sun City added a resort-type, senior-citizen living community to the town. (Courtesy Sun City Vistoso.)

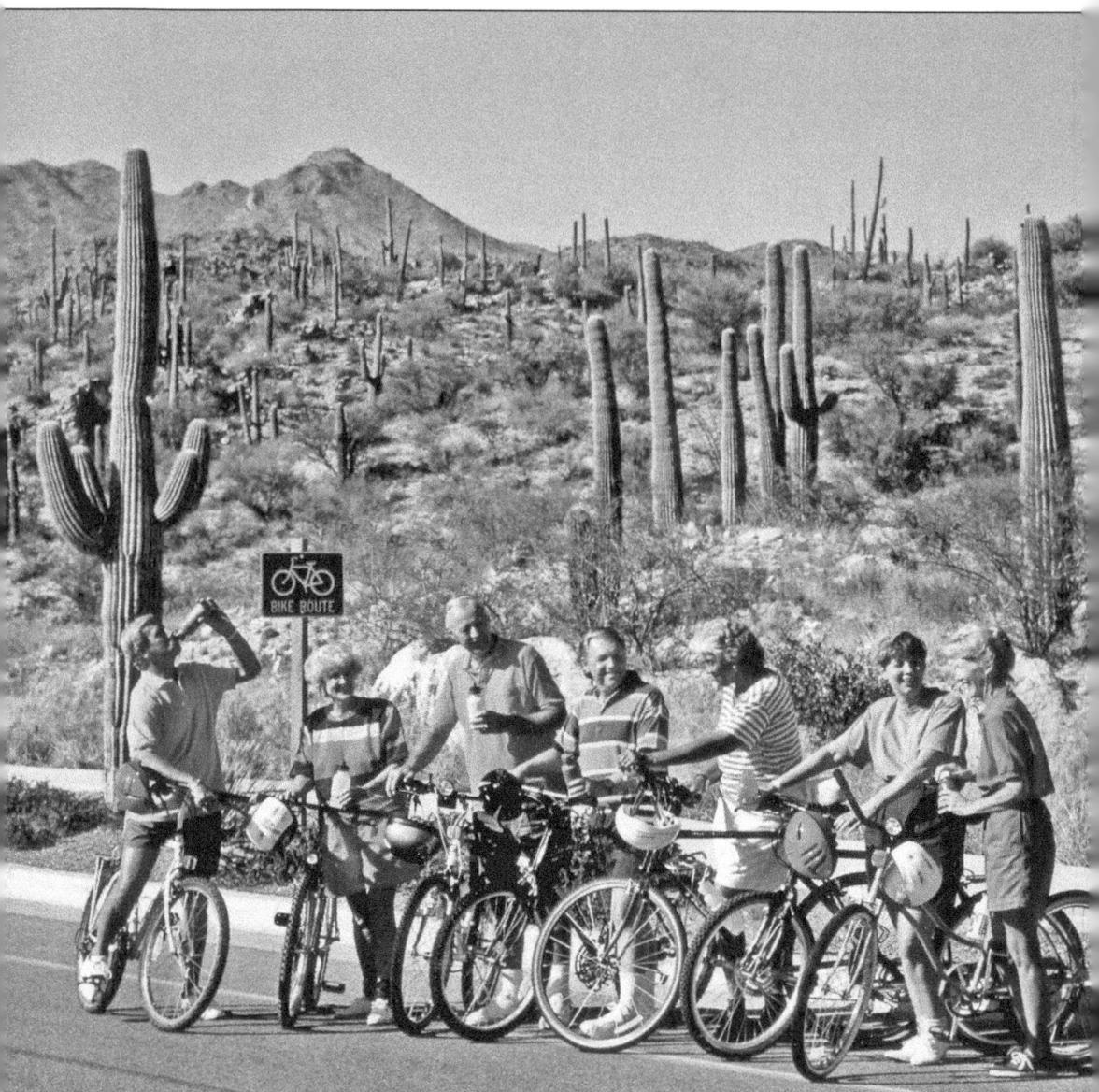

In 1987, the first of 800 residents moved into the Sun City community and started enjoying the good life with golf, hiking, and bike trails. Activities such as biking were offered almost immediately, so residents could take advantage of the community's setting. Eventually Sun City would offer more than 100 diversified activities. (Courtesy Sun City Vistoso.)

Five

GEM OF A TOWN

There were few horses and no cattle, but that did little to diminish the importance of the ranch, for sunken deep into the dusty soil were the roots of Oro Valley's history.

The Santa Catalina Mountains loomed over the scene, with Pusch Ridge and Pusch Peak the predominant landmarks. It was a remarkable day in Oro Valley history; it was a day of celebration—the celebration of the acquisition of the historic Steam Pump Ranch by the town.

Mayor Paul Loomis reminded the audience that the early pioneers were lured to Oro Valley by the beautiful land and the promise of prosperity, much as they are today. He told the celebrating audience that there was an important characteristic then that the town today still embodies: "that spirit to be innovative, to bring new ideas and new energy to a place and watch it flourish and take hold." The mayor reminded all that a community cannot move forward without understanding its heritage and that the understanding of cultural roots is an important consideration in setting successful and meaningful future goals and direction.

Everywhere in Oro Valley, there is evidence of the honoring of its history, the emphasis on the cultural aspects of life, and the support and availability of quality-of-life venues, such as medical facilities, many religious institutions, and an abundance of shopping, including outdoor markets.

Oro Valley has both public and private schools in all levels, and the children of Oro Valley are not forgotten. Programs in art and education are funded and presented every year for the students outside the classroom. These are not only educational but also enjoyable. Venues are carefully planned to appeal to families of all ages, and park events take advantage of Oro Valley's pleasant weather and superb facilities.

From Innovation Park, a biotech area mostly involved in medical research, to the public art scattered around town, to the Steam Pump Ranch, Oro Valley is a gem of a town built on the solid foundation of pride, history, and innovation.

Something has caught the attention of this young girl, who interrupts her reading to glance over her shoulder at whatever it is. Much changes, but the young girl does not, for she is one of Oro Valley's public art pieces cast in bronze. (Courtesy Simon Herbert, Pima County Cultural Resources.)

Some public art is a tribute to mothers and daughters but meant to be enjoyed by all. The public art program requires all commercial developers to set aside one percent of their building budget to fund on-site artworks. (Courtesy Simon Herbert, Pima County Cultural Resources.)

An art tribute to its historic roots, the long-horned ram stands guard outside the town hall. It is mandated that public building projects set aside one percent of their budget for town art. Beautifully executed pieces of art are scattered throughout Oro Valley in public, private, and commercial venues. (Courtesy Simon Herbert, Pima County Cultural Resources.)

Outside the Oro Valley Public Library is a symbolic piece of public art. Executed in copper, it is a glistening tree of knowledge growing out of an open book. The piece makes a significant statement on the importance of reading, of education, and of Oro Valley's values. (Courtesy Simon Herbert, Pima County Cultural Resources.)

Public concerts in the park not only encourage young musicians, but also provide a special evening out for the public. Music as well as art is part of the public arts program offered and managed by the Greater Oro Valley Arts Council. (Courtesy Simon Herbert, Pima County Cultural Resources.)

A physician and her patient stand in front of the Northwest Medical Center. This poignant piece of art is part of the Northwest Hospital's $480,000-plus public art collection. The hospital is a strong supporter of Oro Valley's art program and understands its contribution to a quality lifestyle. (Courtesy Mike Marriott.)

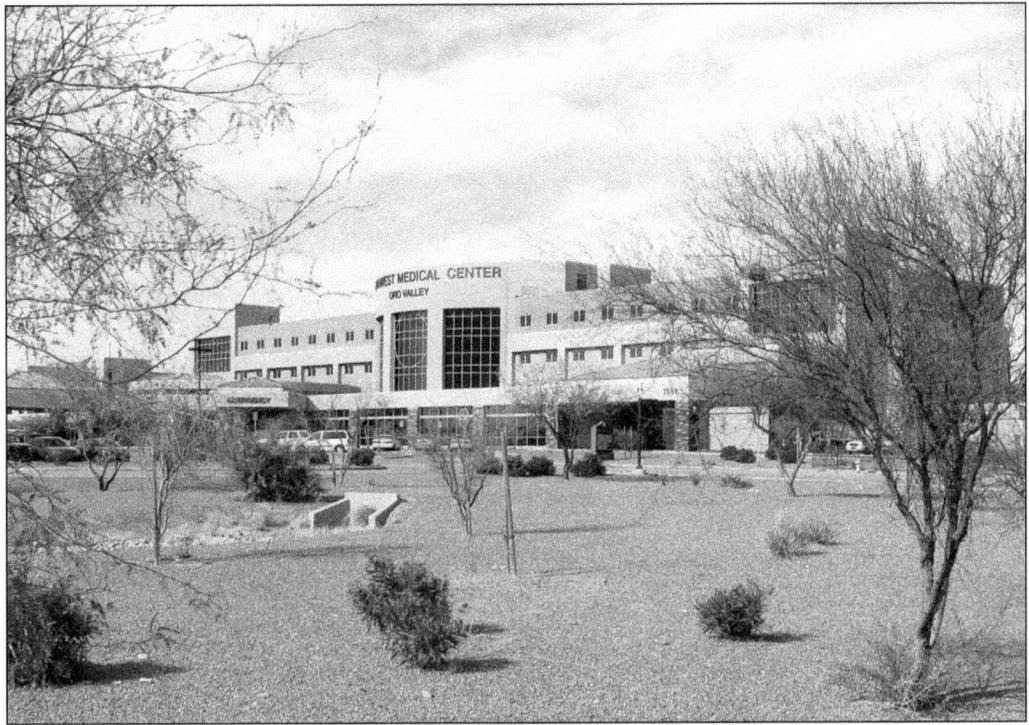

The Northwest Medical Center opened in 2005. In its first year, it had over 3,000 admissions, and over 1,000 surgeries were performed. The hospital employs 402 faculty members full-time and another 112 part-time. Its 500 physicians represent 30 different specialties offering state-of-the-art medical care. (Courtesy Simon Herbert, Pima County Cultural Resources.)

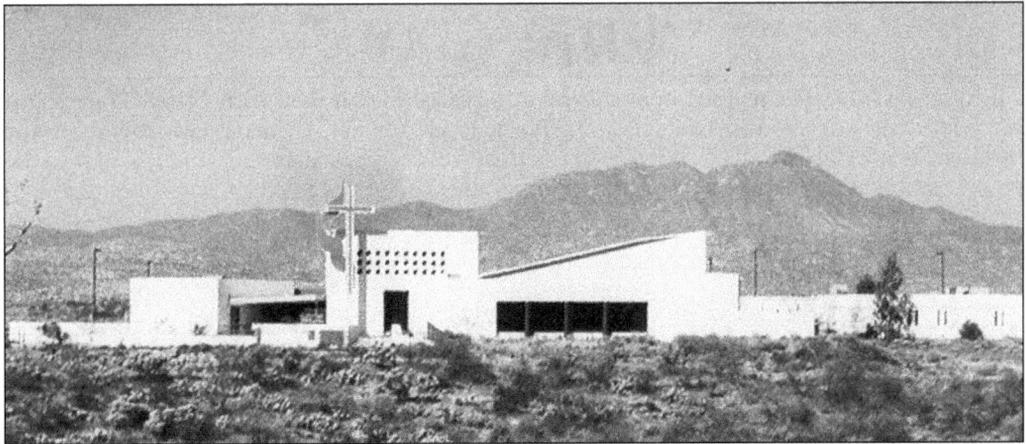

Once a missile site and now the site of a mission, the Vista de la Montaña United Methodist Church is built on what was the Oro Valley Titian missile site. The church purchased the property of 10.18 acres for $230,000 in 1992. Built high on a ridge, its cross is seen for miles. (Courtesy Vista de la Montaña United Methodist Church.)

The official Oro Valley seal incorporates the major features that drew early Native Americans, pioneers, and settlers to this land. The long-horned ram, the Santa Catalina Mountains, and a flowing Cañada del Oro all pay homage to the treasures of this land, from its historic past to the present and into future. (Courtesy Town of Oro Valley.)

BIBLIOGRAPHY

Blue, Alexis. "Founding Father." *Tangerine* Volume 1, issue 2 (July 2007), p. 20.

Bezy, John V. *A Guide to the Geology of Catalina State Park*. Tucson: Arizona Geological Survey, 2002

Marriott, Barbara. *Canyon of Gold: Tales of Santa Catalina Pioneers*. Tucson: Catymatt Publications, 2005

Swartz, Deborah L., and William H. Doelle. *Archaeology in the Mountain Shadows: Exploring the Romero Ruin*. Tucson: Center for Desert Archaeology, 1996.

Visit us at
arcadiapublishing.com

www.ingramcontent.com/pod-product-compliance
Lightning Source LLC
Chambersburg PA
CBHW050712110426
42813CB00007B/2159